COLORADO
EXCURSIONS

—— WITH ——
HISTORY, HIKES AND HOPS

ED SEALOVER

THE
History
PRESS

Published by The History Press
Charleston, SC
www.historypress.net

First published 2016

ISBN 978-1-5402-0334-2

Library of Congress Control Number: 2016932060

Notice: The information in this book is true and complete to the best of our knowledge. It is offered without guarantee on the part of the author or The History Press. The author and The History Press disclaim all liability in connection with the use of this book.

To Lincoln, though you may be too young to remember the roads we traveled for this book, they will remain burned into my heart as some of my best memories.

CONTENTS

Acknowledgements 11
Introduction 13
Colorado Map 16–17

TRIP #1: DENVER
Day 1—Introduction to Denver and Colorado 21
 Historic Site: History Colorado Center 21
 Natural Site: City Park 22
 Drinking Site: Buckhorn Exchange 24

Day 2—Downtown Denver 27
 Historic Site: Downtown Denver Walking Tour 27
 Natural Site: Confluence Park 31
 Drinking Site: Falling Rock Tap House 32

Day 3—Uniquely Denver 34
 Natural Site: Red Rocks Amphitheatre/Dinosaur Ridge 34
 Historic Site: Molly Brown House Museum 36
 Drinking Site: Great Divide Brewing 39

TRIP #2: DENVER AREA
Day 1—Denver and Its Outskirts 45
 Natural Site: Mount Falcon Park 45
 Historic Site: Colorado State Capitol 47

CONTENTS

Drinking Sites: Strange Craft Beer and
 Dry Dock Brewing South Dock 48

Day 2—South Denver and Its Suburbs 52
 Natural Site: Devil's Head Lookout 52
 Historic Site: Littleton Museum 54
 Drinking Site: Laws Whiskey House 56

Day 3—Golden to Boulder 58
 Historic Site: Buffalo Bill Museum and Grave 58
 Natural Site: Golden Gate Canyon State Park 60
 Drinking Site: Avery Brewing 62

TRIP #3: FORT COLLINS AND ESTES PARK
Day 1—Greeley to Fort Collins 67
 Historic Site: Dearfield 67
 Natural Site: Horsetooth Rock 69
 Drinking Site: The Mayor of Old Town 71

Day 2—In and Around Fort Collins 74
 Natural Site: Mount Margaret 74
 Historic Site: Downtown Fort Collins Walking Tour 75
 Drinking Site: Odell Brewing 78

Day 3—Estes Park to Lyons 81
 Natural Site: Rocky Mountain National Park 81
 Historic Site: The Stanley Hotel 84
 Drinking Site: Oskar Blues Grill & Brew 85

TRIP #4: MOUNTAIN CORRIDOR
Day 1—Idaho Springs to Central City 91
 Natural Site: St. Mary's Glacier 91
 Historic Site: Central City Opera House 93
 Drinking Site: Dostal Alley Brewpub 95

Day 2—Georgetown to Dillon 98
 Historic Site: Georgetown Loop Railroad 98
 Natural Site: Dillon Reservoir 100
 Drinking Site: Pug Ryan's Brewing 102

CONTENTS

Day 3—Vail — 104
 Natural Site: Booth Falls — 104
 Historic Site: Colorado Ski & Snowboard Museum — 106
 Drinking Site: Vail Cascade Resort — 108

TRIP #5: CENTRAL MOUNTAINS

Day 1—Leadville Area — 113
 Historic Site: Camp Hale — 113
 Natural Site: Twin Lakes — 115
 Drinking Site: Silver Dollar Saloon — 117

Day 2—Leadville to Aspen — 119
 Historic Site: National Mining Hall of Fame and
 Museum/Matchless Mine — 119
 Natural Site: Maroon Bells Scenic Area — 121
 Drinking Site: Element 47 — 123

Day 3—Glenwood Springs — 126
 Historic Sites: Doc Holliday's Grave and Hotel Colorado — 126
 Drinking Site: Glenwood Canyon Brewing — 130
 Natural Site: Glenwood Hot Springs — 132

TRIP #6: WESTERN SLOPE

Day 1—Grand Junction Area — 137
 Natural Site: Colorado National Monument — 137
 Historic Site: Museum of the West — 139
 Drinking Site: Palisade's Everything Block — 140

Day 2—Silverton to Telluride — 143
 Historic Site: Mayflower Mill — 143
 Natural Site: Box Cañon Falls — 145
 Drinking Site: Telluride Brewing — 147

Day 3—Montrose Area — 149
 Natural Site: Black Canyon of the Gunnison National Park — 149
 Historic Site: Ute Indian Museum — 151
 Drinking Site: Horsefly Brewing — 153

CONTENTS

TRIP #7: SOUTHWESTERN COLORADO

Day 1—Central Durango 157
 Historic Site: Durango & Silverton Narrow Gauge Railroad Museum 157
 Natural Site: Animas Mountain 159
 Drinking Site: Lady Falconburgh's Alehouse and Kitchen 161

Day 2—Cortez/Durango Area 164
 Historic Site: Mesa Verde National Park 164
 Natural Site: Knife Edge Trail 166
 Drinking Site: Ska Brewing 168

Day 3—Lake City 171
 Historic Site: Alferd Packer Massacre Trail 171
 Natural Site: The Alpine Loop 173
 Drinking Site: Packer Saloon and Cannibal Grill 176

TRIP #8: SAN LUIS AND UPPER ARKANSAS VALLEYS

Day 1—San Luis Valley, Part One 181
 Historic Site: Fort Garland Museum 181
 Natural Site: Zapata Falls 184
 Drinking Site: Three Barrel Brewing 186

Day 2—San Luis Valley, Part Two 189
 Natural Site: Great Sand Dunes National Park and Preserve 189
 Historic Site: Town of San Luis 192
 Drinking Site: The Rubi Slipper 194

Day 3—Upper Arkansas Valley 196
 Natural Site: Rafting Browns Canyon 196
 Historic Site: Saint Elmo 198
 Drinking Site: Elevation Beer Company 201

TRIP #9: SOUTHEASTERN COLORADO

Day 1—La Junta to Lamar 205
 Natural Site: Vogel Canyon and Picket Wire Canyonlands 205
 Historic Site: Bent's Old Fort 208
 Drinking Site: The Buzzards Roost 210

CONTENTS

Day 2—Las Animas to Pueblo 212
 Natural Site: John Martin Reservoir State Park 212
 Historic Site One: Camp Amache 214
 Historic Site Two: Sand Creek Massacre National Historic Site 216
 Drinking Site: Walter's Brewery & Taproom 219

Day 3—Cañon City 221
 Historic Site: Museum of Colorado Prisons 221
 Drinking Site: The Winery at Holy Cross Abbey 223
 Natural Site: Royal Gorge Bridge & Park 225

TRIP #10: COLORADO SPRINGS AND CRIPPLE CREEK

Day 1—Around Colorado Springs 231
 Historic Site: Air Force Academy 231
 Natural Site: Pikes Peak Cog Railway 233
 Drinking Site: Bristol Brewing 235

Day 2—Colorado Springs' Westside 238
 Historic Site: Pro Rodeo Hall of Fame &
 Museum of the American Cowboy 238
 Natural Site: Garden of the Gods 240
 Drinking Site: Golden Bee 241

Day 3—Colorado Springs to Cripple Creek 244
 Natural Site: Gold Camp Road 244
 Historic Site: Old Homestead House Museum 246
 Drinking Site: Boiler Room Tavern 249

Index 251
About the Author 255

ACKNOWLEDGEMENTS

U ndertaking *Colorado Excursions with History, Hikes and Hops* has been a journey in more ways than one. Like my first book, *Mountain Brew: A Guide to Colorado's Breweries*, it began as a flicker of an idea that grew slowly. But once my wife, Denise, informed me in May 2015 that we had a second child on the way, it became an eight-month sprint—and it was a wonderful time at that.

First, I have to thank Denise, who allowed me to take on this project while we were raising an infant and preparing for another. She once again designed the maps for this book, rounded up many of the photos and served as my final editor. But she also allowed me to drag her and our son, Lincoln, around the state several times, turning my research into our vacation and bedding down as a family in sometimes remote places like Lake City. It was a hectic, full schedule. And I loved every minute of it.

I want to thank The History Press and my commissioning editor, Artie Crisp, for making my work for a second time into a lasting contribution about the knowledge of Colorado. Though this book builds off of the century-plus of research done by writers and historians who have come before me, I hope that it inspires everyone who reads it to begin their explorations of the state and search for even deeper knowledge of what makes Colorado such an enchanting place.

It's important for me to acknowledge all of the brewers, vintners, distillers, bar owners and historical-site operators who sat down with me and explained why they love what they do and how it fits into the greater picture of this

state. An especially large thanks goes to the incomparable Laura Lodge, who not only walked me through the workings of the Vail Cascade Resort but also took on double duty as my guide through the wildflowers of Booth Falls during my time in Vail.

And while all of the research in here comes from my visitations and from a few place-specific books that are noted in these chapters, I want to tip my hat as well to several publications that were invaluable in helping me plot out my travels. Those include the back issues of *Colorado Heritage* magazine, *Walking into Colorado's Past: 50 Front Range History Hikes* by Ben Fogelberg and Steve Grinstead and the essential *A Colorado History* by Carl Ubbelohde, Maxine Benson and Duane Smith.

A deserving nod goes to friends—Charles Ashby and Tess Furey, Marcus and Trish Montoya and Sara Nesbitt—who housed us during our travels and gave me great ideas on local attractions. Another goes to my friends around Denver and my editors at the *Denver Business Journal*, who haven't seen me as much in these recent months as I pressed forward on this goal, but who haven't abandoned me either.

Finally, a true, heartfelt appreciation goes to all of those who have shaped me into someone with the curiosity and desire to get out and know more about the world around me—and then to share that knowledge with others. God blessed me with a spirt of wisdom I could not have acquired on my own. My late father, Ed Sealover Sr., instilled in me a love of history. Numerous friends got me onto the hiking paths and into the beer halls of this state from the time I moved to Colorado in December 2000. Susan Edmondson, former features editor at the *Gazette* in Colorado Springs, somehow agreed to my suggestion that I could write a beer column for the paper back in 2003. Bill Convery, former Colorado state historian, encouraged me to pursue my love of history and to put it into a book.

Thank you, everyone, who has helped to make not only this book into what it is but who also has helped to make me into who I am. This book is a love letter to the adventures we've had—and to the journeys I hope that I can inspire others to take as well.

INTRODUCTION

While writing *Mountain Brew: A Guide to Colorado's Breweries*, I was struck by the answers of two of my favorite beer makers on why they felt they'd succeeded. Both Great Divide Brewing founder Brian Dunn and Avery Brewing founder Adam Avery spoke of how they were trying to make beer styles that established breweries were making in the early 1990s and found themselves struggling. Then both tossed aside expectations, concocted beers that they loved even if most people weren't drinking them—big, hoppy creations on Avery's part and a high-alcohol old ale on Dunn's—and suddenly they sold like crazy. Today they are among the most respected brewers in Colorado.

Similarly, as I kicked around a potential follow-up to my first book, I asked myself what I wanted to research in depth. And the truth is, there are three things that I truly love doing when I have down time—drinking good locally made beverages, going on beautiful hikes and immersing myself in history. And at the same time, I would argue that Colorado's outdoor recreational opportunities, craft beer scene and fascinating past are the three attributes that are most unique to this state and most compelling. So, while nobody else has tried to combine those three paths into one coherent travel guide, I decided to take that chance and show you why I love this state so much.

The book offers one historic site, one natural site and one drinking site for you to visit each day in relative proximity to each other. And while thirty days is a nice round number—who doesn't want to go on a month-long journey?—I've divided it up into more bite-sized trips of three days each, in

order to highlight destinations that can be traversed during a long weekend or short week.

Some destinations might be no-brainers for anyone planning to spend significant time in Colorado. Rocky Mountain National Park, Mesa Verde and Odell Brewing are likely to be on any significant hiking, history or hop trip list, and in those cases I've tried to illuminate certain hikes or beers that let you get the best feel for the place in a short amount of time. Other locations, however, are far less likely to pop up on most itineraries. As such, I've tried to lay out why the Museum of Colorado Prisons is one of the best museums in the state, why the half-mile hike to Zapata Falls is a life-affirming experience and why a stopover in Telluride for nothing more than tasting the experiments of Telluride Brewing is a trip you will not regret.

While some of the stops certainly deserve more than one day of exploration—the aforementioned Rocky Mountain National Park and Great Sand Dunes National Park are two that come to mind—the book is laid out to allow these daylong suggestions to be accomplished literally in a day. I did most of my research, at least for the non-metro areas, on a series of weeklong vacations with my wife and one-year-old son in the summer of 2015. Though the days could be full, they also were very fulfilling.

I also have organized each day with a suggested order of visitation of the three sites. Sometimes this is done with a direction of travel in mind—going, say, from Colorado Springs to Cripple Creek or moving between multiple locations in some of Colorado's more sparsely populated regions. Sometimes this is done to emphasize certain times of day when hitting a site is optimal; Great Sand Dunes should be hiked as early as possible in the morning, for example, and Glenwood Hot Springs is best experienced at or after sunset. And sometimes I just default to the belief that a good hike is a great way to start the day, and a good brewery or bar is a great way to end it.

The company I kept brings me to my last point about the attractions identified here; they are meant to be accessible to people of most every age and physical ability. Colorado is home to fifty-four fourteeners—mountains that rise above fourteen thousand feet over sea level—and there are few outdoor experiences that can compare to a hike up one of them. But many are not easy jaunts, especially for temporary visitors to this altitude, and they also tend to take up a full day on their own. The outdoor excursions listed here—whether hiking, rafting or riding in a vehicle—all are safe for the whole family. And they're spectacular.

While I realize that not all craft beer fans are history geeks, and not all outdoor enthusiasts want to follow a sunrise hike with a trip to a local

museum, I think there is a bond running between history, hiking and drinking. If you want to discover the soul of Colorado, you will look to find it outside of cookie-cutter restaurants or strip malls. You'll want to learn what separates the attractions here from those found anywhere else in the country. This book will help you to seek those places out and to savor a spirit of independence within these borders.

Happy exploring.

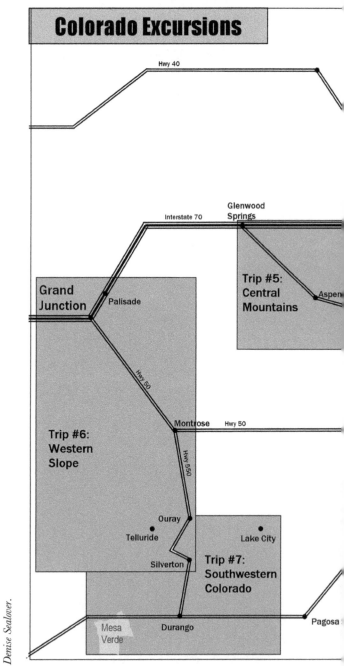

Colorado Excursions

Hwy 40

Interstate 70

Glenwood Springs

Trip #5:
Central
Mountains

Aspen

Grand
Junction

Palisade

Hwy 50

Montrose Hwy 50

Hwy 550

Trip #6:
Western
Slope

Ouray

Telluride

Lake City

Silverton

Trip #7:
Southwestern
Colorado

Mesa
Verde

Durango

Pagosa

Denise Sealover.

TRIP #1
DENVER

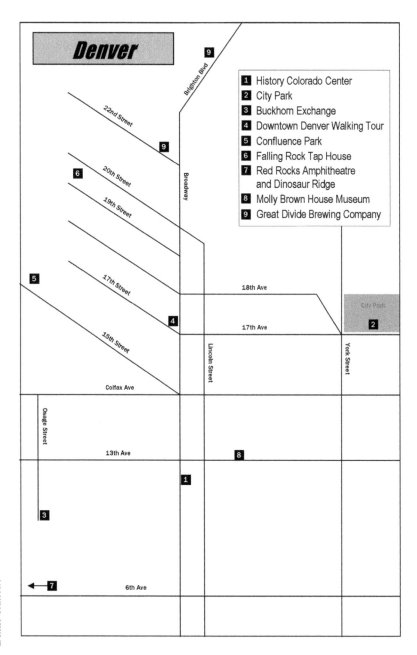

Denver

1. History Colorado Center
2. City Park
3. Buckhorn Exchange
4. Downtown Denver Walking Tour
5. Confluence Park
6. Falling Rock Tap House
7. Red Rocks Amphitheatre and Dinosaur Ridge
8. Molly Brown House Museum
9. Great Divide Brewing Company

Denise Sealover.

DAY 1
INTRODUCTION TO DENVER AND COLORADO

HISTORIC SITE: HISTORY COLORADO CENTER

1200 Broadway, Denver / 10:00 a.m. to 5:00 p.m. daily / www.HistoryColorado.org

Though Colorado became a part of the American story much later than many historic East Coast states, its preserved history stretches back further than most parts of the country. And this museum, opened in 2012 to replace an outdated predecessor, tells not just the stories that many around the country know but also the too-often-overlooked niches of history that have given "Colorful Colorado" a meaning beyond the vibrancy of its landscape.

A digital timeline in the soaring atrium initiates visitors to the breadth of activity here, from formation of the Rocky Mountains to events like the 2008 Democratic National Convention. Near it are H.G. Wells–style time machines that allow the visitor to dial up stories ranging from those of the historic Cheyenne Dog Soldiers to gonzo journalist Hunter S. Thompson's ill-fated 1970 run for Pitkin County sheriff.

"Colorado Stories" walks visitors through some four hundred years of history with a focus on eight places in time. An exhibit on the mines of Silverton literally places you inside the engines of commerce that drew people to the state in the nineteenth century. A section on Lincoln Hills, an African American mountain resort founded in 1922, lets you examine a side

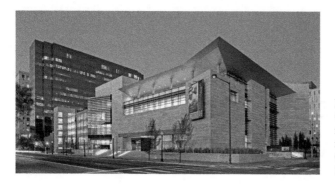

Located in Denver's Golden Triangle neighborhood, the new History Colorado Center opened in 2012. *Frank Ooms*.

of Colorado rarely seen. And an area highlighting Steamboat Springs—home to more Winter Olympians than any city in America—explains why skiing was so important to the development of the state and sends visitors on a simulated ski jump.

Colorado's story is one based on humans interacting with the environment. The "Living West" exhibit explains why people settled at Mesa Verde in southwestern Colorado—and then disappeared. It tells of Colorado's often-overlooked part in the Dust Bowl, immersing visitors in the terrifying Black Sunday storm of 1935. And it explains why forest fires are playing a major part in recent state history.

With 15 million pieces in its collection, including iconic Works Progress Administration dioramas depicting the settlement of Denver, the museum has a constantly rotating schedule of special exhibits, plus standing features on Denver oddities and an early twentieth-century homesteading town on the Eastern Plains. It would take you a month to visit all of Colorado's highlights; History Colorado Center will give you the overview, however, in a few hours.

NATURAL SITE: CITY PARK

2001 Colorado Boulevard, Denver / Open around the clock / www.denvergov.org/parks

Denver respects its natural beauty by preserving a significant number of public spaces. Washington Park in the south-central city is a joggers' and picnickers' paradise. Cheesman Park, east of Capitol Hill, is a picnic hot spot built on a former graveyard. And the best combination of beautiful walks and educational attractions exists in east Denver at City Park.

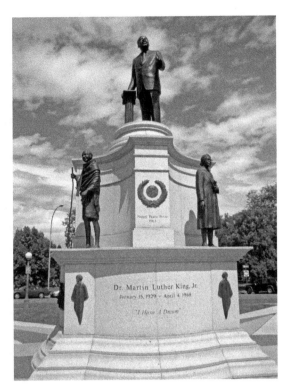

Right: The Dr. Martin Luther King Jr. I Have a Dream Monument in Denver's City Park honors civil rights pioneers from different centuries. *Author photo*.

Below: Denver Museum of Nature & Science stands in the background of the electric fountain in City Park's Ferril Lake. *Author photo*.

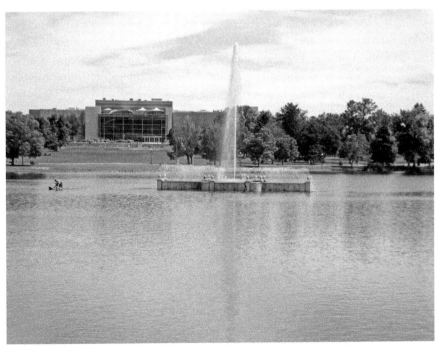

Laid out in the 1880s and 1890s, the 320-acre park is home to two of the city's most visited tourist destinations. Denver Zoo, with its beloved polar bears and elephants, sits on the northern side of the park. The Denver Museum of Nature & Science, which specializes in everything from paleontology to Egyptology, marks the eastern end at Montview and Colorado Boulevards.

City Park's centerpiece is Ferril Lake, a quaint twenty-four-acre body of water that was known as Big Lake before being renamed in 1996 for poet, newspaperman and native son Thomas Hornsby Ferril. In the 1880s, passengers cruised it in swan boats—pedal-powered likenesses of the bird that scared the daylights out of the native geese. Today visitors can rent smaller pedal boats, kayaks or stand-up paddle boards.

Standard bicycles and surrey bikes also are available to get a full view of the park, or you can meander the three-mile Mile High Loop, a paved path that marks the spots exactly 5,280 feet above sea level.

The two-story, Spanish-style pavilion at the west end of Ferril Lake featured white-jacketed waiters serving meals at the turn of the twentieth century—and also held two jail cells for unruly parkgoers. It's now the focal point of a summer jazz concert series.

The Dr. Martin Luther King Jr. I Have a Dream Monument just west of Ferril Lake honors civil rights leaders stretching from Frederick Douglass to King and features timelines of progress, as well as the diagram of a slave ship. Wellington Webb, Denver's first African American mayor, dedicated it in 2002.

Just south of the zoo is Duck Lake, the largest of eight other lakes in the park and home to colonies of black-crowned night herons and double-crested cormorants. So many birds make homes of the trees around the lake that the atmosphere feels Hitchcockian at times.

Many tucked-away gardens make pleasant resting spots. Most intriguing may be the Burns Garden northwest of the pavilion, designed in the French broderie style and featuring both a statute of Scottish poet Robert Burns and three Civil War cannons.

Drinking Site: Buckhorn Exchange

1000 Osage Street, Denver / 11:00 a.m. to close weekdays, 5:00 p.m. to close weekends / www.buckhorn.com

Buckhorn Exchange holds Colorado's liquor license number one and is the oldest restaurant in Denver. But the bar and eatery that's hosted five

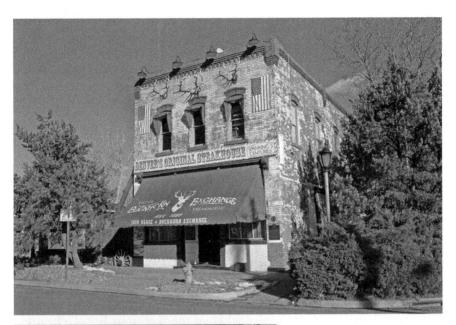

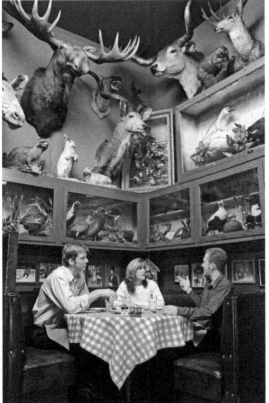

Above: In operation since 1893, the Buckhorn Exchange wears its reputation for serving the meat of exotic animals with pride. *Courtesy of Buckhorn Exchange.*

Left: Diners at the Buckhorn Exchange eat under the watchful eyes of wildlife of all sorts, some shot by original owner Henry "Shorty Scout" Zietz. *Courtesy of Buckhorn Exchange.*

presidents didn't gain its international fame until it decided to serve its now signature dish: fried bull testicles.

Those Rocky Mountain oysters, which co-owner Bill Dutton calls the "original sack lunch," are not just a gimmick; they're among the best-selling items on an exotic game menu that also features smoked rattlesnake, fried alligator tail and the occasionally available ostrich and yak. Just south of downtown, the Buckhorn is such a destination for out-of-towners that the menu is printed in five languages.

Henry "Shorty Scout" Zietz opened the Buckhorn in 1893 after a career that included scouting with Buffalo Bill Cody and riding for the Pony Express. He maintained such a reputation as a guide that Teddy Roosevelt parked his presidential train at the rail stop across from the Buckhorn in 1905 and had Zietz lead him in search of game.

Zietz's treasures now pack the walls of the first and second floors. There are mountings of African gazelles, a two-thousand-pound buffalo and a two-headed calf. More than 120 antique firearms are displayed in glass cases. Souvenirs from famous visitors—including the flag from Roosevelt's train and a fishing license used by John F. Kennedy during a Colorado vacation— are tucked into corners. And Native American photos and artifacts hang prominently as a sign of Zietz's friendship with the tribes.

Zietz ran the Buckhorn until his 1949 death and was famous for his hospitality, including his tradition of giving a free beer to any miner who cashed his paycheck there. His son sold the restaurant in 1978 to a group of investors who sought to preserve its lore and history while turning a steak-and-potatoes joint into one serving now-exotic dishes that once were the staples of the Old West.

In recent years, it's also become a haven of craft beer and whiskey, offering a dozen Colorado-made brews and another dozen small-batch whiskeys, along with extensive wine and single-malt Scotch lists. Its signature drink is the Buffalo Bill Cocktail, which the showman used to order himself— bourbon and apple juice. Dutton thinks it's only appropriate.

"It's the same thing as with our menu," he said. "People like to ask: What do you have that's unique to Colorado?"

DAY 2

DOWNTOWN DENVER

HISTORIC SITE: DOWNTOWN DENVER WALKING TOUR

One of Denver's toughest early moments also was one of its most fortunate. Just five years after the city's 1858 founding, much of the central district—a collection of closely crammed wooden buildings—burned, destroying seventy businesses. City leaders decided to rebuild in brick. And because of that, the ever-changing downtown area is lined today with nineteenth-century structures that tell the tale of Denver's past.

For a proper walking tour, begin at the Brown Palace at Seventeenth Street and Broadway and then follow this guide northwest, away from the capitol.

Built in 1892, the Brown Palace has hosted every president of the past 110 years except Calvin Coolidge and Barack Obama. The American Football League was born from a meeting in its lobby, and democratic revolutionary Sun Yat-sen stayed there the night China declared independence in 1911—events commemorated with displays inside. The current Ship Tavern on the first floor was the site of a historically infamous scandal in 1911, as two men were shot in a feud over an adulterous socialite.

Stroll down Seventeenth Street, and sidewalk markers tell the story of "Wall Street of the Rockies," a place where the mining-supply town's fortunes were made. The Equitable Building at 730 Seventeenth Street was where Henry Dow worked as a trust company vice-president before moving to Wall Street and creating the Dow Jones Index.

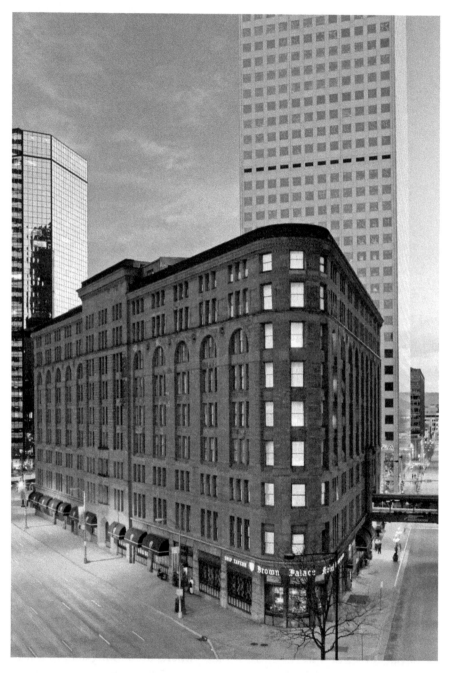

The Brown Palace is Denver's most historic downtown hotel, having hosted most twentieth-century presidents, as well as foreign dignitaries and entertainers. *Courtesy of the Brown Palace Hotel & Spa.*

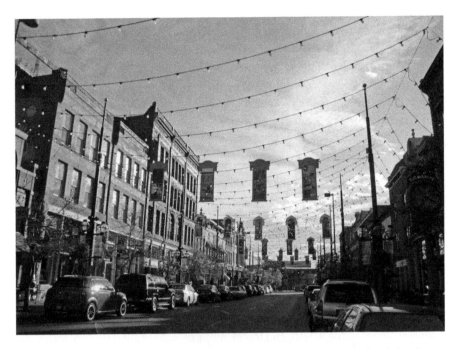

Lights illuminate Larimer Square all year, shining on the city's first historic district. *Author photo.*

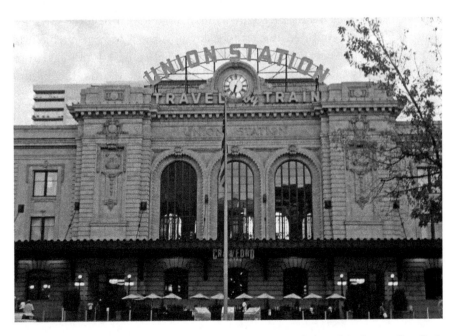

First opened in 1881, Union Station is home to both a transit hub and the luxury Crawford Hotel. *Author photo.*

The Byron Rogers Federal Building at 1961 Stout Street was named for a twenty-year Colorado congressman but is best known as the courthouse where Timothy McVeigh was convicted in 1997 of the Oklahoma City bombing.

The Renaissance Denver Downtown City Center Hotel at Seventeenth and Champa Streets occupies the former Colorado National Bank Building, and its lobby features sixteen works depicting Native American life from Denver's most famous muralist, Allen Tupper True. The 1920s-era work of True also can be found tucked in the outdoor lobby of the CenturyLink building at Fourteenth and Curtis, where his paintings portray Colorado Telephone Co. workers of the time.

Running through the heart of downtown is the Sixteenth Street Mall, designed by architect I.M. Pei when it was converted to a pedestrian thoroughfare in 1982.

At the corner of the mall and Arapahoe Street is the Daniels & Fisher Tower. Built in 1911 as part of the D&F department store, it was the tallest building west of the Mississippi at the time. Though the store fell victim to urban renewal in the 1970s, the tower remains, and guided history tours can be booked at clocktowerevents.com.

Larimer Square, on Larimer Street between Fourteenth and Fifteenth Streets, housed Denver's first bank and dry-goods store after General William Larimer founded the city. It starred in a more recent historic drama when preservationist Dana Crawford saved its buildings from demolition in 1963 and made the shopping and dining block into Denver's first historic district.

Market Street was Denver's red-light district in the 1880s, replete with gambling halls, saloons and opium dens, many located between Sixteenth and Seventeenth streets. The "House of Mirrors" building at 1942 Market Street was known as the classiest brothel in the West.

At the end of Seventeenth Street sits Union Station, opened in 1881 as the city's transportation hub. When Denver hosted the 1908 Democratic National Convention, bands met arriving delegations at its towering welcome arch and paraded them down the street. A 2014 renovation converted the still-active train station into a luxury hotel with local restaurants ringing its lobby, proving that the historic downtown is being remade even as it is being preserved.

Natural Site: Confluence Park

2250 Fifteenth Street, Denver / Open around the clock /
www.denvergov.org/parks

In late 1858, the confluence of Cherry Creek and the South Platte River was a bustling place. Kansas gold-seekers laid a claim there in the summertime and named their settlement St. Charles. Then, when most of them went back home in the fall, the aforementioned General William Larimer jumped that claim, renamed the town Denver and grew the city outward from this spot.

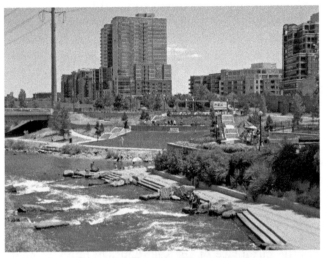

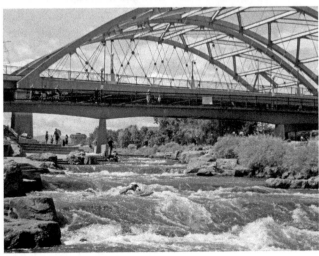

Top: Denverites ride tubes through the rapids and swim in two bodies of water that converge at Confluence Park. *Holly Batchelder.*

Left: Bodyboards are a popular way to ride the rapids through Confluence Park, with many people putting them in right below the Speer Boulevard bridge. *Author photo.*

While there is just as much activity there today, it is of a more leisurely variety. Located on the western edge of downtown, Confluence Park serves as an oasis within the bustling city around it—a spot where you can recreate, people-watch or while away the day at one of the few legitimate (if tiny) beaches in the area.

The best way to experience the park is to rent a kayak, tube or bodyboard from shops like Confluence Kayaks. There are put-ins upriver from the park and right under the Speer Boulevard bridge that marks the south end of the area. Adventurers run the rapids through custom-designed chutes, ending in a pool where the bodies of water meet.

Those seeking less-stimulating pursuits can just wade into the confluence, where dogs will splash and children will walk across Cherry Creek as it slows to a trickle. Or you can lay out on "Mount Trashmore," the rising grass hill in the southeast corner of the park that covers up auto bodies, concrete blocks and the various other instruments of pollution that made this site an environmental disaster before city leaders pulled them out of the water and revitalized the area in 1974.

Drinking Site: Falling Rock Tap House

1919 Blake Street, Denver / 11:00 a.m. to 2:00 a.m. daily /
www.fallingrocktaphouse.com

Though Colorado was the birthplace of the Old Chicago taproom chain in 1976, a funny thing happened after Boulder Beer, the nation's oldest craft brewery, debuted in 1979. For nearly two decades, people who wanted to serve good beer didn't open tap houses; they made their own beer and launched breweries. Then Chris Black moved to Denver in 1997 and changed everything.

His Falling Rock Tap House today is mentioned among the best beer bars in America. Its ninety-two tap handles offer creations from fifty to sixty breweries—about 40 percent from within Colorado, 40 percent from the rest of the country and 20 percent from international beer hot spots like Belgium and Germany.

Come in during the Great American Beer Festival each fall and you'll find some of the best-known brewers in the country offering their rarities on tap to patrons lined up four-deep at the bar. Pop by during the Saint Patrick's Day Parade and Black will have set up a beer trailer outside to

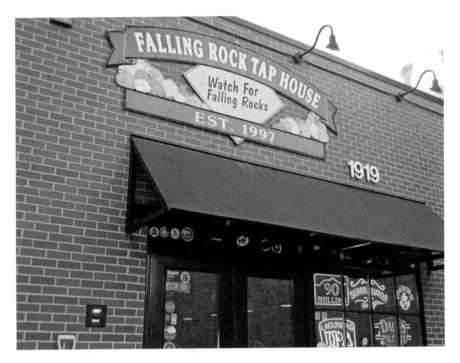

Located half a block from Coors Field, Falling Rock Tap House sports a tap list featuring local and national craft brews. *Author photo.*

serve the overflow crowd. Drop in during mid-afternoon most days and smaller crowds of beer geeks will be discussing the variety of styles Falling Rock features.

Since 2010, tap houses have become far more popular around the area. Still, Falling Rock retains its place of honor.

Black and his bartenders, who offer a simple bar-food menu at this wood-paneled hangout a half block from Coors Field, are happy to direct visitors to the dozen or so breweries within walking distance of his location. Not only does he feel like he's been an "enabler" for Colorado breweries that want to try something experimental and have it served at his place to a beer-knowledgeable crowd, but he also likes to think of himself as a promoter for the state.

"We're kind of like the Colorado Tourism Office in so many ways—but with beer," he said. "The more people have a good time in this state, the more they want to come back."

DAY 3
UNIQUELY DENVER

NATURAL SITE: RED ROCKS AMPHITHEATRE/ DINOSAUR RIDGE

18300 West Alameda Parkway, Morrison / Red Rocks: One hour before sunrise to one hour after sunset / www.redrocksonline.com and www.dinoridge.org

About 70 million years ago, Colorado served as a coast of the Western Interior Seaway, which covered the continent's heartland. Dinosaurs roamed its shoreline, leaving footprints and bones. Over tens of millions of years, that sand hardened into sandstone and got pushed skyward by mountain-building forces. And it left two spectacular sites for visitors to explore.

Red Rocks Amphitheatre is known as one of the best concert venues in the world. Modeled after a Sicilian amphitheater, its stage sits between two red sandstone formations, Creation Rock and Ship Rock, which were thrust four hundred feet high during the geologic uplift. Concertgoers who enter between them to see a 9,450-seat theater also can see the plains stretch beyond the stage for two hundred miles.

This was the largest and most ambitious project undertaken by the Civilian Conservation Corps, as crews moved ten thousand cubic yards of earth rock and debris. Worried that conservationists would oppose his decision to dynamite the boulders and start the project, Denver Parks manager George Cranmer ordered the work to be done quickly on one day in 1936—and then left his office for the day.

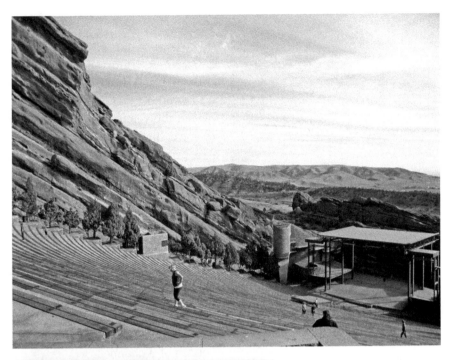

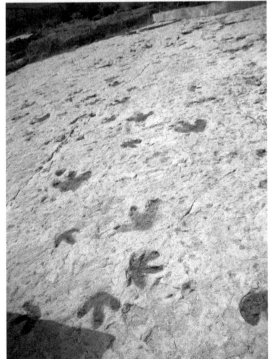

Above: Visitors walk or jog the rows of the Red Rocks Amphitheatre before concerts. *Author photo.*

Left: Dinosaur tracks are visible at several spots along the Dinosaur Ridge hike. *Author photo*.

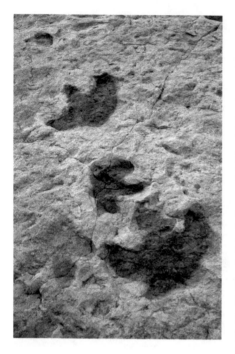

Ornithomimus tracks ranging from ten to eighteen inches in length cover a hillside at Dinosaur Ridge. *Courtesy of Friends of Dinosaur Ridge.*

Today, onlookers jog the stairs and stand on stage before concerts. A visitor center includes a Performers Hall of Fame and a wall-sized list of everyone who has played the venue, from the Beatles to local high school bands. Trails run throughout the 868-acre Red Rocks Park for further exploration.

A small parking lot across Alameda Parkway sits at the entrance to Dinosaur Ridge, a one-and-a-half-mile roadside hike that takes you past the most spectacular fossils and footprints in Colorado. Markers note the outlines of bones and even scratch marks from crocodiles that swam in the shallow water along the bottom of a channel.

The highlight of the walk comes near the end—the clearly visible tracks of Ornithomimus, a twelve-foot-long omnivore. Appearing in a char-gray hue on a chalk-white hillside, the footprints are so abundant that you can almost picture the dinosaurs stomping across the beach.

You can also hike up to the 4.4-mile Dakota Ridge trail, which climbs along the spine of the hogback that was formed from the mountain building. There is a pleasant quiet as you get to stare over both sides of the uplift to Red Rocks Park and to south metro Denver.

Historic Site: Molly Brown House Museum

*1340 Pennsylvania Street, Denver / 10:00 a.m. to 4:00 p.m. Tuesday–
Saturday; Noon to 4:00 p.m. Sunday / www.mollybrown.org*

Each city has its local celebrities. In Denver, none is more revered than the "Unsinkable" Margaret Tobin Brown, a progressive who was ahead of her time when the city was beginning to come into its own.

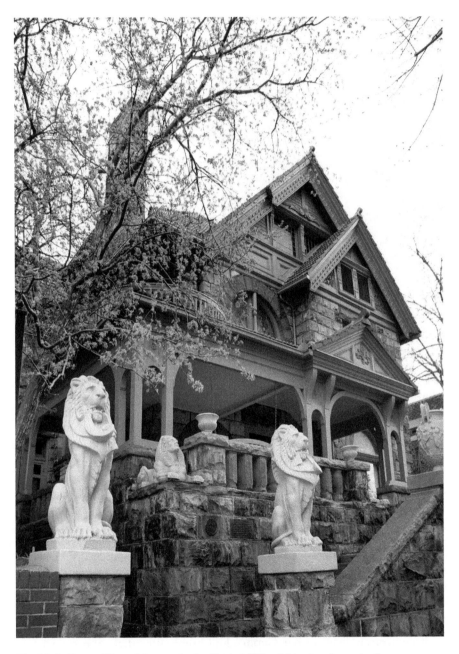

The Molly Brown House Museum in the Capitol Hill neighborhood was the first structure preserved by Historic Denver. *Courtesy of the Molly Brown House Museum.*

The entryway to the Molly Brown House Museum is the best preserved room in the house, featuring original stained-glass windows and light fixtures. *Courtesy of the Molly Brown House Museum.*

Brown moved from Missouri to Leadville when she was eighteen, following a brother who hoped to strike it rich in Colorado's silver mines. She met mine superintendent J.J. Brown, and they wed in 1886. Seven years later, he discovered the largest vein of gold in the continental United States, and the couple moved to Denver in 1894 as newly minted millionaires.

Margaret Brown—she was never called "Molly" during her lifetime; the nickname was an invention of a 1960s play about her that was largely fictionalized—dove into social causes in her new home. She worked for the rights of women, children, animals and miners. She led fundraising efforts for the Cathedral Basilica of the Immaculate Conception and Saint Joseph Hospital, as well as playgrounds. She threw large parties at her house.

Brown was on a tour of Europe and Africa in 1912 when her grandson fell ill, and she jumped the first liner back to the United States—the *Titanic*. After it struck an iceberg, she helped to get people into lifeboats and then lifted the spirits of the passengers in her vessel before being rescued by the *Carpathia*. Once on board that ship, she worked with first-class passengers to raise $10,000 for others who had lost everything. She earned her "Unsinkable" title and remained an advocate for the survivors for the rest of her life.

Brown rarely lived in her Capitol Hill home after that. She served as a nurse during World War I, spent time in Rhode Island and chased her late-in-life dream of being a Broadway actress before dying in 1932. But when her home was threatened with demolition in 1970, activists formed Historic Denver to preserve it.

The house has a number of original pieces, from Brown's library to a silver punch bowl given to her by miners following the Ludlow Massacre in 1914. But more than anything else, the guided tours serve to keep alive the story of a Denver matriarch whose life's work continues to have an impact on the city.

Drinking Site: Great Divide Brewing

2201 Arapahoe Street and 1812 Thirty-fifth Street, Denver / Noon to 8:00 p.m. Sunday–Tuesday; Noon to 10:00 p.m. Wednesday–Saturday / www.greatdivide.com

In recent years, some beer makers began moving to the suburbs to open destination breweries. Meanwhile, Great Divide will, by 2017, have two taprooms on the same five-acre campus in Denver's River North neighborhood.

Founder Brian Dunn has always made sure his brewery had an urban vibe. It opened in 1994 in what is now the Ballpark neighborhood—before there was a ballpark and when Denver leaders had to offer loans to get any businesses in the area.

From there, Great Divide's popularity grew with its experimentation. It solidified its reputation as an envelope pusher in 1995 with its first release of the winter seasonal Hibernation, an English-style old ale that weighed in

Great Divide beers range from the dark and heavy Yeti Imperial Stout series to the lighter Colette farmhouse ale. *Courtesy of Great Divide Brewing.*

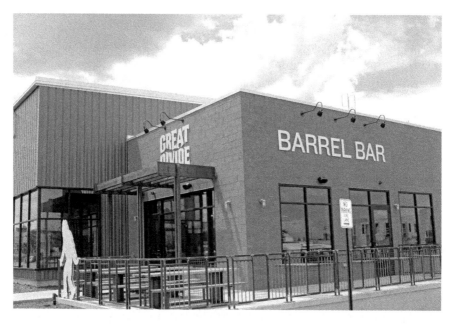

Great Divide opened the Barrel Bar at its Brighton Boulevard location in July 2015. *Courtesy of Great Divide Brewing.*

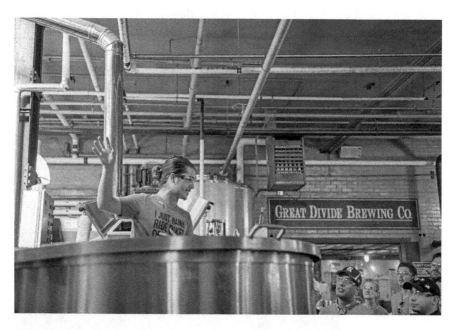

Great Divide Brewing continues to offer tours at its original location in Denver's Ballpark neighborhood. *Courtesy of Great Divide Brewing.*

at a then jaw-dropping 8.7 percent alcohol by volume. The beer is now the oldest recipe the brewery makes.

In 2003, it introduced Yeti, an imperial stout that brought a hop and malt heft that few brews on the market displayed. This, Dunn said, was the time when people began calling and banging on his door, asking to come to the brewery. He opened his taproom four years later.

With sales of Titan IPA and others going through the roof, Dunn opened the first phase of a $38 million brewery in 2015 on Brighton Boulevard—a packaging plant and taproom that gave Great Divide room to make and serve more experimental beers, both at its new location and at the original Arapahoe Street facility, which will remain open. Phase two will involve the addition of a new brewery on the parcel, plus a restaurant, beer garden and second taproom, for those who don't want to walk the whole campus.

Though many see Great Divide as a big-beer specialist—its Hercules Double IPA and Yeti variations made with espresso, chocolate and oatmeal help to define the brewery—Dunn shuns such a designation.

"I try to stay away from labels," he said. "If it was my way, I wouldn't put styles on beers. I think putting styles on beers really pigeonholes you."

The new facility has room for 1,500 barrels for aging beer. And it will continue its program of offering one-dollar samples and sending 100 percent of those proceeds to charity.

Dunn has one label he accepts.

"We believe in downtown. We've always been downtown," he said.

TRIP #2
DENVER AREA

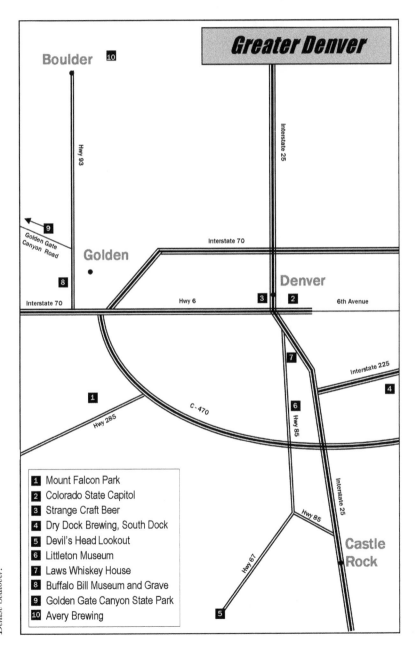

Greater Denver

Boulder [10]

Hwy 93

Interstate 25

[9] Golden Gate Canyon Road

Golden

Interstate 70

[8]

Interstate 70

Hwy 6

Denver

[3] [2]

6th Avenue

[7]

Interstate 225

[4]

[1]

C-470

Hwy 285

[6] Hwy 85

Interstate 25

Hwy 85

Castle Rock

Hwy 67

[5]

[1]	Mount Falcon Park
[2]	Colorado State Capitol
[3]	Strange Craft Beer
[4]	Dry Dock Brewing, South Dock
[5]	Devil's Head Lookout
[6]	Littleton Museum
[7]	Laws Whiskey House
[8]	Buffalo Bill Museum and Grave
[9]	Golden Gate Canyon State Park
[10]	Avery Brewing

Denise Sealover.

DAY 1
DENVER AND ITS OUTSKIRTS

NATURAL SITE: MOUNT FALCON PARK

Take Parmalee Gulch Road south from U.S. 285 and follow signs for the park near Morrison / Open around the clock / www.jeffco.us/open-space/parks/mount-falcon-park

If you had been standing at the head of Mount Falcon Park's Castle Trail in 1905, you would have been among four thousand acres newly acquired by John Brisben Walker. The founder of Denver's first amusement park, Walker had a grand vision to make this scenic area not just a home for his family but also a summer retreat for presidents. And 11.1 miles of trails today demonstrate that while his plans may have been too lofty, his belief in the area's beauty was not misplaced.

Castle Trail begins at the west parking area, and a slight uphill stroll takes you to the ruins of Walker's home, a massive structure that included eight fireplaces, a music room and servants' quarters. Two years after his wife, Ethel, died, the house burned in 1918, leaving only the foundations and a high chimney in one corner. Even in this state of near-rubble, you can feel overwhelmed at the size and scale of his effort.

From the home, a largely flat trail through the park—originally part of Denver Mountain Parks system that Walker proposed—leads to a steep 0.3-mile slog up to where he planned to build the "Summer White House."

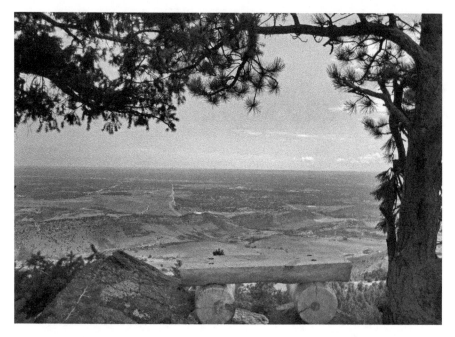

A resting spot near the planned Summer White House shows the expanse of territory visible from Mount Falcon Park. *Author photo.*

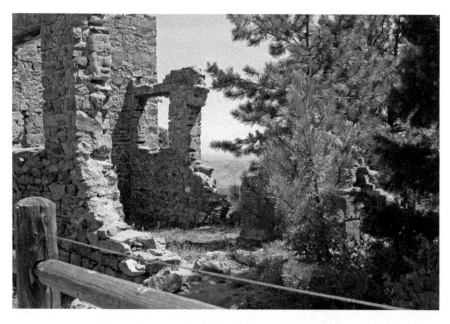

The ruins of John Brisben Walker's home, burned to the ground, stand atop the Castle Trail in Mount Falcon Park. *Courtesy of Jeffco Open Space.*

Walker laid the still-visible cornerstone and began fundraising efforts, but interest faded after World War I. Still, the view is stunning.

Castle Trail then leads downhill until intersecting with Meadow Trail, which crosses through a grove of ponderosa pine and over open land until reaching Tower Trail, where you begin a steep uphill climb again. This path culminates in a shelter in the place of a former fire tower, giving an even more impressive 360-degree view of the sprawling hills and nearby Red Rocks Park, which Walker also owned. A short jaunt takes you back to your car and finishes the refreshing 3.3-mile loop.

HISTORIC SITE: COLORADO STATE CAPITOL

200 East Colfax Avenue, Denver / Tours from 10:00 a.m. to 3:00 p.m. Monday–Friday / www.colorado.gov/capitoltour

In its first six years as a territorial government, Colorado's capitol moved from Denver to a log cabin in what is now Colorado Springs to a series of buildings in Golden (including the still-standing Old Capitol Grill) and back to Denver. And that's when the fun really began.

In 1867, entrepreneur Henry Cordes Brown donated ten acres to the state for a permanent capitol just northeast of downtown Denver. Colorado became a state by 1876, but even three years after that, no work on the building had begun. Brown, who'd hoped to get rich by developing the land around "Brown's Bluff," sued to get his property back. A court sided with the state, and only in 1886 was the first dirt moved, noted Derek Everett in *The Colorado State Capitol: History, Politics, Preservation*.

Over the next twenty-three years, a state board hired famed architect Elijah Myers and then fired him as costs increased. It quarried materials from throughout the state—granite from Gunnison for the exterior, marble from Marble for the floors and rose onyx from Beulah for the wainscoting. It erected a copper dome, but when that material tarnished it opted for a still-standing gilded gold dome. And it moved in state officials and a state history museum (which later moved out).

The capitol has seen great change. In a unique moment in American history, three governors ruled within a twenty-four-hour period in March 1905—when the legislature threw out the results of a corrupt election after the new governor had taken office, reappointed the former governor on condition that he resign immediately and then let his lieutenant governor try to heal the state's

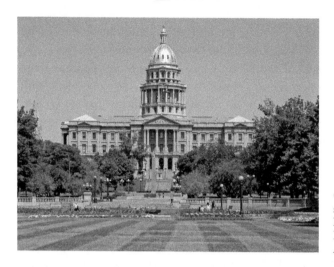

Colorado's state capitol sits on a raised piece of land known as Brown's Bluff. *Photo by Michael Barera.*

wounds. From 1925 to '27, the Ku Klux Klan ran the statehouse with a puppet governor. Since the 1980s, the capitol has become a national experimentation lab on ideas ranging from tax reform to marijuana legalization.

Tours lead visitors through "Mr. Brown's Attic," the fourth-floor museum on the history of the building, into the 272-foot-tall dome, allowing them to gaze out for miles from a cast-iron balcony. Around nearly every corner of the building, honors mark the state's most revered citizens, including stained-glass windows of twenty-seven famous Coloradans in the dome and legislative chambers and busts of senators and governors throughout the three main floors. Near the governor's office, the Japanese community erected a plaque to former governor Ralph Carr, honoring a man who agreed to take in interred Japanese Americans during World War II to treat them humanely. Below ground, though off limits to the public, is a series of tunnels connecting the capitol to five other state buildings.

And history is still being made here—observable to the public from galleries above the House and Senate while the legislature is in session from January through May.

DRINKING SITES:
COLORADO'S BREWERY TAPROOM PIONEERS

Strange Craft Beer: 1330 Zuni Street, Denver / 3:00 to 8:00 p.m. Monday–Thursday; noon to 9:00 p.m. Friday–Saturday; 1:00 to 6:00 p.m. Sunday / www.strangecraft.com

Dry Dock Brewing South Dock: 15120 East Hampden Avenue, Aurora /
At least noon to 9:00 p.m. daily / www.drydockbrewing.com

One of the most unique aspects to the roughly 350 breweries that call Colorado home is that the majority of them sell their beer only across cozy bars in taprooms. To understand the model, it's worth visiting the two breweries that made everyone understand it could work.

Two miles southwest of the capitol sits Strange Craft Beer, the longtime dream of two homebrewer friends who were pushed into opening it when their employer, the venerable *Rocky Mountain News*, closed in 2009. But after cashing in their 401K's and finding space in an industrial strip mall south of Sports Authority Field at Mile High, they refused to borrow an extra half million dollars to start a bottling facility when they opened the next year, co-founder Tim Myers said.

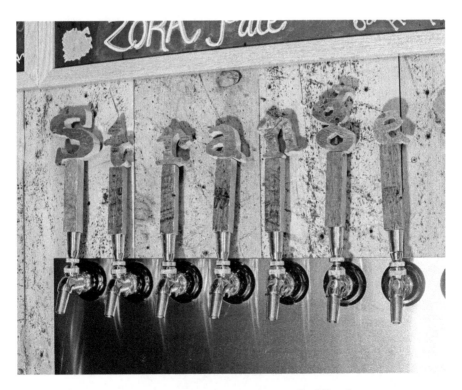

Wooden handles dispense the sixteen offerings that Strange Craft Beer has on tap at any given time. *Courtesy of Strange Craft Beer.*

They began making a wild array of beer—from a kriek to a watermelon hefeweizen to a sour cherry stout—in one-barrel batches and serving them to customers in the brewery space. And they began inviting food trucks to sit in their parking lot, launching a trend that now finds the mobile kitchens at almost every Denver-area taproom many nights a week.

Strange's reputation grew, and awards followed. Beer bars demanded kegs of Breakfast Grapefruit IPA, and the brewery pumped out bombers of its Dr. Strangelove Barleywine and others. Today it's no longer the secret it was when some customers brought a picnic basket to camp out for the night.

But it still serves 80 percent of its beers across the bar. And Myers and partners Daryl and Jules Hoekstra still love the benefits of a small, personal space.

"Jules and Daryl know everybody. They know their kids and their dogs' names and where they work," Myers said. "A lot of these guys, this is their stop on the way home. They become family."

But Myers admits none of this would be possible without the trailblazing of Dry Dock Brewing, located fifteen miles southeast in the suburb of Aurora.

Dry Dock founder Kevin DeLange was running The Brew Hut, a homebrew-supply store, when an eight-hundred-square-foot space opened next door in 2005 and he got the idea to put his own brewery there. Even after he got explicit permission from the state liquor enforcement division to operate just a taproom, the city denied his zoning request three times.

When it finally opened, Dry Dock resembled a speakeasy. Its entrance was on its back side, and most customers came directly from The Brew Hut. But after the six-month-old brewery won a 2006 World Beer Cup gold medal for

Taster glasses of Dry Dock beer sit on a bar by the brewery's barrel collection. *Courtesy of Dry Dock Brewing.*

HMS Victory ESB—now its Amber Ale—people crammed into the twenty-seven-seat bar until there were lines out the door.

Today the taproom is significantly larger, and the original focus on English-style beers has expanded to include double IPAs, sours and both vanilla and raspberry porters. Apricot Blonde, a beer for which Dry Dock uses thirty thousand pounds of apricot puree per year, makes up 56 percent of sales and is ubiquitous in Colorado bars. Dry Dock began canning and bottling and, in 2013, opened a production facility with a small taproom in north Aurora. But the heart of the brewery is still at its "South Dock" taproom, where DeLange still asks the opinions of his regulars.

Dry Dock won Small Brewery of the Year at the 2009 Great American Beer Festival and since has nabbed more awards than any beer maker in Colorado. Yet DeLange, who doesn't understand why it took so long for breweries to follow his taproom lead, still thinks of the business as the one in that cramped space that thrilled homebrewers and inspired, in time, a generation of Colorado taproom entrepreneurs.

"People like small. They like to be able to see the brewers and owners and talk to them," he said. "I still like to think of us as a small brewery, though that's changing fast."

DAY 2
SOUTH DENVER AND ITS SUBURBS

NATURAL SITE: DEVIL'S HEAD LOOKOUT

9.3 miles south on Rampart Range Road off of Highway 67, Sedalia /
Open April through November

Shortly after the turn of the twentieth century, the tree-blanketed areas of the Front Range were guarded by fire spotters holed up in ramshackle wooden lookouts on high, rocky outcroppings. Of the seven lookouts built by the U.S. Forest Service between Wyoming and New Mexico, just one remains in use. It still houses eagle-eyed forest workers, but it's also a destination for outdoor enthusiasts who want a new perspective on the landscape around them.

The 1.4-mile trail up to Devil's Head Lookout, which was built in 1912, challenges you as it gains nearly one thousand feet in elevation. You pass first through a swath of trees downed by a 2015 tornado and then near sandstone monoliths flanked by climbers. Distant mountain ranges peek occasionally through the trees that surround you. Finally, you arrive at a cabin on the peak, staring up 143 steps to an observatory that is packed with fire-spotting equipment and a phone. The lookout offers just enough shelter for a designated representative and a handful of the tens of thousands of hikers who make this trek yearly.

Visibility extends for more than one hundred miles in every direction. Pikes Peak is apparent to the south, as is the whole of the Castle Rock

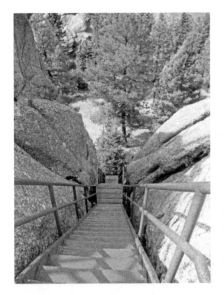

Left: From a platform midway up their climb to Devil's Head Lookout, hikers can look back down some of the 143 steps of the staircase. *Author's photo.*

Below: Views from the lookout at Devil's Head extend for one hundred miles in every direction. *Author photo.*

area and beyond. Perched 9,748 feet high, this is the third iteration of the observatory in this location. That cabin below is the summertime home of the men and women who have made the daily trek up the wooden ladder to its location for more than a century, spotting everything from small flare ups to the Hayman fire, which engulfed more than 138,000 acres in 2002.

This oddly shaped boulder sits on the trail to Devil's Head Lookout. The boulder is an example of Pikes Peak granite. *Glenn F. Cowan.*

Past lookouts have reported seeing the ghost of an old prospector wandering the ground below in search of the entrance to a mythic gem mine. But the best view is the one that looks straight over the top of the clouds. You won't be an expert on wildfire observation when you leave, but time spent here lets you see how Colorado's wide-open spaces are both beautiful and dangerous. And you can do so in a place that is simultaneously historic and modern.

Historic Site: Littleton Museum

6028 South Gallup Street, Littleton / 8:00 a.m. to 5:00 p.m. Tuesday–Friday; 10:00 a.m. to 5:00 p.m. Saturday; 1:00 to 5:00 p.m. Sunday

Like many of the smaller towns that ring Denver, Littleton began as a distant farming community, developed as the Mile High City grew and found its own personality in the late twentieth century. Today this city some twenty-

three miles north of Devil's Head is home to a thriving downtown and growing aerospace sector.

But one thing that sets Littleton apart from other suburbs is its devotion to preserving its past. And that trait can be seen most clearly at the Littleton Museum, which features two living-history farms that pull visitors back to a time when Colorado was a simpler place.

The 1860s farm is dedicated to the pioneers of the area—people like town founder Richard Little, a civil engineer who supplied clean water to gold camps. Little became smitten with the land surrounding the South Platte River south of Denver and bought a large swath of it, eventually subdividing it to turn the area into a town. In 1890, it became its own municipality.

The pioneer farm features steers, donkeys and pigs, and it presents the do-everything spirit of the people who moved west when infrastructure and amenities were nonexistent. A one-room schoolhouse featuring a thirty-six-star U.S. flag and the wood-fired stove that kept its fifteen students warm is the original 1865 learning center in Littleton. A two-level cabin decked out in silverware and tools of the time originally sat on the other side of the South Platte.

A windmill stands beside a barn on the 1890s farm at Littleton Museum. *Author photo.*

Meanwhile, the 1890s farm tells of the evolution of the town's residents from groundbreakers to settled homeowners. A reconstructed blacksmith shop brims with equipment for making horseshoes, saws and common tools. A turn-of-the-century windmill reminds visitors of the necessities of rural life.

Lastly, a 1940s-era home and victory garden nod to the town's role in World War II. On weekends and throughout the summer, costumed historical interpreters work the kitchen of this house, as well as the blacksmith shop and old school.

Exhibits in a museum on the property tell the more detailed story of Littleton's past, from its boom after landing a stop on the Denver and Rio Grande Railroad in 1871 to the way it bounced back from the South Platte flood of 1965, when a twenty-foot-tall wall of water knocked out shops, homes and bridges. It's Littleton's history, but in many ways it tells the story of all of the Denver area.

DRINKING SITE: LAWS WHISKEY HOUSE

1420 South Acoma Street, Denver / 2:30 to 7:00 p.m. Thursday–Friday;
1:00 to 5:30 p.m. Saturday; 2:00 to 4:00 p.m. Sunday /
www.lawswhiskeyhouse.com

It wasn't until twenty-five years after the opening of Colorado's first craft brewery that someone realized that residents of the state would take a shine as well to locally made, small-batch spirits. But once Stranahan's Colorado Whiskey started churning out its unique product in 2004, makers of vodka, gin, liqueur and other whiskeys soon followed suit, leaving the state with more than fifty craft distilleries by the end of 2015.

None has taken the tasting-room visit as far into the realm of being an educational, immersive experience as Laws Whiskey House. Though opened only in 2014, the south Denver distillery can trace the arc of the Colorado spirits movement; its head distiller, Jake Norris, held the same position with Stranahan's when it opened.

The distillery is the longtime dream of Al Laws, a former Wall Street oil analyst with a collection of six hundred whiskey bottles who left the financial world after fifteen years to pursue this passion. It offers access through hour-long curated tours that begin in the "whiskey church," a

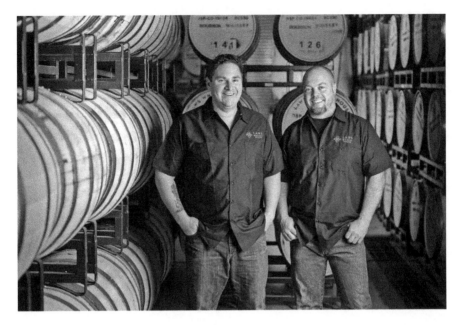

Laws Whiskey House founder Al Laws (left) and head distiller Jake Norris stand among the 1,500 barrels of whiskey aging at the distillery. *Courtesy of Laws Whiskey House.*

room with four pews and a chalkboard explaining the industry. Those continue past its open-air fermenters, through its 1,500-barrel rack room and into its small tasting room.

While a number of Colorado distilleries make whiskey, Laws is one of very few in the country that makes four-grain whiskey, which contains barley, wheat and rye in addition to the standard corn base, creating a bolder flavor in which each ingredient adds a distinct note. In 2015, it offered its first rye whiskey, and 2016 brought about a wheat whiskey—the first in a series of experiments it plans to roll out.

Laws and Norris age their whiskeys an average of three years, though they've been known to go longer if the taste isn't perfect.

"We're stewards of the whiskey," Norris said. "We don't tell it what to do. It tells us what to do."

Laws gets all of its grains in-state. And in doing so, it hopes drinkers can discern a product that is as unique in its way as the whiskeys coming from Kentucky or Scotland—and believes that flavor will become even more characteristic of the Centennial State as more local distilleries open and grow.

"In our whiskey, you get the taste of Colorado," Al Laws said.

DAY 3
GOLDEN TO BOULDER

HISTORIC SITE: BUFFALO BILL MUSEUM AND GRAVE

987½ Lookout Mountain Road, Golden / 9:00 a.m. to 5:00 p.m. daily,
May–October; 9:00 a.m. to 4:00 p.m. Tuesday–Sunday, November–April /
www.buffalobill.org

To nineteenth-century Americans, nothing represented the Wild West like Colorado. And the most common lens through which they—and many others in the world—viewed the state and its part of the country was that of Buffalo Bill's Wild West show, the brainchild of William F. Cody

A cavalry member, Cody fought in the Civil War and the Indian Wars. He hunted bison for the Kansas Pacific Railroad, earning his nickname for his prowess. He guided hunts and was the subject of dime novels and plays, which inspired him to become an actor and a writer. And in 1883, he got his grand idea to put together an outdoor exhibition showcasing all he'd seen.

The Wild West show featured trick riders, target shooters and lasso throwers. It offered respectful glimpses of Indian life—including Sitting Bull for one season—despite Cody having earned a medal for fighting the Native Americans. The show toured Europe from 1887 to '92, playing in front of the likes of Queen Victoria of England. When it returned to the United States, Cody added international rough riders to give it an exotic twist.

Though widely admired, Cody never invested smartly. Denver sheriffs seized the show's property in 1913 and auctioned it off to pay back an

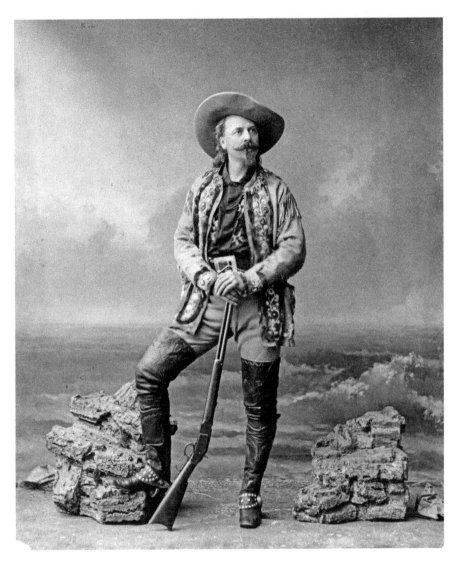

Historical photo of William "Buffalo Bill" Cody. *Courtesy of Buffalo Bill Museum.*

outstanding loan. Cody tried his hand at being in others' shows and at making movies, but he died in 1917 while living in Denver with his sister, saying he wanted to be buried at Lookout Mountain because of its beauty. Some twenty thousand people attended his funeral there.

Just four years later, Cody's adopted son opened the museum, which features numerous relics and silent films of his production. His grave is worthy of a statesman: a six-foot-high marble-and-rock headstone noting

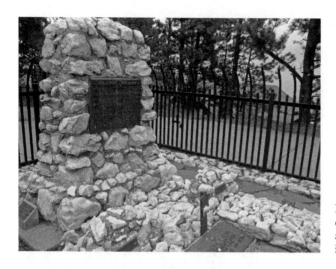

Buffalo Bill's grave sits on Lookout Mountain, a spot he admired for its views. *Author photo.*

his military service and medals. Visitors have been putting money on it ever since a former Lakota performer with the show left Indian-head nickels on the grave to honor him.

And Cody remains there, despite efforts from distant relatives to move his body to Cody, Wyoming, a town he founded in 1895. In 1948, the American Legion post in that town even offered $10,000 to anyone who would steal his body. Colorado National Guard members mobilized at the grave, ensuring a local icon who traveled the world never leaves the state again.

NATURAL SITE: GOLDEN GATE CANYON STATE PARK

*92 Crawford Gulch Road, Golden / 5:00 a.m. to 10:00 p.m. daily /
www.cpw.state.co.us/placestogo/parks/GoldenGateCanyon*

Take Highway 93 North a mile and a half out of Golden, and you will come to the windy road that leads you to the gem of Colorado's state parks: Golden Gate Canyon. While it may seem a world removed from Denver's suburbs, the park offers a clear view back to the nearby cities—and to the mountains that drew settlers here some 150 years ago.

This twelve-thousand-acre area offers several fishing ponds, a multitude of campsites and a dozen interlocking trails that extend over 37.8 miles and range from moderate strolls to serious uphill slogging. The visitor center features exhibits on the wildlife that inhabits the park, from black bear to marmots, as well as a handicapped-accessible trout pond that sells fish food.

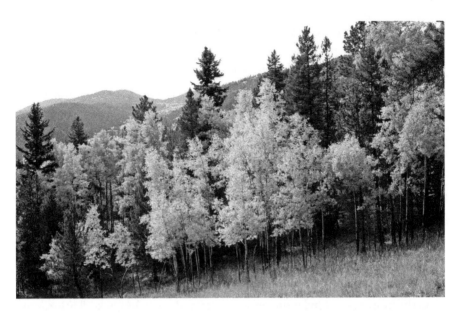

A cornucopia of colors decorates Golden Gate Canyon State Park in the fall. *Courtesy of Colorado Parks and Wildlife.*

To truly get a sense of Golden Gate Canyon's beauty, hike a 2.5-mile path around Panorama Point, an overlook offering the best views in the park. From it, you can see four of the state's fourteen-thousand-foot-tall mountains, half a dozen counties and outlines of old mining towns like Central City and Black Hawk.

From the overlook, turn left to start on Raccoon Trail (all of the park's trails are named after wildlife) as it meanders downhill through a forest of pine trees, consistently offering you views of the snowcapped mountains around you. As you descend, the forest transitions to aspen trees—often covered with scuff and bite marks from the elk and deer that use the bark as food and rub their antlers on it—until you plateau in a meadow.

The small stream that began as a trickle at the top of the path becomes more powerful and it can be seen and heard growing to your right. You'll pass over a creek just as you spot a private cabin and begin to climb again.

The return to the overlook can be quite steep at times. But in addition to the black-tailed squirrels that pop up throughout this walk, there are numerous openings through the pines where the mountains stare back at you. Raccoon Trail joins with Mule Deer Trail for the last 0.3 miles of the sojourn, narrowing to give you a sense of accomplishment as you arrive back at your starting point, exhausted but exhilarated.

Drinking Site: Avery Brewing

4910 Nautilus Court, Boulder / 11:00 a.m. to 11:00 p.m. Tuesday–
Sunday; 3:00 to 11:00 p.m. Monday / www.averybrewing.com

Famous for its street performer–laden pedestrian mall and its distinction as the first U.S. city to replace "pet owners" on its law books with "pet guardians," Boulder is known to many Coloradans as "fifteen square miles surrounded by reality." It's only appropriate, then, that the best-known brewery to come from this town is one that bends the curve on how beer is made and aged.

Avery Brewing came about in 1993 during co-owner Adam Avery's "quarter-life crisis" and desire to leave his sales job. But it really came to life with the 1998 introduction of Hog Heaven, a hugely hopped barleywine that was unlike anything Coloradans had drunk at the time—and sold better than the more typical styles the brewery was making in its back-alley location.

Since then, Avery has been the state's experimental brewery, turning out gems like Rumpkin, a rum barrel–aged pumpkin ale, and the Maharaja, a 10 percent alcohol-by-volume imperial IPA that has become its third-best-selling beer. Demand grew so much faster than capacity that Avery pulled out of eighteen metro markets in 2011 and led to its biggest experiment yet—a 5.6-acre destination brewery in Boulder County that opened in February 2015 and will ramp up its production fivefold.

That growth, however, is tiny compared to the expansion of Avery's barrel-aging program. Launched in the mid-2000s with a handful of rum

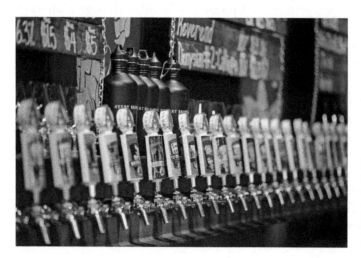

Some thirty taps offer traditional and experimental beers at Avery Brewing. *Courtesy of Avery Brewing.*

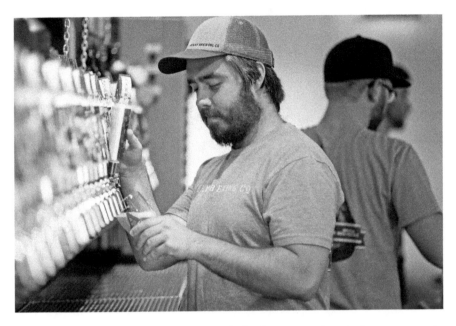

Bartenders offer Avery Brewing beers to crowds that have grown since the brewery opened its new facility, complete with two bars, in early 2015. *Courtesy of Avery Brewing.*

and whiskey vessels, the effort will number six thousand barrels by the end of 2016—largest for a brewery of its size nationally—and include containers that once held port, Madeira, red wine and more. With it, Avery can produce enough batches of aged beer to supply its thirty taproom handles and numerous limited bottling releases.

It hasn't abandoned its roots, however. When opening the new brewery, it ordered three hop-dosing vessels from Germany that were so large—to accommodate its assertive line of beers—that unbelieving installers took pictures of how many hops the brewery added to its batches and sent them back to Europe to prove their wild tales, Avery said with a smile.

The new location allows for self-guided tours and features a swine-heavy restaurant that pairs Hog Heaven with the likes of a pork burger or pork-belly Brussels sprouts. And it allows the brewery to keep pushing the boundaries of beer tastes.

"There's nothing subtle about this place," said Walter Becker, the company's events specialist.

TRIP #3
FORT COLLINS
AND ESTES PARK

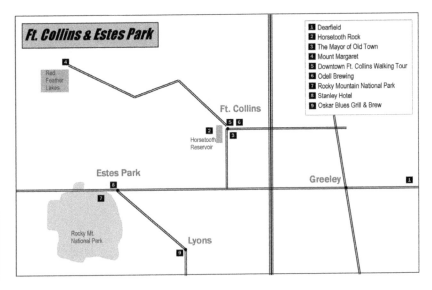

Denise Sealover.

DAY 1
GREELEY TO FORT COLLINS

Historic Site: Dearfield

*On Highway 34, twenty-three miles east of Greeley / Open around the clock /
www.blackamericanwestmuseum.org*

The five dilapidated buildings sitting inconspicuously behind a Highway 34 roadside marker are all that remain of one of Colorado's short-lived but great pioneering colonies—the African American farming community of Dearfield.

In 1910, Oliver Toussaint Jackson filed a claim on these 320 acres of dry prairie, aiming to create a town where African Americans could control their destinies at a time when the influence of the Ku Klux Klan was on the rise in Denver. Just seven families followed him there during the frigid winter of that first year—only two of which had wooden houses—but the years beyond featured gradual growth.

Dearfield residents followed in the footsteps of numerous other groups who had tried over the previous thirty years to create oasis communities in Colorado. From Mormon towns in the San Luis Valley to a Salvation Army colony on the southeastern plains that resettled destitute midwesterners, Colorado's open lands became havens of experimentation.

By 1915, twenty-seven families lived in Dearfield, and five years later the population neared six hundred people. Men often worked day jobs in Denver while women and children tended the farms, growing corn, potatoes and a variety of other crops that could survive arid conditions.

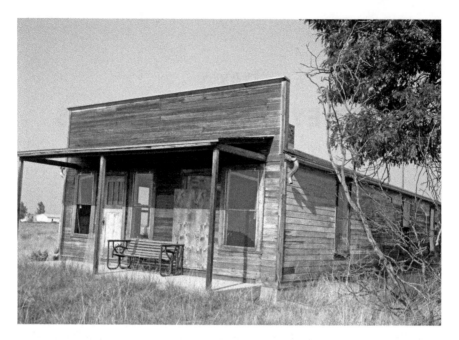

The home of Dearfield founder Oliver Toussaint Jackson is one of the few buildings remaining on the site of the former African American farming colony. *Author photo.*

Dearfield also became a social hub for the black community at a time when entertainment options were limited in the big city. A barn pavilion held weekend dances populated by large crowds that rode the train seventy miles from Denver. The town also had businesses like a boardinghouse, garage and lunchroom.

Like many Eastern Plains farming communities, however, its decline began after World War I, when food prices fell rapidly and banks foreclosed on equipment and homes. Jackson tried fruitlessly to market Dearfield as a resort in the 1930s. He died there in 1948, and the last resident passed away in 1973.

The Museum of the Black American West purchased most of the land at the start of the twenty-first century and hopes to put a visitor center and museum at the site. Located in Denver, the museum features exhibits and a video on Dearfield.

Those who go to the site will see only the tattered remains of the lunchroom, a blacksmith's shop and, farther down the dirt road, Jackson's home. But by gazing at the arid, treeless plains around it, one can get a true sense of both the struggles the community undertook to exist and the courage of the people who made that happen.

NATURAL SITE: HORSETOOTH ROCK

*Larimer County Road 38 East, 6.5 miles west of Taft Hill Road /
Open around the clock / www.co.larimer.co.us/parks/htmp.cfm*

Native Americans passed down that Horsetooth Rock, four miles west of Fort Collins, was the heart of a giant who was felled by a warrior. Fur trappers felt it looked more like equine chompers. But one thing they had in common with today's Colorado State University students and northern Front Range residents was a desire to get to the top and enjoy one of the best views under eight thousand feet in Colorado.

Part of the Horsetooth Mountain Open Space—a 2,886-acre area with twenty-nine miles of hiking and biking trails above Horsetooth Reservoir—the five-mile-round-trip hike to the rock is a story of intermittent steep climbs and level areas. Rising more than 1,400 feet, it offers spectacular views of the water below as it sparkles in the morning sun. Maps are available at the trailhead.

The trail climbs slowly to a group of signs explaining the history of the park. It then turns into steeply rising steps, followed by a series of switchbacks.

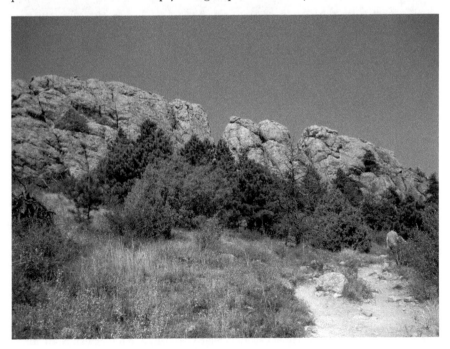

Hikers make their way over the last stretch of the trail to Horsetooth Rock. *Author photo.*

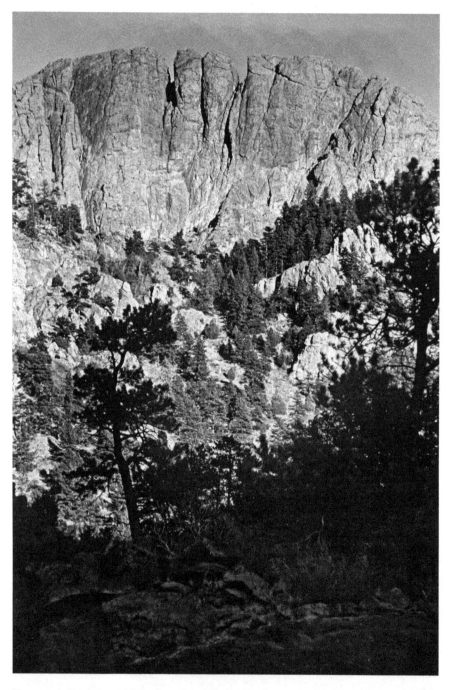

Horsetooth Rock draws hikers from Colorado State University and throughout Northern Colorado. *Richard Ernst.*

A number of bump-outs allow you to admire the park below and catch your breath. Be aware, however, that you are sharing spaces like these not just with occasional foxes and skunks but also with rattlesnakes that find such flat rocks wonderful places to rest.

As the switchbacks end, stay right at an unmarked fork, and you will get your first views of the bumpy peak. The trail disappears in places over the next quarter-mile, as you find yourself trudging over red rocks, sometimes using both hands and feet. Then you come to a final stretch in which you pull yourself up through small openings and do your best to keep your center of gravity low.

The scenery from the 7,256-foot-high peak is jaw dropping, giving you a bird's-eye view west toward Rocky Mountain National Park and north into Wyoming. There is a sense of instant camaraderie among the hikers who have made it there, and photo taking and mutual congratulations abound. After all, everyone has joined a club that, while it may not be exclusive, does understand when people say, "Yeah, I saw the world from the top of Horsetooth Rock."

DRINKING SITE: THE MAYOR OF OLD TOWN

*632 South Mason Street, Fort Collins / 11:00 a.m. to midnight daily /
www.themayorofoldtown.com*

Fort Collins can make a legitimate argument for being the best per-capita beer town in America. This 150,000-population city was home to seventeen breweries by the end of 2015, including two of the fifty largest craft breweries in the United States (New Belgium and Odell Brewing), a former Great American Beer Festival Small Brewery of the Year (Funkwerks) and local purveyors making everything from German-style classics to cutting-edge sours.

Before July 2011, however, sampling the full variety of the city's scene usually involved biking from brewery to brewery or hoping someone would volunteer to be the designated driver. After traveling the country and finding the variety of beer bars that his city wasn't offering, real estate–management company owner Kevin Bolin decided his next property needed to be a one-hundred-beer taproom that would spotlight Northern Colorado products while serving the best the United States has to offer.

The Mayor of Old Town is just as likely to have a Chocolate Stout from nationally distributed Fort Collins Brewery as it is to feature an Inclination

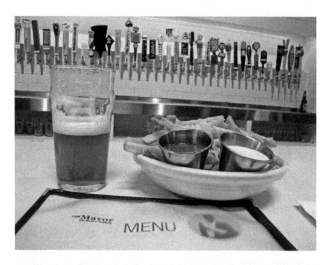

Top: Locally made IPA and parmesan truffle fries are just two of the offerings available at The Mayor of Old Town. *Author photo*.

Left: The front entrance to The Mayor of Old Town sits less than two blocks from the Colorado State University campus. *Author photo*.

IPA from local upstart Snowbank Brewing. Bolin and his wife, Barb, also keep a heavy rotation of beers from neighboring Loveland and Weld County and try to maintain equal portions of the tap list from Colorado, the rest of the United States and international brewers. During the GABF each fall, they offer a Northern Colorado tap takeover.

Though it's less than two blocks from Colorado State University, The Mayor is not your typical college bar. Yes, it attracts students—often on fancier occasions like dates or visits from their parents. But it also brings in professors, industry professionals and a whole lot of tourists, as breweries have surpassed even the college for their impact on visitation to Fort Collins.

"You literally can have a twenty-one-year-old who's on his first beer ever sitting next to a CSU professor and strike up a conversation with him about beer," Bolin said of a scenario he's seen before.

The food menu is heavy on burgers and sandwiches and features kicked-up appetizers like Thai pork meatballs. And the beer menu offers several selections of just about any style imaginable.

If there's a drawback to The Mayor, it's that the beer list—displayed on an electronic board above a wall of end-to-end taps—can be almost overwhelming. Then again, so can the Fort Collins beer scene.

DAY 2
IN AND AROUND FORT COLLINS

NATURAL SITE: MOUNT MARGARET

Larimer County Road 74 East, twenty miles west of U.S. 287 /
Open around the clock

Throw a rock pretty much anywhere in Colorado and you can find a trail that leads up a mountain. But only at Mount Margaret will you find a scenic and serene hike in which you lose 190 feet in elevation in order to get to the tip of a peak.

Nestled in the Roosevelt National Forest, Mount Margaret is part of Red Feather Lakes, a mountain village about an hour northwest of Fort Collins that abounds in outdoor recreational bounties, from fishing to kayaking to whitewater rafting. Those wanting to escape the world for a weekend also can pay a visit to the Shambhala Mountain Center—a Buddhist retreat that is home to America's largest stupa, reaching 108 feet in height.

The trip to Mount Margaret is a 7.6-mile-round-trip stroll through a forest that is different in several ways than most hikes along Colorado's Front Range.

It meanders through agricultural land in an up-close way. Cows stand watch like spectators as you pass through a field connecting the parking lot to the forest. About three-quarters of a mile down the trail is a sign directing stock to the left and hikers to the right.

You wander through both meadows and lodgepole pine glades, giving you a changing sense of scenery that may cloak deer or elk watching you from the trees.

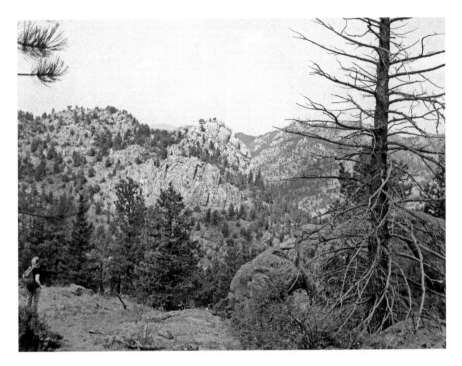

The hills and valleys of the Roosevelt National Forest are in full view from the peak of Mount Margaret. *Author photo.*

And even though you descend gradually to the 7,957-foot-tall peak, the view is no less spectacular across the rolling hills and valley from the boulders that dot its summit. Trees cling warily to the side of the surrounding hills, and craggy outcroppings offer a sense of high-altitude seclusion.

Bring your family, bring a friend or just bring a book to read as you plop down at the end of the trail. Mount Margaret is not just in one of the most peaceful outdoor areas in the state; it is exhibit A of how Colorado can offer you about any experience you desire.

HISTORIC SITE:
DOWNTOWN FORT COLLINS WALKING TOUR

The army outpost that immediately preceded the establishment of the town of Fort Collins was, in truth, not much to behold. Camp Collins operated here only from 1864 to 1867, and its military contributions to the frontier were negligible.

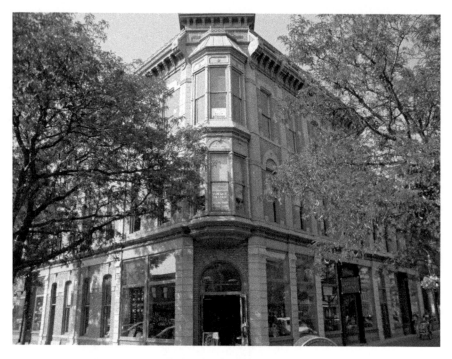

Above: The former Linden Hotel in downtown Fort Collins helped to inspire the design of Disneyland's Main Street U.S.A. *Author photo.*

Left: Old Town Square is home to Coopersmith's Pub & Brewing, one of the pioneer Colorado craft breweries. *Author photo.*

But the city, founded in 1873, became home to the second-largest university in the state, Colorado State University, and is ranked often among the best places to live in America. And a stroll through downtown reveals both remnants of the events that helped to make it what it is and a surprising number of firsts in American history.

The Antoine Janis Cabin, built in 1859, is one of four historic structures in Library Park in Fort Collins. *Author photo.*

Begin at Old Town Square, a nineteenth-century center of commerce that also featured in the mid-1980s downtown revitalization launched by developer Gene Mitchell. Brewpubs and boutique shops now sit in buildings that housed the grocers and billiards parlors of the 1870s.

One block north, at 173 North College Avenue, is the former Miller Bottling Works plant, which went dry when the city OK'd prohibition in 1896. Shockingly, Fort Collins didn't allow liquor sales again until 1969.

Four blocks northeast at 317 Cherry Street is a modest one-story house, sandwiched between newer developments, which served as the childhood home of Hattie McDaniel, whose performance as Mammy in *Gone with the Wind* nabbed her the first Academy Award given to an African American. It remains a private home.

Backtrack southeast to 250 Walnut Street and you come upon the old Linden Hotel, a turn-of-the-century lodge that now houses retail and offices. If the building looks familiar, it should—Fort Collins native Harper Goff showed his employers at Disneyland photos of the old structure when the theme park was being planned, and it inspired the design of Main Street, U.S.A.

Head south to 137 Mathews Street, where you come across a home of unusual distinction. The McIntyre House was built for Captain Josiah McIntyre, a Civil War officer with the Sixteenth Pennsylvania Volunteer Cavalry who, according to the Poudre Landmarks Foundation, was shot in the face and gradually lost his sight by 1885. That did not stop him, however, from obtaining a law degree from the University of Michigan in 1889, becoming the first blind person in the United States to do so.

Finally, many of Fort Collins's firsts are on display at Library Park behind the old Carnegie Library at 200 Mathews. The Antoine Janis Cabin belonged to a man who staked a claim on the Cache la Poude River back in 1844 and built this cabin west of the area in 1859. And the Auntie Stone Cabin is the last remaining structure from the old military post, having served as the officers' mess hall and a tiny schoolhouse at a time far removed from modern-day Fort Collins.

DRINKING SITE: ODELL BREWING

800 East Lincoln Avenue, Fort Collins / 11:00 a.m. to 6:00 p.m. Sunday–Tuesday; 11:00 a.m. to 7:00 p.m. Wednesday–Saturday / www.odellbrewing.com

Doug Odell was a pioneer in his own right. The longtime homebrewer moved from Washington State to Fort Collins at a time when it was a one-brewery town and, in 1989, opened his own brewery, which sits east of downtown and reigns as one of Colorado's most revered producers of experimental beer as well as a major community supporter.

Two of Odell Brewing's best sellers are homebrew recipes from the Reagan era—90 Shilling Ale and Easy Street Wheat. But what's launched the brewery into the national spotlight, despite selling its wares in just eleven states, is its continued evolution in the styles it makes and techniques it employs.

Its IPA has become one of the standard bearers in a state known for its hoppy creations. An increasing selection of barrel-aged beers runs the gamut from bourbon-barrel products to a porter aged in Fernet barrels that carries a heavy licorice taste. And its slowly growing line of sours includes the internationally honored Friek, which combines several kriek-style offerings with wild yeast and tart cherries to bring about a one-of-its kind taste.

Right: Odell Brewing's offerings range from drinkable wheat beers to barrel-aged and sour experiments. *Courtesy of Odell Brewing.*

Below: Odell Brewing added a patio as part of the most recent of six expansions at its facility. *Courtesy of Odell Brewing.*

Since launching in a small production facility, Odell has moved to a farmhouse-style building located along the street that is considered the town's brewery row, and it has expanded six more times. Its latest growth added a large outdoor patio, a visitor center and more space in a taproom that is filled on a daily basis with people trying the six to twelve one-offs coming out of the brewery's pilot system.

Knowing what the community has done for him, Odell has set his brewery apart by what it's given back in turn. Bartenders forgo tips to give proceeds from taster trays to multiple community organizations. And the brewery

has donated a substantial amount of money to Colorado State University's fermentation science program, including an invitation to each brewing-science class to make a beer on its pilot system.

Some breweries have national ambitions. Odell, in contrast, has beer buyers begging for it across the country but chooses to concentrate on its hometown and home state.

"I do like regional products. When I travel to other parts of the United States, you get to try different things," Doug Odell said. "I think if you can get something everywhere, then it's like McDonald's."

DAY 3
ESTES PARK TO LYONS

NATURAL SITE: ROCKY MOUNTAIN NATIONAL PARK

1000 U.S. Highway 36, Estes Park / Open around the clock /
www.nps.gov/romo

When Enos Mills led the fight to designate the sprawling moraine parks and mountains extending west from Estes Park as one of America's first national parks, his chief aim was to "arouse interest in the outdoors." And in his legacy of Rocky Mountain National Park, he and other early preservationists have set aside arguably the most beautiful and untamed wilderness in America, a 416-square-mile paradise that has spawned generations of natural enthusiasts.

The park is home to the Continental Divide and headwaters of the Colorado River, and it nurtures five active glaciers. Those seeking an adventurous way to view its splendor can climb 14,259-foot-tall Longs Peak, one of the crown jewels among the state's fifty-four "fourteeners." Those who prefer more leisurely admiration of the area can motor in summertime from the park's eastern edge to its western gate along Trail Ridge Road, the highest continuous paved highway in North America.

No one hike or one day is enough to take in the majesty of elk-laden Rocky Mountain National Park. But a 3.6-mile jaunt that leads past three of the most scenic lakes in the park—Nymph Lake, Dream Lake and Emerald Lake—allows you in one morning to see the essence of what leaves visitors agape.

Snow covers Flattop Mountain overlooking Emerald Lake in Rocky Mountain National Park. *Courtesy of Rocky Mountain National Park.*

Bluebird Lake shimmers under snowcapped peaks in Rocky Mountain National Park. *Courtesy of Rocky Mountain National Park.*

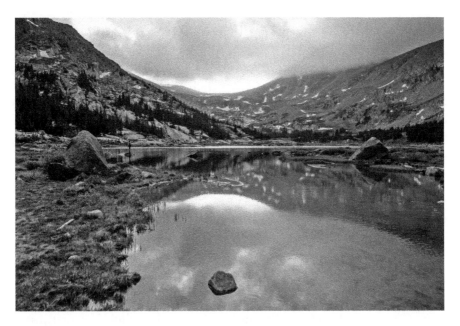

Lawn Lake sits at the northern edge of Rocky Mountain National Park. *Courtesy of Rocky Mountain National Park.*

Beginning at the Bear Lake parking area ten miles south of the park entrance, you turn left and then right at a pair of forks to start your upward march. After a half mile you plateau on the shore of a lily pad–strewn green-blue lake draped in sunlight and resting under the gazes of Hallett Peak and Flattop Mountain.

After pausing at Nymph Lake, wooden stairs lead you to a boulder overlook that brings you eye to eye with Longs Peak and the jagged Keyboard of the Winds formation. Cross a pair of wooden footbridges and land at Dream Lake, an oasis in a glacial gorge. It's a popular spot for fly-fishing and for sharing a snack with curious chipmunks.

Another seven-tenths of a mile up, the trail drops you at Emerald Lake, a tranquil and wide body of water whose dark color reflects its name. Hallett and Flattop once again stand guard, though closer. The beauty here calls you to rest after a hike lengthened by your constant need to stop and peer around.

Rocky Mountain National Park has five campgrounds and a constant schedule of ranger talks allowing you to get to know it better. And despite the throngs of annual visitors, it remains as un-trampled as when it was designated in 1915, beckoning people to see Colorado at its most spectacular.

Historic Site: The Stanley Hotel

333 Wonderview Avenue, Estes Park / Tours daily from 10:00 a.m.
to 4:00 p.m. /www.stanleyhotel.com

Twice in its century-long life, the Stanley Hotel has emerged as one of Colorado's most prominent inns. The first time was when its wealthy founder introduced the world to Estes Park. The second came after a little-known horror writer spent the night in a virtually empty dump and spawned its new reputation.

Freelan Oscar (F.O.) Stanley and his brother, F.E., made their fortunes by mass-producing dry plates for photography and by creating the Stanley Steamer, a steam-powered automobile that could reach 127 miles per hour. In 1902, F.O. moved west after contracting tuberculosis and being given six months to live.

Not only did he survive, he fell so in love with his new home that he built a "guest house" for East Coast friends. The Stanley Hotel had electricity from the get-go—a rarity in 1909—and F.O. built a hydroelectric plant to power it and the town. He brought John Philip Sousa out to play in a concert hall that is a one-third-scale model of Boston's Symphony Hall. Luminaries flocked to grand parties there as it operated in the spring and summer.

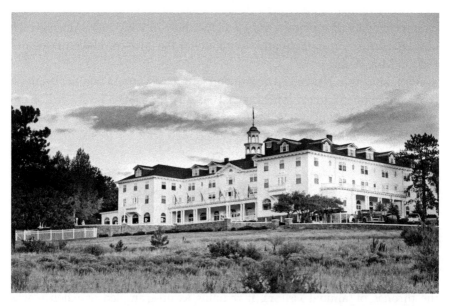

Opened in 1909, the Stanley Hotel attracts luxury travelers as well as horror film buffs to Estes Park. *Courtesy of Grand Heritage Hotel Group.*

After Stanley died, a succession of owners let the property wear down. Then, on September 30, 1974, a young writer named Stephen King stayed in the hotel with his wife on its final day before closing for the season. As they were the only guests, King heard spine-chilling stories while drinking through the night with the bartender, and he saw what he thought were twin girls as he wandered the fourth floor. Three years later, he wrote *The Shining*.

Current owner John Cullen has honored the Stanley's history, by repurchasing historic pieces like the original pool table. But he's also capitalized on the luxury inn's reputation as one of the most haunted places in Colorado. Daily tours relate tales of Room 217, where the long-dead housekeeper still unpacks bags and where actor Jim Carrey stayed for only three hours before running out and demanding new lodging. The hotel hosts an annual horror film festival and is working to build a horror film center.

This fourth-floor hallway in the Stanley Hotel, where staff used to watch children, is one of the most haunted areas of the hotel. *Author photo.*

Whether for ghosts or grandiosity, the Stanley now scares up a clientele of curiosity-seekers from around the world.

DRINKING SITE: OSKAR BLUES GRILL & BREW

303 Main Street, Lyons / 11:00 a.m. to 10:00 p.m. Sunday–Thursday; 11:00 a.m. to 2:00 a.m. Friday–Saturday / www.oskarblues.com

Before Oskar Blues had opened breweries in three states and before it realigned the craft beer industry by introducing cans, founder Dale Katechis had a smaller but similarly bold vision. In 1997, he maxed out a series of credit cards to start a restaurant serving up Cajun food and blues

The Elvis statue on the upstairs floor of Oskar Blues Grill & Brew demonstrates owner Dale Katechis's twin loves of beer and music. *Author photo.*

music in Lyons, a town of 1,400 people that sits twenty-one miles southeast of Estes Park along U.S. 36.

Oskar Blues Grill & Brew remains in that same nondescript shopping center today, even after the main brewery for the craft beer giant moved to Longmont and Katechis opened additional plants in North Carolina and

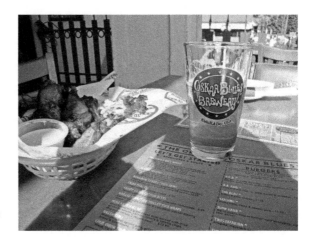

Wings, Cajun food and hoppy beer are the hallmarks of Oskar Blues Grill & Brew, especially when enjoyed on its upstairs patio. *Author photo.*

Texas. And it still serves po'boys and attracts Delta-bred musicians, even if the special sauces on its wings are made with Oskar Blues beers that are distributed nationwide.

Katechis calls Grill & Brew "the epicenter of our culture and of our soul." It is where he continues to test new beers. And it's where he holds training programs for new staff, so they can understand the history of the company.

After opening in a four-foot-deep snowstorm in April 1997, the restaurant added a brewery two years later when a customer agreed to work with Katechis on recipes. In 2002, it released its signature Dale's Pale Ale in cans and got some snickers from a craft beer community that associated aluminum containers with light and watery beer. But the hoppy beer quickly turned heads, spread to other states and convinced others that the can—lighter and more environmentally sustainable than bottles—was the way to go. Today Oskar Blues is the second-largest brewery in Colorado and the twenty-fourth-biggest craft brewery in America.

Meanwhile, the restaurant has become the community heart of Lyons, a place that attracts local and destination visitors and has stepped up in times of need. After a flood ravaged the town in September 2013, Katechis launched the CAN'd Aid Foundation, which raised several million dollars to help local businesses and residents before federal disaster money became accessible.

"It kind of became town hall, in a sense, in that it seemed to be the center of town," Katechis said. "And we've taken that responsibility to help the town."

TRIP #4
MOUNTAIN CORRIDOR

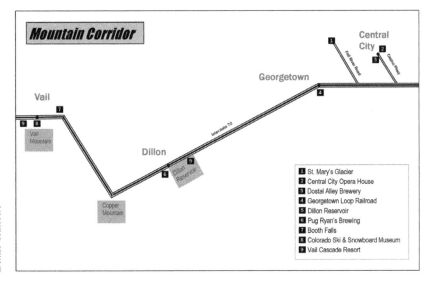

Mountain Corridor

Central City

St. Mary's Glacier

Fall River Road

Central City Opera House

Casino Pkwy

Dostal Alley Brewery

Georgetown

Georgetown Loop Railroad

Vail

Booth Falls

Colorado Ski & Snowboard Museum

Vail Cascade Resort

Vail Mountain

Interstate 70

Dillon

Dillon Reservoir

Pug Ryan's Brewing

Dillon Reservoir

Copper Mountain

1 St. Mary's Glacier
2 Central City Opera House
3 Dostal Alley Brewery
4 Georgetown Loop Railroad
5 Dillon Reservoir
6 Pug Ryan's Brewing
7 Booth Falls
8 Colorado Ski & Snowboard Museum
9 Vail Cascade Resort

Denise Sealover.

DAY 1
IDAHO SPRINGS
TO CENTRAL CITY

NATURAL SITE: ST. MARY'S GLACIER

About nine miles up Fall River Road from Interstate 70 /
Open around the clock / www.stmarysglacier.com

St. Mary's Glacier, the protrusion of ice and snow hovering over St. Mary's Lake, is not technically a glacier. Rather, it's a perennial snowfield, meaning powder and ice dot the landmark even in the dog days of August. And that is, in large part, what makes this one of the most unique short hikes in Colorado.

Located nine miles north of Exit 238 off I-70 and just above the former mining town of Alice, the glacier and lake are a picnic ground at which every level of outdoor activity is available. Dogs splash in the frigid water while owners set up makeshift hammocks nearby. Steel-skinned adventurers dive off a popular rock into the lake. And winter warriors hike around the water's edge up to the 11,236-foot peak of the glacier, cascading down via ski or snowboard twelve months a year.

After parking in one of the two designated pay lots, you proceed up a compact but very rocky three-quarters-of-a-mile trail, keeping left at two forks along the way. Though it's a pretty serious uphill climb, it's common to see families following dogs while carrying babies in backpacks. And it can get crowded.

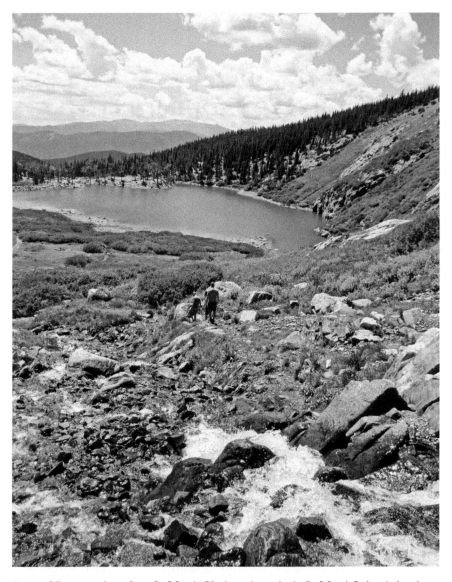

A waterfall streams down from St. Mary's Glacier as it overlooks St. Mary's Lake. *Author photo.*

Once you reach level ground, you are greeted by a blue-green lake as sought after by anglers as it is by nature photographers. Stay on the path to the right side of the lake, and you climb through foliage to a mustache-thin stream cascading through the rocks as a pleasant waterfall. From here, you can sprawl on the rocks, overlook the shore below and nap in the sun.

St. Mary's Lake rests placidly in front of St. Mary's Glacier, which features snow even in August, when this photo was taken. *Author photo.*

Your other alternative is to continue to the top of St. Mary's Glacier. Compact winter snow gives way to slushy residue by the summer, but many make the trek just to say they've found year-round powder. Snowshoeing is popular in the winter. And summer hikers can continue for another two and a half miles to James Peak, a 13,300-foot-high mountain named for Dr. Edwin James, the first person who recorded a summit of Pikes Peak.

In the 1880s, this, like much of Clear Creek County, was home to gold mining. Today, however, it is a place of peace not far from a bustling highway, the kind of stop-off where you can rest and enjoy the true riches of the view.

HISTORIC SITE: CENTRAL CITY OPERA HOUSE

124 Eureka Street, Central City / Tours available through Gilpin Historical Society at 303-582-5283 / www.centralcityopera.org

Of all the Colorado gold-mining towns, none boomed with the ferocity of Central City. John Gregory discovered a gold lode on May 6, 1859, in

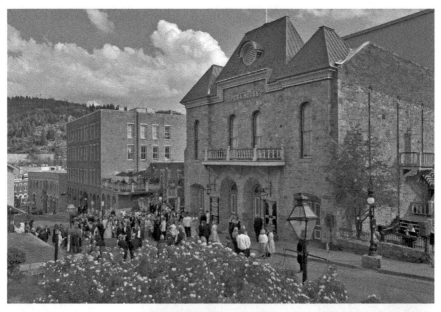

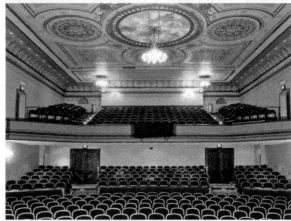

Above: Crowds gather in front of the Central City Opera House in this former mining town. *Courtesy of Central City Opera.*

Right: Central City Opera House continues to offer summer events in the same building that drew the biggest acts of the nineteenth century. *Courtesy of Central City Opera.*

a gulch that would bear his name between the eventual towns of Central City and Black Hawk. Within two months, some ten thousand people inhabited the town.

Unlike many of its contemporary mining villages, Central City wasn't just saloons and brothels. In 1872, future U.S. Senator Henry Teller opened the still-standing Teller House, a hotel so nice that it hosted President Ulysses Grant the next year. And in 1878, local leaders passed a hat among citizens, raised $20,000 and built the Central City Opera House, which grew a reputation as the finest institution of its type west of the Mississippi.

The shows at the opera house became such an attraction that wealthy Denverites built homes around the 550-seat theater and stayed for the whole summer season. But the town faded along with the gold boom, and the opera house followed the same slow descent, closing in 1927. In 1931, when it was set to become a garage, the daughter of its longtime owner joined forces with the daughter of Colorado's second territorial governor to raise money to revive it. In doing so, they not only preserved a key icon of Colorado's gold-rush years; they also launched the first true historic-preservation effort in state history.

Ida Kruse McFarlane (the owner's daughter) and Anne Evans sold the naming rights to every chair in the opera house for $100, tagging the seats not with their donors' monikers but with the names of famous Coloradans like Zebulon Pike. They restored it largely to the look of its 1878 heyday. And the Central City Opera House Association purchased many of the other historic homes and commercial buildings in the area, including the Teller House and its mysterious *Face on the Barroom Floor* painting.

Today, volunteers with the Gilpin Historical Society offer walking tours of the Teller House and Opera House, allowing visitors a chance to find those name plates and hear the still-reverberating acoustics. And though the annual festival is far shorter than its nineteenth-century precursors, summer visitors can still catch a performance under the same proscenium arch where audiences have watched everyone from Buffalo Bill to Christopher Reeve strut their stuff on stage.

DRINKING SITE: DOSTAL ALLEY BREWPUB

116 Main Street, Central City / 10:00 a.m. to 2:00 a.m. daily / www.dostalalley.net

Colorado has breweries hidden in former churches, farmhouses and industrial strip malls. But only one beer maker in the state can boast of being in a casino—and that is not Dostal Alley's only claim to fame.

Tucked away on the upstairs floor, casino co-owner Buddy Schmalz launched the brewery in 1998—seven years after Dostal Alley opened as the smallest casino in the state—as a way to make the family-owned gambling hall stand out. But he found that he really liked brewing. And after the original brewer left, he took over the duties and crafted the beers for which this mountain gem has become known.

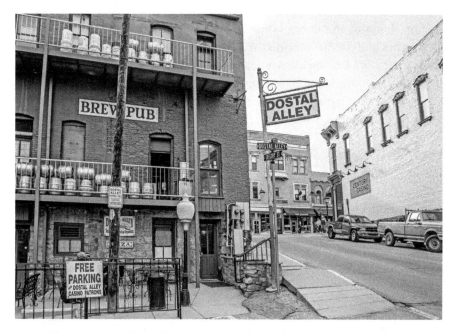

Dostal Alley Brewpub sits in an 1874 building that originally housed a grocery store and saloon. *Courtesy of Kent Kanouse.*

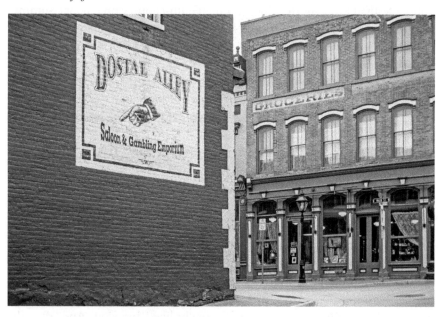

Central City, home to Dostal Alley, is one of three Colorado towns that feature limited-stakes gambling. *Courtesy of Kent Kanouse.*

Shaft House Stout, a three-time medalist at the Great American Beer Festival, came about as a tribute to the Guinness beer that Schmalz enjoys. Jacob Mack Mild Ale, an amber mild that is Dostal Alley's bestseller, pays tribute to the brewing history of the city, which dates back to the Civil War era. Each year, Schmalz goes around to various houses in the 660-person town and collects the main ingredient in the beer—hops that grow wild in yards throughout Central City. Those hops, he believes, are the descendants of ones that Mack himself asked town residents to plant when he operated his Rocky Mountain Brewery there from 1862 to 1898.

Though Central City is now a one-brewery town, it once was awash with beer. Historian and beer writer Dave Thomas found that six breweries operated there in 1870, when it boasted a population of roughly 5,500 people. Schmalz believes Dostal Alley preserves the traditions from times when establishments like Central City Brewery and Excelsior Brewery operated in and around town. He tries to use historical ingredients in his recipes. And the only place he sells the beers is on the premises of his 140-year-old building, built with bricks by grocer and saloon operator John Dostal after an 1874 fire had torn through many of the town's wooden structures.

Schmalz can brag of creating his own history, too. He was elected mayor of Central City in 2002, becoming Colorado's first post-Prohibition brewer-mayor one year before John Hickenlooper went from being the chief beer maker to the chief lawmaker in Denver. Dostal Alley remains a small operation, typically offering five beers on tap and two in bottles, both to patrons at its seventy slot machines and those at its pizza restaurant downstairs. But it's one whose roots run particularly deep.

DAY 2
GEORGETOWN TO DILLON

Historic Site: Georgetown Loop Railroad

646 Loop Drive, Georgetown / Daily excursion from May through September, then themed weekend rides through January /www.georgetownlooprr.com

Georgetown, briefly considered the "Silver Queen of the Rockies," was one of many Colorado towns that exhumed its commerce from the earth in the second half of the nineteenth century. And its lifeblood, like that of many other cities, was the railroad, bringing workers to these profitable holes in the ground to start the day and hauling ore back at days' end. Today it has one of the best-preserved railroads and abandoned mines in the state.

The Central Colorado Railroad reached Georgetown in 1877, and a spur connecting it to Silver Plume, home to a profitable mine, began operations in 1884. A six-mile-round-trip loop now takes sightseers over that same rebuilt route.

The engineering—starting with the three-hundred-foot-long Devil's Gate High Bridge, which passes through a verdant valley beside Clear Creek—is quite a feat. Narrow-gauge tracks were used to get up steep passes in a corkscrew pattern with grades of more than 4 percent at places.

These tracks reach the remnants of the Lebanon Silver Mine, located deep within Republican Mountain. It produced more than $250,000 worth of lead-silver compound from 1871 to 1901, offering miners the wages of three dollars per day—more than five times the average American's pay at

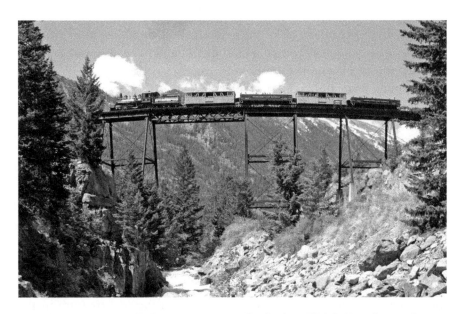

Above: Georgetown Loop Railroad cars pass over Devil's Gate High Bridge. *Courtesy of History Colorado.*

Below: The Georgetown Loop Railroad is seen circa 1899. *Photo by William Henry Jackson, courtesy of Library of Congress.*

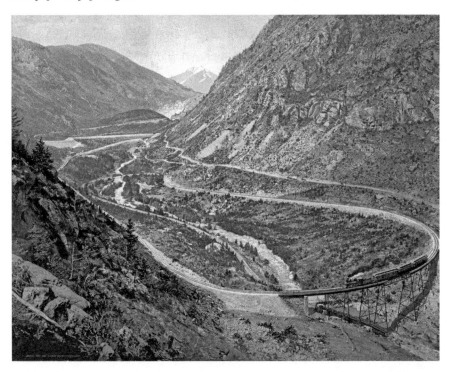

the time. Tunnels running off of the main shaft still display silver in the rock. And they also contain the original hoist bucket and picks that were left here by workers when the mine shut down for good.

The mine tour and train ride offer a couple of historical gems. The manager's office includes rare pictures of underground hard-rock mining— rarities because the bright lights of camera flashbulbs were thought to risk a cave-in by disturbing the Tommyknocker spirits that dwelled in the mines. The Silver Plume stop also features old transportation vehicles, including a passenger car, a boxcar and a gondola.

Passenger service on the route was discontinued in 1927, and the tracks were pulled up and sold for scrap in 1939. But the Colorado Historical Society acquired land and rebuilt the loop over a twenty-five-year period, and it's been operating continuously since 1984.

Stories abound that the streets of Georgetown were paved accidentally with silver until town leaders discovered the mineral and dug up the roads and sidewalks. The loop railroad, however, was the real treasure in the town's history.

NATURAL SITE: DILLON RESERVOIR

Exit 205 of Interstate 70 / Open around the clock /
www.denverwater.org/recrecation/dillon

The 26.8 miles of shoreline and 3,233 acres of surface area of Dillon Reservoir, the most popular water playground in Colorado, sit just steps from the fourth iteration of the town of Dillon. The first three locations of the Summit County town now rest in the reservoir.

Opened in 1963, Dillon Reservoir is the largest water-storage area for Denver Water and was sought for its key location to divert water under the Continental Divide to the South Platte River basin. But it turned also into a place where boating, fishing and stand-up paddle boarding take center stage in this landlocked state, less than ninety minutes west of Denver.

Founded in 1883 as a stage stop, Dillon had to be relocated twice in the nineteenth century when key railroads bypassed it. During the Great Depression, Denver leaders started buying large chunks of land around the town when residents failed to pay property taxes. By the 1950s, they were ready to move the town northeast to its present site and build a 231-foot-high earthen dam to hold 85.5 billion gallons of water.

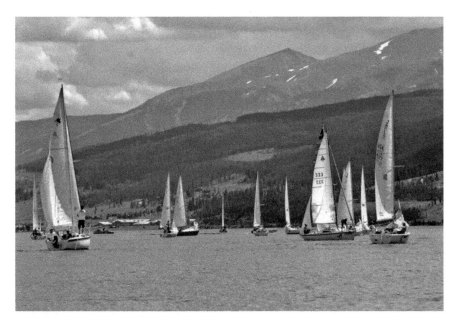

Sailboats fill the waters of Dillon Reservoir during the summer months. *Courtesy of Dillon Marina.*

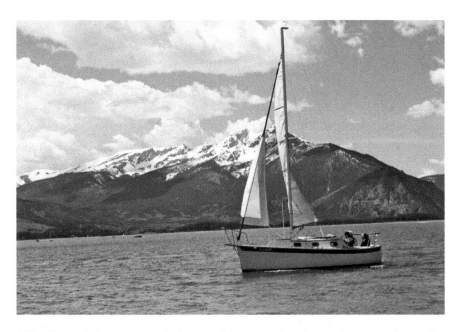

Dillon Reservoir is a recreational playground for visitors but also a main source of water for Denver-area homes. *Courtesy of Dillon Marina.*

The most popular activity on that water today is boating, whether in owner-occupied craft that can launch from marinas in Dillon or Frisco, or via fishing boats, sailboats and pontoons that can be rented on the lake. Swimming and water skiing are prohibited in order to keep the drinking water as clean as possible, though windsurfing and SUPs are OK if done in a full bodysuit.

Fishing also is a popular pastime, since the Colorado Division of Wildlife stocks the lake with some 350,000 rainbow trout annually. Anglers wanting to make a multiple-day trip out of it can bunk up at one of the dozens of motels around the area or stake out one of 325 campsites around the reservoir.

Maybe the best way to take in the beauty of the man-made lake, however, is just to stroll around it, starting from popular points in front of well-occupied playgrounds and disappearing into quieter patches as you cross over the dam wall into the trees. There is an eighteen-mile paved path around the reservoir, and there are dirt trails reaching into nature from all of the campground areas.

DRINKING SITE: PUG RYAN'S BREWING

104 Village Place, Dillon / 2:00 p.m. to close Monday–Friday; 11:30 a.m. to close Saturday–Sunday / www.pugryans.com

As a turn-of-the-twentieth-century outlaw, Pug Ryan saw little peace in life, robbing banks and killing Summit County sheriff's deputies before dying in prison as an old man. It is somewhat of an irony, then, that the brewery named after him sports the only easy, breezy waterfront bar of any beer maker in Colorado.

Pug Ryan's began life in 1975 as a white-tablecloth steakhouse in downtown Dillon and added its brewery in 1996. Today that beer can be found in cans across Colorado, but sales manager and longtime bartender Chris Caldwell swears it tastes better on the restaurant's forty-five-person deck or at the Tiki Bar, a 150-seat summer offering at Dillon Marina, where you can almost reach out and touch paddle boarders.

In a state known for its high hop profile, head brewer Dave Simmons stands out for his concentration on European-style lagers, a trait he picked up after a 2008 tour of Germany. Yes, Pug's has a bitter Pack Iron Pale Ale, but its most notable offerings are its Peacemaker Pilsner, Hideout Helles

Pug Ryan's Peacemaker Pilsner is one of the Western-themed lagers for which the brewery is known. *Courtesy of Pug Ryan's Brewing.*

and Deadeye Dunkel. Even its darkest year-round creation, Outlaw Stout, is a vanilla stout.

"The market is saturated with IPAs and big hoppy beers and other stuff," Simmons said. "We live in the mountains. These are the things you see here."

They're also the things you see when boaters and area brewers gather together at the Tiki Bar, open from Memorial Day to late September and offering a sandwich- and appetizer-focused menu. The concept took root even before Pug's owners decided to install a brewery, and it's grown from a tin shack to a deck with two tents and a permanent kitchen.

"It's held together with spit and sawdust," Caldwell observed. "But it gives it its character."

Similarly, Summit County's brewing community has grown since the mid-1990s to include six craft breweries serving beer to the skiers that populate the mountain region during the winter and the wide range of travelers who come to relax in the summer.

Pug's went through a rebranding in 2012, refocusing its beers around the outlaw theme (all except for its iconic Morningwood Wheat, that is). Simmons will break out seasonals and experiments occasionally, but he has a hard enough time just keeping up with the growing crowds knocking on the brewery's two doors and seeking its easy-drinking vibe.

DAY 3
VAIL

NATURAL SITE: BOOTH FALLS

Booth Falls Road, Vail/Open around the clock

Though bereft of lakes, Colorado is blessed with hikes to stunning waterfalls. And while there are falls that are steeper and more rushing than Booth Falls, there is no trail in the state where you can gawk at a greater variety of wildflowers and stunning scenery on the way up.

Just off the north frontage road connected to Exit 180 off Interstate 70, the Booth Creek Trail is part of the expansive Eagles Nest Wilderness within the White River National Forest, a place of soaring peaks, high valleys and creeks carrying alpine lake waters down to mountain villages.

You begin this hike on a straight-uphill trajectory surrounded by dainty purple harebells and sun-seeking violet asters. By the second switchback, you can take in views of East Vail, including two waterfalls cascading off the rocks across the highway. Continuing upward—this trail rises 1,500 feet in slightly more than two miles—you are blanketed in cottony white yarrow and in broad-leaved mariposa lily, the plant that kept the Mormons from starving during their early harsh winters near the Great Salt Lake.

As you turn inward from the highway, your views become those of an aspen-covered grove reflecting sunlight. Flat rocks dot this stretch, appropriate for spreading a picnic on the way up or down.

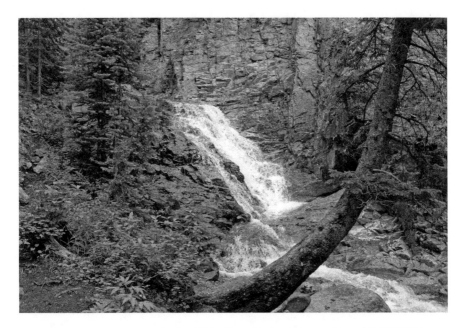

Booth Falls streams over rocks in the White River National Forest. *Courtesy of SUNGOD.*

A variety of wildflowers and aspens dot the hike to Booth Falls. *Courtesy of SUNGOD.*

The colors continue on the ascent, from the purple monkshood (notable for the leaf of the flower draping over the central plant like a hood) to red twinberries that can induce vomiting in case of poisoning. Two-thirds of the way up you reach a field of shoulder-high fireweed and buckwheat flowers, a respite before the final uphill slog.

As you reach the falls, you find two overlooks—one with a more distant but straight-on view of the creek, and another that pulls you right to the edge and stands you over the rushing stream. As you descend, you'll find several bump-outs that extend over the water and give you a soaring look at the valley below.

You can continue about three miles farther on the trail to reach the glassy Booth Lake. But the joy of this hike is tromping slowly through the beauty of the wildflowers and ending on a sun-draped perch over the roaring water, letting its sound envelop you and make you forget how close you are to civilization.

Historic Site: Colorado Ski & Snowboard Museum

231 South Frontage Road East, Vail / 10:00 a.m. to 6:00 p.m. Tuesday—
Sunday in summer; 10:00 a.m. to 6:00 p.m. daily in winter /
www.skimuseum.net

The history of the ski industry in Colorado is not just that of fluffy powder and schussing visitors. It involves the perseverance of military veterans, occasional tragedy and survival from attacks by environmental extremists. And while there are twenty-five ski resorts in the state, the industry is epitomized—and memorialized by a museum—in Vail, a high-brow town with downhill ambitions.

Skiing came to Colorado in the 1860s, when Scandinavian miners who had used snowshoes to cross passes began to hold impromptu downhill races. A half century later, ski carnivals and jumping contests spread and towns like Steamboat Springs began to center their economies on winter sports.

Vail Mountain opened in 1962, during the post–World War II era when soldiers who were part of the Tenth Mountain Division came home and began looking for opportunities to transform their training into a craft. By the 1980s, major resorts and local ski hills dotted the state. Colorado now gets the largest share of winter sports visitors in the country.

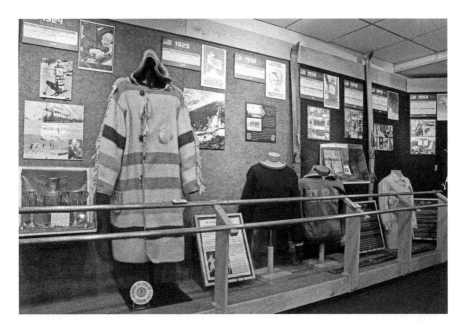

A games-by-games history of the United States Olympic ski and snowboard teams is laid out at the Colorado Ski & Snowboard Museum. *Courtesy of Colorado Ski & Snowboard Museum.*

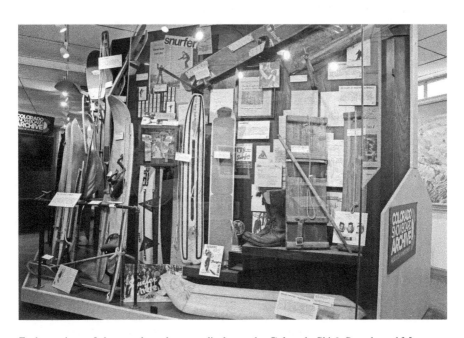

Early versions of the snowboard are on display at the Colorado Ski & Snowboard Museum. *Courtesy of Colorado Ski & Snowboard Museum.*

Such development wasn't without obstacles, though, in the former mining town of Vail, as in other cities. Environmental activists set fire to several of the resort's buildings in the late 1990s. And the resort weathered the tragedy of a gondola crash in 1976 that killed four people.

The museum, which is located above the parking garage in Vail Village, tells these stories but also walks visitors through the history of winter sports in the state, offering displays on the evolution of boots, skis and bindings, including precarious-looking tie-in bindings of the 1890s. It features an extensive exhibit on the start of the snowboarding movement, including a fantastic video from the first known competition, in which the winner declares his hopes that the sector gets more professional.

And the museum highlights the outstanding individuals who have helped bring skiing to its peak of popularity. There is a great history of the Tenth Mountain Division, a year-by-year telling of the successes of the U.S. Olympic team, a comprehensive Colorado Ski and Snowboard Hall of Fame and a wonderful display on the short-lived World Pro Skiing tour of the 1970s.

And if you happen to visit in winter, the slopes of Vail Mountain are mere yards away. This stop is the closest thing you can find to immersing yourself in the state's skiing culture in one fell swoop.

DRINKING SITE: VAIL CASCADE RESORT

1300 Westhaven Drive, Vail / Fireside Bar open 2:00 p.m. to close
Monday–Thursday and noon to close Friday–Sunday / www.vailcascade.com

While watching news reports about the enormous crowds at the 2011 Great American Beer Festival in Denver, the Vail Cascade's general manager turned to one of his employees, Laura Lodge, and said he wanted to bring the craft beer crowd into the mountains. Luckily, Lodge had a bit of knowledge on the subject, having run the enormously popular Big Beers, Belgians and Barleywines Festival in Vail since 2001 with her brother.

What Lodge did next was create the first craft beer program at a mountain resort in Colorado, taking the drink that helped to define the Denver and Boulder areas and infusing it into a part of the state where it had seemed absent. Since then, she's inspired several other destination lodges to give it a try, though none have gone to the same lengths as this hamlet west of the Lionshead Village area.

Fireside Bar at Vail Cascade Resort features craft beer on its taps, in bottles and on a cellar list. *Courtesy of Vail Cascade Resort.*

"To be able to convince the resorts in Colorado that this is a Colorado experience…it's not the last frontier, but it was one of the major frontiers we were lacking," said Lodge, now an independent craft beer consultant.

The craft beer program at the Cascade starts at the Fireside Bar, where five rotating beers are on tap, thirty are in bottles and another ten or so appear on the cellar list. Nationally known Sam Adams is usually found there, but so are local luminaries such as Crazy Mountain Brewing and Bonfire Brewing.

Atwater on Gore Creek, the resort's upscale restaurant, offers craft beer flights, puts on frequent beer dinners and has a staff of servers who can recommend the perfect pairing for your pub burger or your Kobe beef steak. About four times a year, the resort features brewmasters' weekends full of talks and tastings from Colorado beer makers.

The program has made the Cascade a hangout not only for beer aficionados from the Vail Valley but also for some Denverites who need a weekend retreat— with good beer. Lodge said it's been used to close sales on corporate meetings, and she's engineered team-building dinners with beer pairings.

"The resort component is very important to craft beer because until craft beer is everywhere you go, it won't be an everyday component of life," she said. "This is bringing it to not only your home life but your vacation life."

TRIP #5
CENTRAL MOUNTAINS

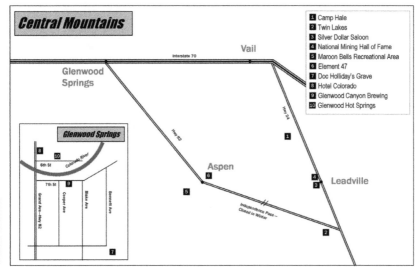

Denise Sealover.

DAY 1
LEADVILLE AREA

HISTORIC SITE: CAMP HALE

14.3 miles west of Leadville on Highway 24 / Open around the clock

In November 1942, the first of sixteen thousand soldiers began pouring into a glacial valley north of Tennessee Pass. Over the next two years, Camp Hale would become home to some of the unsung heroes of World War II—the Tenth Mountain Division, which undertook two years of rigorous high-altitude training before dislodging the German hold on northern Italy.

The idea of training units of soldiers to climb mountains and ski down them came from Charles "Minnie" Dole, founder of the National Ski Patrol. The army finally consented and began construction in February 1942 on Camp Hale, erecting more than one thousand buildings on a 247,000-acre area where soldiers learned to shoot anti-tank rockets and other heavy artillery.

Life could be grueling at the camp, as soldiers carried ninety-pound rucksacks while skiing or snowshoeing on nearby Cooper Hill and B-Slope. But after Leadville agreed to crack down on gambling and prostitution, Camp Hale also welcomed the locals with dances, athletic competitions and the other amenities of wartime base life.

Deployed to Italy in January 1945, the division opened the way through the strategic Po Valley even as it took heavy losses at Riva Ridge and Mount Belvedere. German troops retreated into the Alps and surrendered on May

An exhibit at the Colorado Ski & Snowboard Museum explains the history of the Tenth Mountain Division troops who were trained at Camp Hale. *Courtesy of Colorado Ski & Snowboard Museum.*

Veterans gather to commemorate their service at Camp Hale. *Courtesy of U.S. Forest Service.*

2 in one of the last confrontations before victory was declared in Europe on May 8. The Americans then participated in the liberation of Norway.

Tenth Mountain Division veterans founded the ski resorts of Aspen, Vail and Arapahoe Basin after the war. Camp Hale itself was used sporadically, including for secret training of Tibetan soldiers, before being shuttered in 1965.

Today, two monuments to it remain in the area. About eight and a half miles west of Leadville on Highway 24 sits the Tenth Mountain Division Memorial Monument, featuring the story of the units and a tribute to the 1,001 members who died in World War II battles. Some five and a half miles farther west, an outlook peers into the valley that once was alive with military activity. Only the concrete skeleton of an unidentified structure remains, while five weathered plaques relate the tale of Colorado's greatest contribution to the most worldwide of wars.

Natural Site: Twin Lakes

Two miles west on Highway 82, fifteen miles south of Leadville /
Open around the clock / www.leadvilletwinlakes.com

Heading southeast on Highway 24, you pass through Leadville, one of the richest of Colorado's silver mining towns of the late nineteenth century. Then, fifteen minutes out of town, you come to Twin Lakes, where the wealthiest of the wealthy used to play.

Nestled beneath the peaks of the San Isabel National Forest, the town of Twin Lakes, situated on the west side of the water, was a stopover between Aspen and Leadville during the mining boom years, and some of its historic structures remain. The lakes, meanwhile, have become playgrounds for all sorts of water excursions. Seven fishing areas, two campsites, a boat ramp and picnic grounds beckon to visitors.

The true jewel of the site, however, lies on the southwestern corner of the lakes. Inter-Laken Resort was a nineteenth-century getaway for the wealthy that imported an orchestra from Leadville to play each summer weekend in its pavilion. Today you can access it two ways—either a boat ride from the marina or a four-mile round-trip hike that is resplendent in its view of the lake.

To access the trail, turn west from Highway 24 onto Highway 82 and then head south about six-tenths of a mile later onto Lake County Road 25. Travel

Right: The Inter-Laken Resort is shown decades after closing in this historic photo. *Courtesy of History Colorado.*

Below: This historical image shows Dexter House overlooking Twin Lakes in 1974. *Courtesy of History Colorado.*

one mile down a dirt road past the eastern edge of the lake and through campsites, and you'll spy a sign pointing you toward the Colorado Trail.

The path is largely flat, but the view to your right changes depending on the tree coverage along the trail. At first, you can eye Mount Elbert—the tallest peak in Colorado—just through selected openings in the foliage. But about halfway through the hike, the path ends up ten feet above the shore of the lake, which can be placid and charmingly turquoise as the light bounces off of it.

Follow a sign at a fork toward Inter-Laken, and you'll pass through a greener and wetter zone before you are greeted first by Dexter House,

then a half dozen wooden cabins and finally the towering main lodge. Inter-Laken Hotel closed when owner James Dexter died in 1899, and the hotel became a boardinghouse until the end of World War I. It's been abandoned ever since.

Today it is believed to be the only site on the National Register of Historic Places without a parking lot. And it serves as a symbol both of the wealth of the past and the natural beauty that has outlasted silver in the area.

DRINKING SITE: SILVER DOLLAR SALOON

315 Harrison Avenue, Leadville/11:00 a.m. to 2:00 a.m. daily

Every attribute of the Old West was present in Leadville, from the boom-and-bust mining economy to the gamblers and gunmen in its saloons. While most of the buildings that were home to such scurrilous behavior are gone, the Silver Dollar Saloon still stands—and serves drinks—as it's done since 1879.

Originally known as the Board of Trade, the saloon's conspicuously upright name veiled a long history of gambling. The back room downstairs was separated by silk draperies into areas for faro and keno in the nineteenth century. The upstairs area housed card and dice games from poker to "chuck-a-luck," according to a printed history still distributed by the saloon.

Much of the structure of the saloon remains as it was during its heyday. The bar back of white oak and mirrors of diamond dust—two of the three of them, at least—are the same ones that came from St. Louis in the 1880s. The oak windbreak at the front door stands just where it did to keep wives, who did not enter bars in those days, from being able to see and retrieve their husbands inside.

The Silver Dollar saw its share of historic characters. Oscar Wilde threw down shots here after giving a lecture across the street at the still-standing Tabor Opera House. Doc Holliday killed his last man in a gunfight in the street in front of the bar.

When Prohibition hit, the Silver Dollar adjusted. Owners installed a trap door behind the bar for speedy removal of evidence of drinking. Booths in the back were hung with curtains to offer imbibers privacy.

Today the bar respects its Old West roots, as evidenced by the holstered gun hanging from the back bar, horseshoes on its beams and pictures of Silver Dollar Tabor—daughter of the town's most successful miner—ringing the

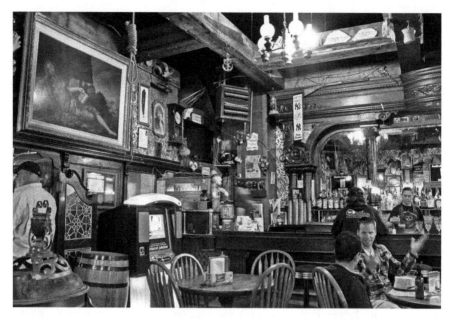

Remnants of its historic western past hang throughout the Silver Dollar Saloon. *Larry Lamsa.*

establishment. But it also has become a center of Irish culture and is home to bagpipers during the town's twice-a-year St. Patrick's Day celebrations (September 17 as well as March 17).

Though only lunch is offered, the bar serves alcohol from late morning into the early next morning, and its beer list includes some larger local and national craft brews. You won't find gunfights or gambling anymore, but you can still imagine them here.

DAY 2
LEADVILLE TO ASPEN

HISTORIC SITE: NATIONAL MINING HALL OF FAME
AND MUSEUM/MATCHLESS MINE

*120 West Ninth Street, Leadville / 9:00 a.m. to 5:00 p.m. daily; closed
Mondays from November to May; mine closed from October to Memorial Day /
www.mininghalloffame.org*

Miners first discovered silver in the Leadville area in 1860. But the event
that made the town boom occurred in 1879, when society climber Horace
Tabor purchased the Matchless Mine for $117,000, dug down 153 feet and
found a lode of silver that made him one of Colorado's wealthiest and most
important men.

Tabor transformed the town with his wealth, building an opera house
and nabbing an appointment to the U.S. Senate. While in Washington, he
married Elizabeth "Baby Doe" Tabor, a beauty twenty-four years his junior,
before his divorce from his first wife was final. Though shunned by polite
society women, they lived extravagantly until 1893, when the silver bust left
them penniless. Horace died in 1899 of appendicitis.

Matchless Mine, which eventually produced $7.5 million in minerals,
remains on display, allowing visitors to see the same shaft through which
miners descended and the machinery that made it go. Just feet from that
economic engine, however, is a sadder landmark—the cabin to which Baby

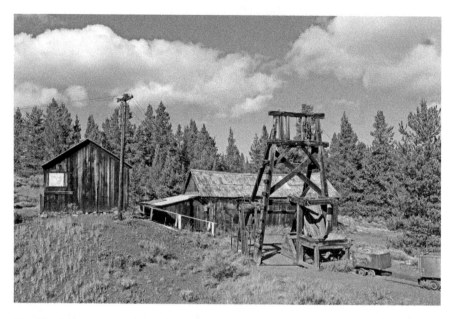

Matchless Mine was a major factor in Leadville's boom in the 1880s. *Photo by Jeffrey Beall.*

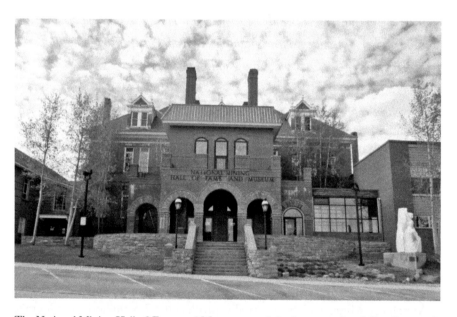

The National Mining Hall of Fame and Museum stands in downtown Leadville. *Courtesy of the National Mining Hall of Fame and Museum.*

Doe moved after being widowed. She lived alone there for thirty-three years before her death. Impoverished, she would wrap her feet in rags when she went into town, and residents would leave groceries for her at the bottom of the road. Her partially rebuilt cabin stands today as the symbol of how quickly fortunes turned in Colorado mining.

The bigger picture of the mining industry can be examined at the hall of fame and museum, through which tours of the Matchless Mine site can be purchased. It is an essential story, as the gold rush that began with the discovery of a nugget south of Denver in 1858 largely populated the state. When the gold dried up and silver went bust, Leadville became the center of mining for molybdenum, a steel alloy used in the production of military weapons.

The museum offers dioramas on the state's mining history, historical equipment, reproductions of several mines and linkages to all the uses of the minerals, including a special section on their relation to space exploration. It is, in some ways, an academic experience. But it is a truly Colorado experience.

Natural Site: Maroon Bells Scenic Area

Maroon Creek Road, southwest of Aspen/Open around the clock

Highway 82 connects the state's past and its present, leading from one-time boomtown Leadville west to Aspen, the most opulent gem among Colorado cities today. But nothing man-made in this wealthy mountain hamlet can compare to the priceless view that awaits you at Maroon Lake.

The emerald-green waters of the 9,580-foot-high lake reflect North Maroon Peak and South Maroon Peak behind it. Reputed to be the most photographed mountain site in North America, this spot can seem the epitome of peace in a glacier-carved valley, though the peaks, collectively known as the Maroon Bells, have earned the nickname "Deadly Bells" for the number of climbers who have perished on their unstable rock.

To get here between 8:00 a.m. and 5:00 p.m., you must hop a bus at Aspen Highlands Village for the ten-mile ride up Maroon Creek Road. But once you have situated yourself, there are a variety of ways to explore this 181,000-acre area within the White River National Forest.

Those seeking lighter activity need only to stroll the one-mile perimeter of the lake under the eye of the snow-capped purple peaks until it reaches

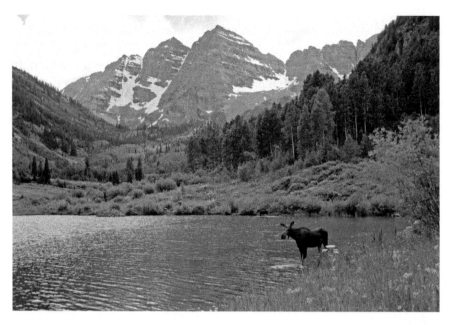

Moose wade into Maroon Lake under the watchful eye of the Maroon Bells, some of the most photographed mountains in North America. *Courtesy of U.S. Forest Service.*

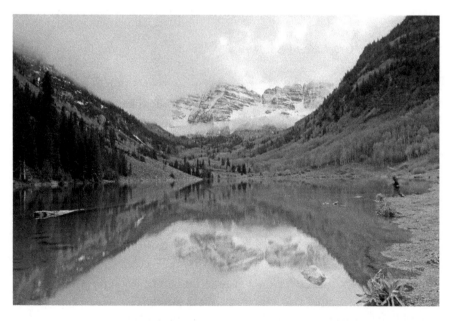

Maroon Bells Scenic Area receives 200,000 visitors per year. *Courtesy of U.S. Forest Service.*

a seemingly immovable beaver lodge on its far side. From there, you can cross a wooden bridge onto the start of the 3.6-mile Crater Lake Trail, following the path as it narrows and leads you beside a rushing creek before planting you in front of a small waterfall. Turning back, you pass through shoulder-high plants and wildflowers, and sandstone-peaked Sievers Mountain looms to your left.

Or you can follow the trail even farther as it leads to Crater Lake, a ten-thousand-foot-high hideaway fed by melting mountain snow that emerges after a sometimes-steep trail. The path exits the aspen groves and traverses lunar-looking landscapes for a short while. Chilly as the water may be, it is a refreshing splash after a tiring hike.

Throughout your journeys, you may spy some of the area's wildlife inhabitants, from the pudgy marmot to the adorable pica. And you undoubtedly will glimpse the five fourteen-thousand-foot-tall mountains that dot the state's fifth-largest wilderness area. Each can be climbed, though some require technical skills.

Regardless of your specific path through the wilderness area, Maroon Bells is a place that will awe and delight. Bring your own food and water, for there are no concession stands here. And whatever you do, don't skimp on photos.

DRINKING SITE: ELEMENT 47

675 East Durant Avenue, Aspen / 7:00 a.m. to 11:30 p.m. daily /
www.thelittlenell.com

Colorado may be a beer state, but when you're in Aspen, you are in oenophile territory. And if you're looking for the best glass of red or white, there's no reason to go anywhere besides this upscale wine bar that has been rated one of the one hundred best in the country and sports a cellar of no fewer than twenty-two thousand bottles.

Situated in the Little Nell, a luxury hotel that's been ranked among the top thirty in the world, Element 47 does double duty as the upscale restaurant on the slope-side property as well. The hotel is named after a silver mine in the area, while the wine bar moniker represents the periodic table number for that precious metal.

The extensive offering list of some three thousand labels represents renowned regions from Bordeaux to Napa, and an attic features another

Left: Slope-side views help to make Element 47 one of the most revered wine bars in Colorado. *David O. Marlow*.

Below: Element 47 features a cellar of some twenty-two thousand bottles of wine. *Jessica Grenier*.

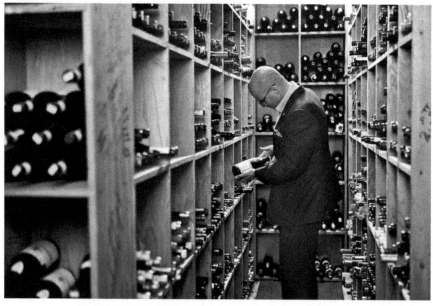

one thousand Burgundy labels not on the general list. But sommeliers travel frequently to lesser-known areas of high quality as well, seeking out bottles that are both up and coming and food friendly. And they go out of their way to feature bottles under seventy-five dollars.

"We want it to be approachable and fun for everyone, regardless of their education levels or budgets," former sommelier Nick Barb said.

Selections can be enjoyed in the restaurant, on a covered porch area or around a pool. In the summertime, the pool is a fascinating mix of European sunbathers, couples toting small dogs and children splashing. It serves as a reminder that while Aspen is fancy, this is still Colorado, and the pretension is held in check.

And if wine isn't your beverage of choice, the menu features thirty-six tequilas, about thirty whiskeys and a series of signature drinks, including a French martini with Chambord and pineapple. The beer list has ten approachable Colorado craft beers—and Aspen Brewing and its award-winning saisons sit just a half mile away.

Aspen began life like many of its mountain neighbors as a central point for the silver miners heading into the hills. In a state of practical, rugged towns, it stands out now as a true luxury spot. But at Element 47, you can drink like a mining baron without having anyone stare at you like you're merely an hourly laborer.

DAY 3
GLENWOOD SPRINGS

HISTORIC SITES: DOC HOLLIDAY'S GRAVE
AND HOTEL COLORADO

Bennett Avenue between Thirteenth and Fourteenth Streets, and 526 Pine Street, Glenwood Springs / Open around the clock / www.hotelcolorado.com

Between them, Doc Holliday and Teddy Roosevelt spent less than a year in this tourism-centered town made famous by its hot springs. But the two men left such an impression that their imprints can be seen throughout Glenwood Springs today.

Well past his famed days in Arizona and the shootout at the O.K. Corral, Holliday arrived here at the end of his rope in May 1887. America's most famous dentist-turned-gunfighter had spent several years drinking and gambling in Leadville and lived for a short stint in Denver. Suffering from tuberculosis, he hoped that the famed vapors of Glenwood's hot springs could heal him—but he was wrong.

Holliday died in November 1887 at the age of thirty-six in the Hotel Glenwood. His last words—"This is funny"—were recognition that no one had expected him to die in bed rather than by a bullet. Destitute, he was interred in an unmarked grave the same day in the newly opened Linwood Cemetery.

Today, his grave marker—no one knows the exact site of his burial—stands out in the otherwise aging cemetery. Surrounded by a wrought-

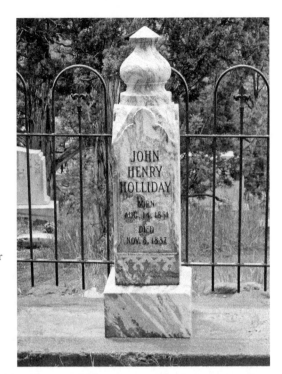

Right: A marker denotes gunfighter Doc Holliday's burial in Linwood Cemetery in Glenwood Springs. *Courtesy of Frontier Historical Society.*

Below: The hiking trail up to Linwood Cemetery begins on Glenwood Springs's east side. *Courtesy of Frontier Historical Society.*

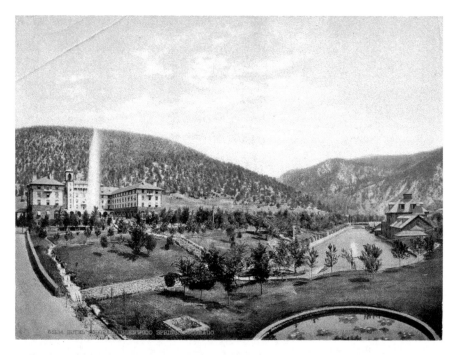

A photochrom postcard published by the Detroit Photographic Company between circa 1897 and circa 1924 shows Glenwood Springs and the Hotel Colorado. *Beinecke Rare Book & Manuscript Library, Yale University.*

iron fence, his headstone plaque is covered frequently by cigarettes or shots of whiskey left by modern admirers. The Hotel Glenwood also is gone—burned down in 1945—but the door of the retail shop erected in its place at 732 Grand Avenue still notes it as the site where Holliday took his final breath.

Roosevelt traveled to Glenwood under happier circumstances. First as vice-president and then as president, he came to the nearby Flat Tops Wilderness to hunt bears, staying at the Hotel Colorado each time. His 1905 trip was so long that the luxury hotel became known as the "White House of the West."

When Roosevelt returned from one of his excursions empty-handed, the hotel staff presented him with a stuffed bear made from scraps of cloth, and his daughter named it "Teddy." The fact that Colorado gave birth to the teddy bear is marked today by a display of early such creations near the hotel's entrance, beside a bust of the former president.

Roosevelt didn't just shoot game in Colorado, though. He also spoke to a large crowd from a balcony outside his second-floor room—an action

The sun sets over Denver's City Park, including Ferril Lake and the Spanish-style pavilion that has anchored the lake since 1896. *Holly Batchelder.*

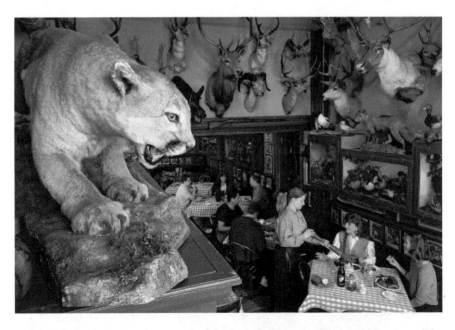

A mountain lion peers over diners at the Buckhorn Exchange in Denver, which serves wild game and holds Colorado liquor license No. 1. *Courtesy of the Buckhorn Exchange.*

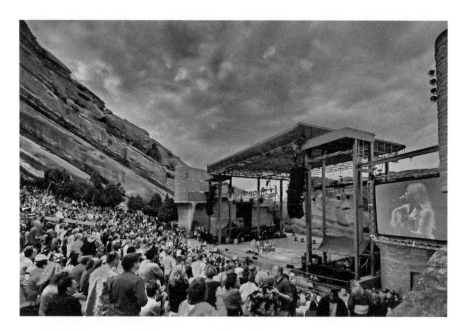

Crowds pack Red Rocks Amphitheatre in Morrison to watch national performers, set against the backdrop of sandstone rock formations. *Stevie Crecelius*.

Tim Myers, co-founder of Strange Craft Beer, sits in the Denver brewery's taproom. *Courtesy of Strange Craft Beer*.

Right: A server pours a seasonal draft from the tap at Dry Dock Brewing's South Dock location in Aurora. *Courtesy of Dry Dock Brewing.*

Below: Avery Brewing's Boulder County facility features two taprooms and a restaurant with a pork-centric menu. *Courtesy of Avery Brewing.*

The moon glows over Horsetooth Rock, a popular hiking destination west of Fort Collins. *Richard Ernst*.

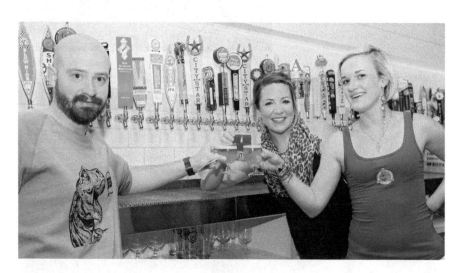

Servers at the Mayor of Old Town in Fort Collins pour beer from one hundred taps, with an emphasis on offering Northern Colorado craft brews. *Brian Lackey*.

Craft beer lovers gather around a bonfire on the patio of Odell Brewing in Fort Collins. *Courtesy of Odell Brewing.*

Hallett Peak and Flattop Mountain reflect in the water of Dream Lake at Rocky Mountain National Park. *Courtesy of Rocky Mountain National Park.*

Though Rocky Mountain National Park is known for its elk population, a variety of other animals, including bighorn sheep, roam its 416 square miles. *Courtesy of Rocky Mountain National Park.*

Patrons both have imbibed and witnessed spirits at the Stanley Hotel's Cascades Whiskey Bar in Estes Park. *Courtesy of Grand Heritage Hotel Group.*

Sailing is a popular pastime at Dillon Reservoir, as water lovers flock to the 3,233-acre lake. *Courtesy of Dillon Marina.*

Cans of Pug Ryan's Deadeye Dunkel get filled at the Dillon brewery. *Tom Fricke.*

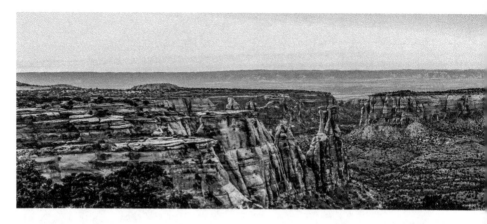

Monument Valley at Colorado National Monument features some of the most spectacular rock formations in the state. *Dustin C. Gurley.*

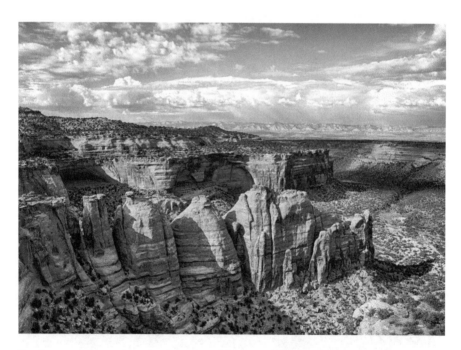

Sandstone rock formations rise throughout Monument Valley in Colorado National Monument near the town of Fruita. *Courtesy of Colorado National Monument Association.*

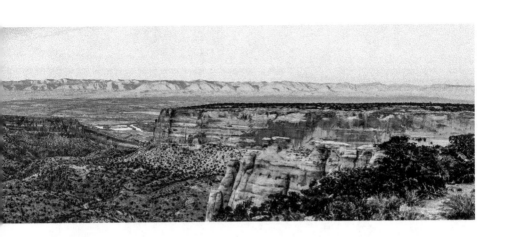

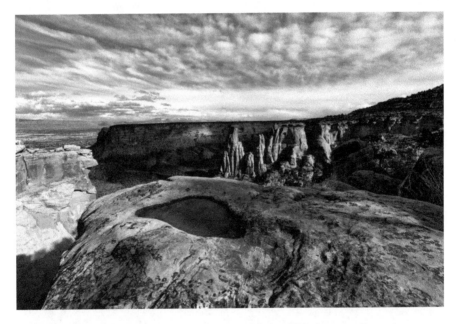

Potholes in the sandstone basins around Colorado National Monument collect rainwater and offer relief to creatures in the dry desert environment. *Courtesy of Colorado National Monument Association.*

The full spectrum of the beer rainbow is represented in the variety of offerings at Glenwood Canyon Brewing in Glenwood Springs. *Courtesy of Glenwood Canyon Brewing.*

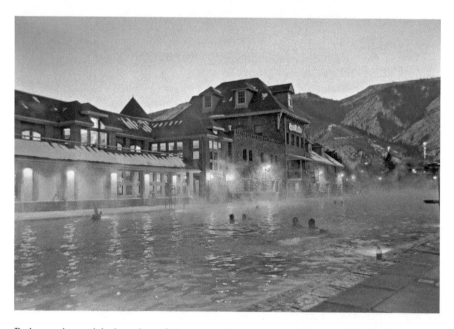

Bathers enjoy a nighttime view of the surrounding canyon in Glenwood Hot Springs. *Courtesy of Glenwood Hot Springs.*

Left: Tap handles at Three Barrel Brewing in Del Norte reflect its whimsical beers, including its Burnt Toast brown ale and Hop Trash IPA. *Courtesy of Three Barrel Brewing.*

Below: Patrons who drink one hundred beers at Lady Falconburgh's Alehouse and Kitchen in Durango get a brick on its wall of fame. *Author photo.*

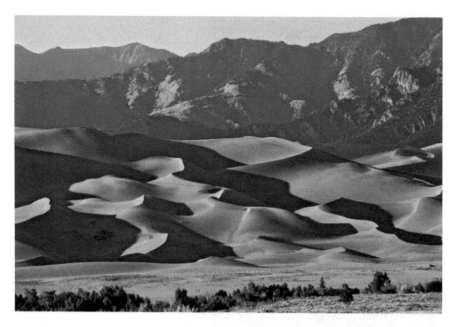

The tallest dunes in North America gather at the feet of the Sangre de Cristo Mountains in the Great Sand Dunes National Park and Preserve. *Courtesy of National Park Service.*

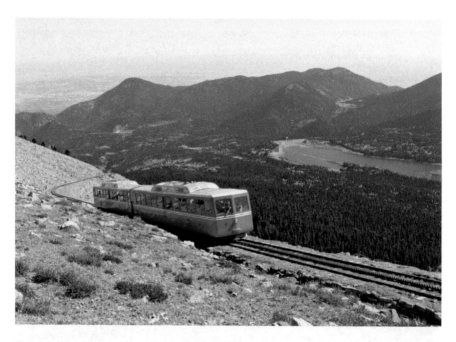

Cog railway cars move through four distinct life zones and pass lakes and campgrounds on their way to the top of Pikes Peak. *Courtesy of Pikes Peak Cog Railway.*

The formations of the Garden of the Gods are seen from the terrace of a restaurant at the park's visitor center in Colorado Springs. *Courtesy of Garden of the Gods.*

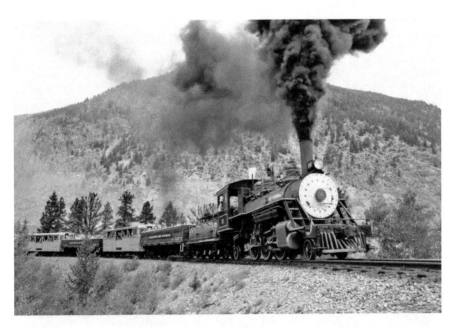

Train No. 12 carries passengers along the Georgetown Loop Railroad to the Lebanon Silver Mine. *Courtesy of History Colorado.*

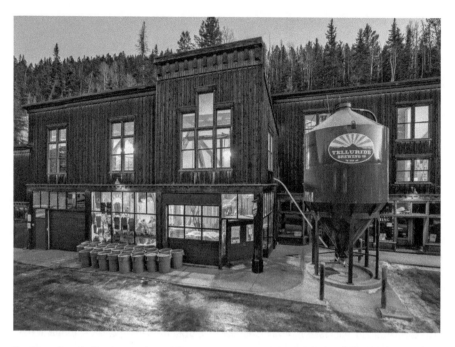

Buckets of grain lined up to be used in the beer-making process at Telluride Brewing. *Courtesy of Telluride Brewing.*

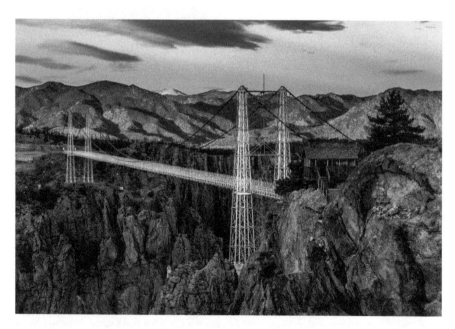

The suspension bridge crossing the Royal Gorge was largely unscarred by a 2013 fire that destroyed most of the rest of the buildings at the park. *Eve Nagode.*

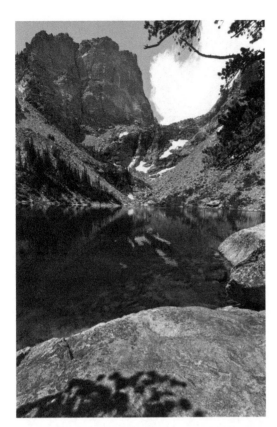

Left: Emerald Lake is the last of three bodies of water that greet visitors on arguably the most scenic hike in Rocky Mountain National Park. *Courtesy of Rocky Mountain National Park.*

Below: Trees line the miles of walkways stretching throughout Denver's 320-acre City Park. *Holly Batchelder.*

The two-level tasting room at Ska Brewing in Durango highlights the beer brewed by longtime friends who also draw a comic book series. *Courtesy of Ska Brewing.*

The Cathedral Park area along Gold Camp Road features a lake and one of many spectacular scenic views along the path. *Mark Byzewski.*

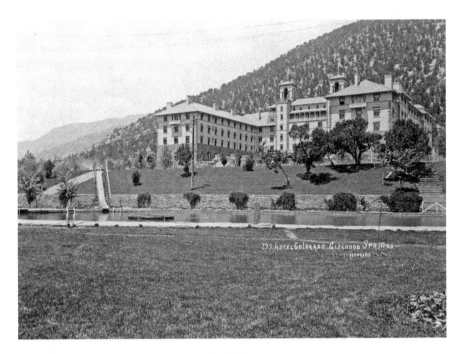

The Hotel Colorado in 1893. *Courtesy of Hotel Colorado.*

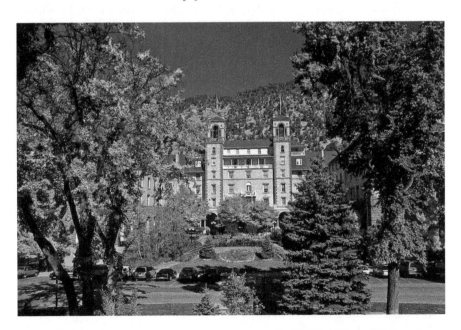

The second-floor balcony from which Teddy Roosevelt and William Howard Taft made speeches is partially obscured by trees at the Hotel Colorado. *Courtesy of Hotel Colorado.*

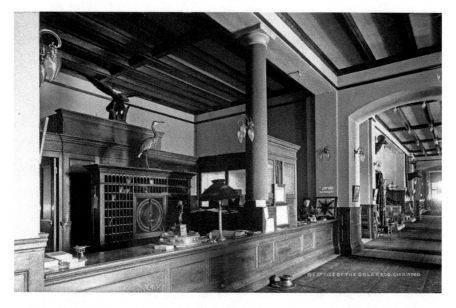

A historical photo shows the prominent role that stuffed and mounted animals played in the lobby of the Hotel Colorado. *Courtesy of Hotel Colorado.*

repeated several years later by his successor and one-time friend, William Howard Taft. The balcony has been rebuilt and covered in patriotic garb where it faces onto a courtyard. Meanwhile, the second-floor hallway serves as a sort of mini-museum of Roosevelt's life—an impressive homage especially considering how many other famous Americans, from physicians to mobsters (all pictured in a downstairs display), visited this historic lodge as well.

DRINKING SITE: GLENWOOD CANYON BREWING

402 Seventh Street, Glenwood Springs / 11:00 a.m. to 10:00 p.m. daily / www.glenwoodcanyonbrewpub.com

Stationed across the street from the 1904 railroad depot, the Hotel Denver sits at the heart of Glenwood Springs' downtown. But its grand restaurant space saw a succession of eateries come and go until owners Steve and April Carver got the idea in 1996 to open a brewpub.

Since then, Glenwood Canyon Brewing has specialized in English-style ales. It's found five in particular that are beloved by locals and tourists alike,

This page: Glenwood Canyon Brewing has been a staple of downtown Glenwood Springs life since 1996 and features a full pub menu to go with its eight beers on tap. *Courtesy of Glenwood Canyon Brewing.*

and it's kept those on tap for years—No Name Nut Brown Ale, St. James Irish Red Ale, Hanging Lake Honey Ale, Vapor Cave India Pale Ale and Grizzly Creek Raspberry Wheat. Three other house taps rotate seasonal and occasional selections, ranging from the Strawberry Daze amber ale that surfaces each summer during the town's strawberry festival to newer efforts like a Berliner Weisse.

The beers have captured more than a dozen Great American Beer Festival medals. For the first eighteen years of the brewpub, they came from local brewing legend Ken Jones. But when Jones decided to retire in 2014, he called up Colorado native Todd Malloy, who was working at nationally renowned Firestone Walker Brewing in California, and asked him to take his place.

"I love Colorado. I love the small brewing environment. I love the pub environment. There's nothing better," Malloy said. "When you're working at a big brewery, sometimes you lose sight of it."

Malloy has added edgier beers to the rotation, from sours to barrel-aged products, and he's even gotten some yeast out of the local Historic Fairy Caves with which he plans to experiment. But while newer comers like Glenwood's Casey Brewing & Blending and Roaring Fork Beer Company of Carbondale have attracted a few more beer tourists to the area, he realizes the brewpub first and foremost remains a haven for visitors of both elementary and advanced palates, and he wants to keep it as accessible as the town itself.

Natural Site: Glenwood Hot Springs

401 North River Street, Glenwood Springs / At least 9:00 a.m.
to 10:00 p.m. daily / www.hotspringspool.com

Within walking distance of both the Hotel Colorado and downtown Glenwood Springs sits the largest naturally heated mineral pool in the world. And while it is open throughout the day, there may be no better time to experience Glenwood Hot Springs than a summer night, especially after you've made the steep hike up to Linwood Cemetery.

Ute Indians were known to seek the medicinal qualities of the springs for centuries. Prospector Richard Sopris recorded his finding of the spring in 1860, and Walter Devereux commercialized it by opening the pool in 1888 and the sandstone bathhouse two years later. There now is a spa and a 107-room lodge as well on the property, which has remained continuously open to the public except for a stint from 1943 to '50 when it was a convalescent area for World War II naval veterans and then a private hospital.

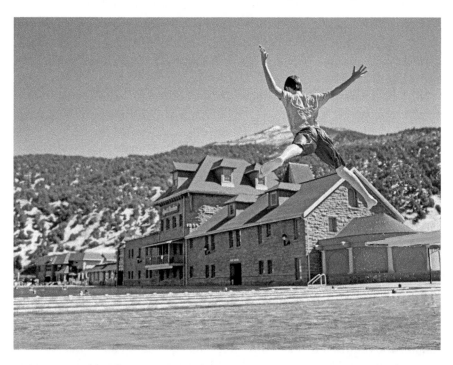

Glenwood Hot Springs features a diving board as well as plenty of room for lounging in the water. *Courtesy of Glenwood Hot Springs.*

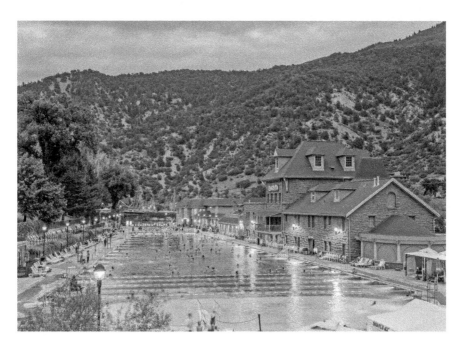

The main pool at Glenwood Hot Springs is more than four hundred feet long. *Courtesy of Glenwood Hot Springs.*

Water flows into the two pools on property from the nearby Yampah Spring and the Colorado River, heated by the presence of a geothermal gradient in the area. The main pool, more than four hundred feet long, reaches temperatures above ninety degrees, while a smaller, one-hundred-foot-long pool tops out at over one hundred degrees.

Families and visitors flock to the pool throughout the day, but its size ensures that you can grab space on the side and just watch the activity on the diving board or the slide without getting caught up in it. The pool rents both bathing suits and towels if you forget your own, and there are quarter-operated lockers to hold your belongings.

A discount exists for the final hour of the day, and there is an ethereal feel to being in the water while surrounded by mountains on two sides as the sun sets. Here, after all, is a place to which people have journeyed for centuries, and you become a part of that legacy as the light blue glow of the stars glimmers off the hillside.

TRIP #6
WESTERN SLOPE

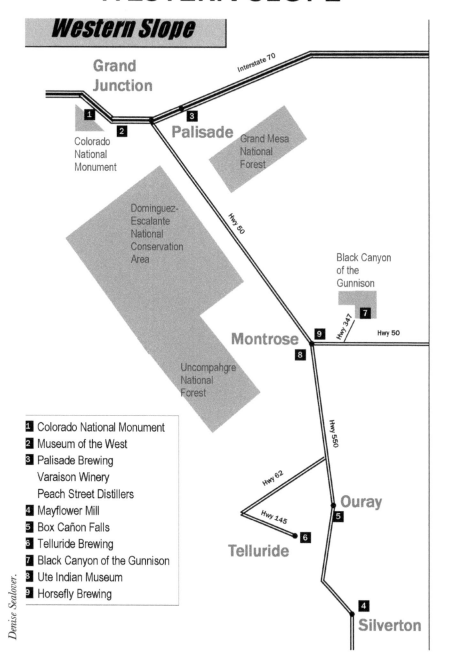

Western Slope

Grand Junction

Interstate 70

1
2
3 Palisade

Colorado National Monument

Grand Mesa National Forest

Dominguez-Escalante National Conservation Area

Hwy 50

Black Canyon of the Gunnison

7

Hwy 347

9 Hwy 50

Montrose
8

Uncompahgre National Forest

Hwy 550

Hwy 62

Ouray

Hwy 145

5

6

Telluride

4

Silverton

1 Colorado National Monument
2 Museum of the West
3 Palisade Brewing
 Varaison Winery
 Peach Street Distillers
4 Mayflower Mill
5 Box Cañon Falls
6 Telluride Brewing
7 Black Canyon of the Gunnison
8 Ute Indian Museum
9 Horsefly Brewing

Denise Sealover.

DAY 1
GRAND JUNCTION AREA

Natural Site: Colorado National Monument

1750 Rim Rock Drive, Fruita / Open around the clock/www.nps.gov/colm

Though Colorado National Monument sits just 140 miles west of Maroon Bells, stepping into it feels like an otherworldly experience.

This thirty-two-square-mile National Park Service area veers from the wildflower paths and scenic lake hikes of Colorado's central-mountain areas and deposits visitors instead into a red-and-brown landscape of sheer canyon walls, artfully sculpted rock formations and backcountry paths that wind along dried creek beds.

The rock formations of this dry landscape, part of the Colorado Plateau that includes the Grand Canyon, steal the show. From the visitor center near Fruita, several half-mile trails guide you to overlooks of sky-prodding Independence Monument or the domed Coke Ovens feature. Sculpted by wind and waters over thousands of years, these uniquely shaped landmarks have no twins in Colorado.

Rim Rock Drive winds for twenty-three miles through the park, stretching from the valley floor to the plateau rim and passing descriptively titled bumpouts like Cold Shivers Point. As it drops you at the east entrance near Grand Junction, stop at Devils Kitchen Trail for the best short hike in the area.

After a three-quarter-mile walk, the trail leads you up a path marked by cairns into a natural rock room surrounded by Wingate Sandstone cliffs, and

Above: Clouds settle in over the sandstone formations of Colorado National Monument. *Courtesy of Colorado National Monument Association.*

Left: A sign at the Fruita entrance of Colorado National Monument welcomes visitors to the park. *Daniel Schwen.*

Below: Independence Monument rises in Colorado National Monument with the town of Fruita in the background. *Daniel Schwen.*

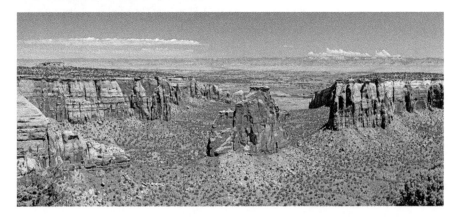

you find yourself in Devils Kitchen. Inside this oddly named amphitheater-like structure—it is neither oven-like nor particularly demonic—rocks rise steeply beside you and create one of the few homes in the park for green plants. Climb the rocks in the back of the kitchen to reach a narrow portal with a view of the plateau and city. It's a unique, sheltered setting.

Seven backcountry trails take you into and through a quartet of canyons, though the waterfalls and lakes they promise become mere trickles and puddles in the heat of summer. But just seeing the expanse of rock formations here informs you why park founder John Otto worked so hard to build paths through it and preserve the area for future generations.

HISTORIC SITE: MUSEUM OF THE WEST

462 Ute Avenue, Grand Junction / 9:00 a.m. to 5:00 p.m. Monday–
Saturday and noon to 4:00 p.m. Sunday, May through September; 10:00
a.m. to 4:00 p.m. Monday–Saturday, October through April /
www.museumofwesternco.com

From mysterious aboriginal ancestors to underground nuclear detonations, Colorado's Grand Valley area has a singular history. And Grand Junction's Museum of the West lays out what went into the settling of the part of the state often overlooked by people living in Denver and Colorado Springs.

The valley—bordered on the east by Grand Mesa, the world's largest flat-top mountain—received visits in early centuries from both Aztec and Spanish explorers. Before then, stretching back to 200 AD, it was home to the Fremont, a desert-dwelling, insect-eating group of Native Americans who produced rock art but moved away without leaving many clues as to who they were or why they disappeared.

White settlers began coming to the area around the 1870s and using it for agriculture. But it remained a largely open badlands, and the Thrailkill Collection of firearms in the museum displays that lineage in everything from sawed-off shotguns used by the bank-robbing Fleagle gang to the .32-caliber pistol carried by the wife of Nathan Meeker after he fell victim to a Native American massacre in 1879.

The modern history of the area revolves around energy, but in different forms than the rest of the state. After World War II, uranium mines populated the region, and a reproduction tunnel in the museum

shows how that metal is pulled from the earth. And in one of the most harebrained exploration schemes ever concocted, a nuclear bomb was triggered about a mile underground to try to release natural gas in the Rulison area fifty miles northeast of Grand Junction in 1969. That gas turned out to be too radioactive to use, and Colorado voters later passed a constitutional amendment banning the detonation of nuclear devices in the state.

The museum in downtown Grand Junction also includes a tower that visitors can climb to see the whole of the valley—and to understand the landscape that inspired such diverse history.

Drinking Site: Palisade's Everything Block

Palisade Brewing: 200 Peach Avenue / 11:00 a.m. to close daily / www.palisadebrewingcompany.com

Varaison Vineyards and Winery: 405 West First Street / 10:00 a.m. to 5:00 p.m. daily / www.varaisonvineyards.com

Peach Street Distillers: 144 South Kluge Avenue / Noon to 10:00 p.m. Monday—Thursday; noon to midnight Friday—Saturday; 10:00 a.m. to 10:00 p.m. Sunday / www.peachstreetdistillers.com

The town of Palisade is the heart of Colorado's wine region, home to twenty vineyards. And it is here that travelers can find the only one-block area in the state that is home to a brewery, a distillery and a winery (actually, two).

Palisade Brewing is the hopped oddball in a grape neighborhood. Since its reopening in 2010 under new ownership, it has grown significantly every year, offering flavors from its Dirty Hippie Dark American Wheat to its Soul Shakin' Imperial Red, which boasts one of the boldest tastes in the Grand Valley. Head brewer Danny Wilson has a barrel-aging program, but it relies on bourbon barrels from neighbor Peach Street as much as it does any wineries in the region. And he tries to keep ten of his beers on tap, including a few lighter options, for visitors who need a break from vineyard hopping.

Located at a popular corner in a town known for its winery tourism, Palisade Brewing offers a variety of beers and a large outdoor patio. *Courtesy of Palisade Brewing.*

Palisade Brewing's Dirty Hippie Dark American Wheat has a strong following on the Western Slope. *Courtesy of Palisade Brewing.*

"Every time I see a group of people come in, they're desperate for a change," Wilson said. "You see it in their eyes: 'I just want something refreshing.'"

Across the avenue is Peach Street, a distillery launched by the founders of Durango's Ska Brewing in 2005 after they saw the craft spirits trend growing and wanted to open their own in a region known for its peaches and other fruit. While it has always bottled a variety of spirits from grappa to brandy to vodka, Peach Street took off after co-founder Rory Donovan and other workers began mixing up drinks and sitting on the porch with them, attracting passersby who wanted to join in the fun. From there, the distillery opened its bar and began serving cocktails with their own twists. Be sure to see its pear brandy bottles, which are set up on trees in the spring to allow the fruit to grow right into the glass.

Next to the distillery is the tasting room for DeBeque Canyon Winery, which makes an award-winning Cab Franc. But for a truly unique experience, walk up the block to Varaison Vineyards, where a fifth-generation winemaker named Alex West offers complimentary ninety-minute tasting seminars to visitors and sells old-world wines that sometimes have waiting lists to buy.

Varaison caters to international tour groups, walking them through the secrets of enjoying its Crème Brulee Chardonnay, its Barbara and other specialty products. It also makes a dry cider finished on French oak and Saigon cinnamon, and the offerings typically run thirty-five dollars per bottle. Though most business is call-ahead, walk-ins get the same lavish treatment, as part of the winery's attempt to show just how much the valley has to offer.

"People pay for experiences. They don't pay for beverages," West said. And this block is an experience.

DAY 2
SILVERTON TO TELLURIDE

HISTORIC SITE: MAYFLOWER MILL

135 County Road 2, Silverton / 10:00 a.m. to 5:00 p.m. daily, Memorial Day weekend through Labor Day / www.sanjuancountyhistoricalsociety.org/ mayflower-mill.html

The town of Silverton blew up in the 1870s, after the U.S. government pushed the Utes off the surrounding land and pent-up prospectors rushed in to seek gold and silver. While other towns boomed, busted and disappeared, Silverton was home to precious-metal activities for 120 years—enough to keep it alive but never enough after World War I to provide the secluded town with sufficient economic activity to revitalize. Thus, according to local historian Beverly Rich in her *Walking Silverton*, the town has the highest concentration of pre–World War I architecture in the United States.

It's not just Victorian-era buildings that make this small downtown area a mandatory historic stroll, though. Buildings on the "Notorious Blair Street"—home to thirty-two bordellos, saloons and casinos—have been preserved or rebuilt. Brothels were so ingrained in the city's culture that the last lady of the evening left town in 1949, meaning the Nazis were vanquished before Silverton was prostitute free.

Silverton also has one of the most unique mining-era structures in the United States—the Mayflower Mill. While gold-mine tours are common,

Before its 1991 closure, the Mayflower Mill processed 9.8 million tons of mineral ore over its sixty-three-year existence. *Courtesy of San Juan County Historical Society.*

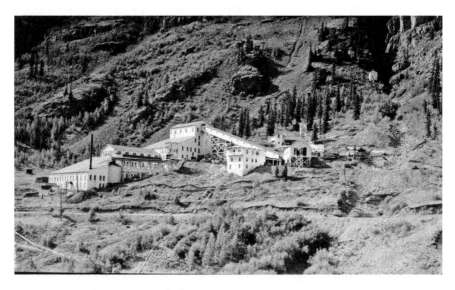

This historical photo of Mayflower Mill shows it at a time when it was a major contributor to the Silverton economy. *Courtesy of San Juan County Historical Society.*

gold processing–mill tours are rare, and many that exist have reproduction equipment. The Mayflower, however, shut down in 1991 after sixty-three years of operation, and owners locked the door and left equipment inside. Their loss is your gain.

The mill was the last built to handle the bounty coming out of nearby Arrastra Gulch. It processed 9.8 million tons of crude ore for gold, silver and base metals, reaching a height of 1,200 tons per day. It also was an environmental pioneer, creating some of the first ponds for the safe disposal of mine tailings, the mounds of which can be seen just west of the mill.

Visitors on self-guided tours can see the machines that were part of the process, from a bucket tram that delivered ore to the crusher plant that pulverized it to the flotation areas where precious metals rose to the top. A half dozen machines still work with the push of a button. Harrowing pictures show miners riding trams across the valley. And a bin still holds eight hundred tons of crushed ore, putting you briefly back into the boomtown era.

Silverton's 625 residents rely on tourism rather than natural resources these days. Yet the newly quaint charm leaves you torn between enjoying the peace and wanting to step back to a much rowdier time.

NATURAL SITE: BOX CAÑON FALLS

County Road 361, Ouray / 9:00 a.m. to 5:00 p.m. daily, May; 8:00 a.m. to 8:00 p.m. daily, Memorial Day through Labor Day; 8:00 a.m. to dusk, Labor Day through October / www.cityofouray.com/boxcanonfalls

Heading north out of Silverton, you come upon the state's greatest man-made scenic pathway—the "Million Dollar Highway," a twenty-three-mile road that climbs over Red Mountain Pass, offering panoramic views and death-defying hairpin curves. Some say the road cost $1 million when constructed from 1922 to '34, while others say it's paved with flecks of gold from surrounding mountains. The most likely origin of the moniker, however, comes from a story that a passenger in one of the first cars over the pass declared he wouldn't travel it again for a million dollars.

That highway deposits you in Ouray, a mining town turned into an ice-climbing mecca known as the "Switzerland of America" for its staggering overlooks. Its most incredible site gets you up close and personal with a rushing waterfall.

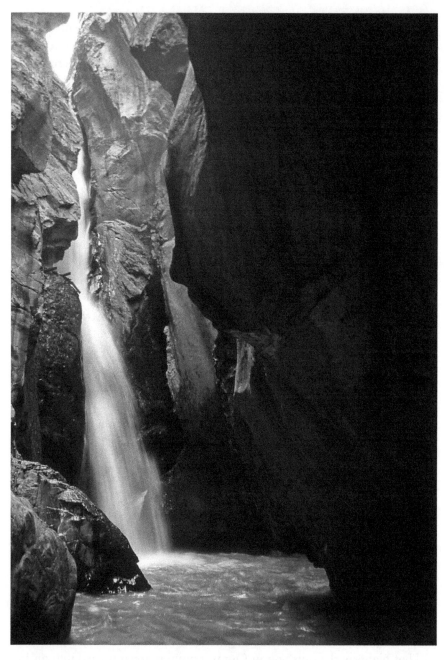

Box Cañon Falls sits just south of the town of Ouray. *Wes Jackson*.

Discovered in 1875, Box Cañon was a bust as a silver mine, leading its owner to lease it to the city as a park. A gently sloping trail now leads from the visitor center inside a quartzite canyon. In the half-light of the narrow crevasse, the sound of Canyon Creek amplifies as it barrels into a waiting pool at the rate of thousands of gallons of water per minute.

The experience is immersive. Canyon rocks hang so close to your head along the railed path that you duck, bob and weave along the way. Standing by the bullet-speed waters, you are enveloped in mist and spray. A damp stairwell drops you into a grotto where you can wade into the water. The force of the falls shakes the stairs.

Back at the top, you can climb a steeper quarter-mile trail to a bridge that formerly carried pipeline between two reservoirs. From this vantage point above the creek, the water seems to flow more gently and the canyon dives deeper. You can even see the remnants of a long-forgotten mining winch.

A low-hanging tunnel connects this vantage point to the Ouray Perimeter Trail, from which the entire town is accessible. But few things will be as memorable as staring eye to eye at the roaring falls.

Drinking Site: Telluride Brewing

156 Society Drive, Telluride / 3:00 to 7:00 p.m. Monday–Friday; noon to 7:00 p.m. Saturday / www.telluridebrewingco.com

Telluride is not a place you wind up by accident. From Ouray, you travel two state highways for an hour over high-altitude passes. And when you stop in this mountain-base village, you realize that the people who've come from around the country to settle here are aiming in many ways to escape the world.

"The first word that comes to me about Telluride is 'weird.' Weird in a good way," said Telluride Brewing co-owner and chief brewing officer Chris Fish, who settled in town in 2002 and launched this venture with longtime friend Tommy Thacher in 2011. And it is to that dynamic that he aims his classically styled beers that are kicked up with an extra dose of hops.

As removed as it is from the rest of Colorado, Telluride is also a destination. It hosts a nationally attended film festival each Labor Day weekend, a bevy of music festivals throughout the summer and a handful of Olympic-level skiers each winter who seek challenging slopes without the crowds. It is

Telluride Brewing's tasting bar is nestled in a back corner of its brewery. *Courtesy of Telluride Brewing.*

simultaneously an outdoor paradise and a high-dollar village filled with second homes of the wealthy.

Located about four miles west of downtown, Telluride Brewing has little concern with aesthetics; its tasting room is smack in the middle of the brewery, offering visitors the chance to interact with Fish and others as they are mashing in the grain. Its success is causing good problems, though: in its first four years of operation, it expanded three times and continues to grow.

The brewery burst onto the Colorado scene with Face Down Brown, a hopped-up English-style brown ale that captured a World Beer Cup medal when Fish submitted his first batch of the beer for the competition. It's now found in most top-tier beer bars in the state. But Fish likes to push the envelope too with big, grassy offerings like his Fishwater Project double IPA and Freaky Fish Belgian double IPA.

Pop in at the right time and you may hear him jamming to the Grateful Dead while brewing up Russell Kelly Pale Ale, named after a deceased friend who loved the band. Or you may spot him collaborating with musical acts like Greensky Bluegrass on their own creations. In Telluride—the city or the brewery—you never know what you may find.

"We're not on the way to anywhere. We're not off of any major highways," Fish said. "If you're in Telluride, you're here to be here."

148

DAY 3
MONTROSE AREA

NATURAL SITE: BLACK CANYON
OF THE GUNNISON NATIONAL PARK

Seven miles north on Highway 347 from U.S. 50 intersection in Montrose /
Visitor center 8:00 a.m. to 6:00 p.m. daily in high season /
www.nps.gov/blca

Though less visited than its grand cousin in Arizona, Black Canyon of the Gunnison can lay claim to having the greatest combination of depth, steepness and narrowness of any canyon in the United States. And one look from the drives or trails along its rim will explain why early explorers declared this chasm in the earth to be impenetrable.

Waters of the Gunnison River began to slice through these gneiss rocks shortly after the Gunnison Uplift some 65 million years ago. But it wasn't until 1901 that man seemingly conquered the canyon when two explorers ran the river on a rubber mattress in search of a diversion point for an irrigation tunnel. Since then—and especially since its 1933 addition to the National Park System—people have been coming to stare into its depths, which descend more than half a mile at some points.

The seven-mile South Rim Drive offers twelve overlook points ranging from roadside stops to four-hundred-yard hikes that tell the story of the immensity of the forty-eight-mile-long canyon. The view is best from Pulpit

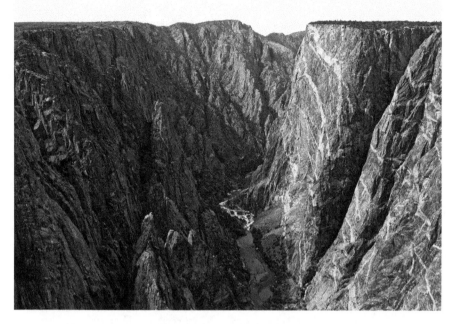

Gneiss walls of the Black Canyon of the Gunnison rise two thousand feet from the river below. *NPS/Lynch*.

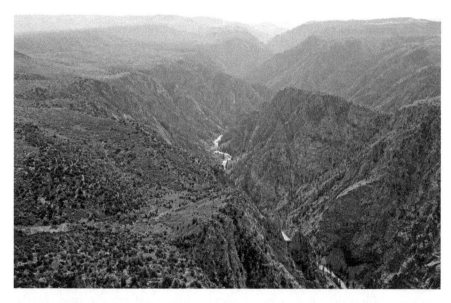

Twelve miles of the forty-eight-mile-long Black Canyon of the Gunnison are located within the national park. *NPS/Lynch*.

Rock, where you can lean daringly over the rocks to get a full picture of the wide and occasionally raging river.

Most trails in the park are along the South Rim, which gets less sun and has eroded at a faster rate than its northern counterpart. Hikes like the one-mile-round-trip Rim Rock Trail are simple but highly worthwhile jaunts, acting like the rim drive on steroids as they offer a chance to peep over the edge and glance dark shadows and deep chasms.

That's not to say that a descent into the canyon is impossible. Experienced climbers can try their hands at scaling some of the walls, and both kayakers and rafters can retrace that 1901 expedition, though a permit is necessary for inner-canyon activities. And for those who need more than one day to take this in, campgrounds sit on both rims. This offers a way to search for the hunter birds, such as the great horned owls and peregrine falcons, that scour the park and to spy the mule deer and elk that frequent its diverse natural areas especially in the fall.

Within the canyon, the Gunnison loses more elevation than the Mississippi River does during its entire southward journey across the United States. It's just one more distinction for an area that's one of North America's silent jaw-droppers.

Historic Site: Ute Indian Museum

17253 Chipeta Road, Montrose / 9:00 a.m. to 4:30 p.m. Monday–
Saturday and 11:00 a.m. to 4:30 p.m. Sunday in high season /
www.uteindianmuseum.org

The Ute people are the most historic in Colorado, having lived in the Rocky Mountain West for one thousand years before white explorers found their way here. They were fierce warriors who believed they were closely related to the bear—hence, their traditional Bear Dance—and when the Spanish introduced them to horses in the 1500s, that made them even more effective hunters and raiders.

Their dominance over the area that is western Colorado was challenged in the mid-nineteenth century, however, as prospectors poured in and clashed repeatedly with them. In 1860, Ouray became chief of the Ute and, with his wife, Chipeta, spent the rest of his life trying to bring peace. Their former homestead is now the site of a museum explaining the proud traditions of their people.

Reproduction tipis dot the lawn of the Ute Indian Museum. *Courtesy of History Colorado.*

Chief Ouray achieved major successes. An 1868 agreement granted the Utes 15.1 million acres in western Colorado—the largest territory ever given to Native Americans through a treaty. He spoke for his people in Washington, D.C., and earned respect from both whites and Native Americans. He is honored as one of the Utes' great leaders.

But in 1879, relations with Nathan Meeker, the regional Indian agent, deteriorated. A band of Utes, angry at tactics that sought to force them to give up their traditional hunting ways and settle into an agrarian lifestyle, attacked the agency in northwest Colorado and killed Meeker and ten of his workers—an event memorialized at the White River Museum in the town of Meeker. Ouray had just finished a journey to negotiate peace again one year later when he fell ill and died. The tribes were forced to leave the state, and only fifteen years later did they acquire the two reservations on which they now live in southwest Colorado and Utah.

Chipeta's grave rests on the grounds of the museum, which is scheduled to reopen following a renovation in summer 2016. Inside the facility operated by History Colorado, there are numerous exhibits on Ute culture, including the Bear Dance. Nineteenth-century artifacts ranging from jewelry and headdresses to a wickiup—a clothless forebear to the tipi—also are on display.

Colorado's history can't be told without understanding its oldest inhabitants. This museum presents that history with care and respect.

Drinking Site: Horsefly Brewing

846 East Main Street, Montrose / 11:00 a.m. to close daily / www.horseflybrewing.com

When Nigel Askew and Phil Freismuth poured the first beers out of their taps in the former tractor dealership that housed Horsefly Brewing in 2009, Montrose was a transitioning agricultural community and craft beer wasteland. Seven years later, it is home to several high-tech industries and is the burgeoning center of craft beer for Colorado's Western Slope.

Askew—a Zambian-born former hotel executive who settled in the small town after becoming a homebrewer—said he and his law enforcement officer partner Freismuth can't take direct credit for the wave of breweries in town. But Horsefly has become the center of Montrose's drinking community, a lively brewpub with a sprawling, hops-adorned patio decorated in what customers lovingly refer to as a "junkyard" style.

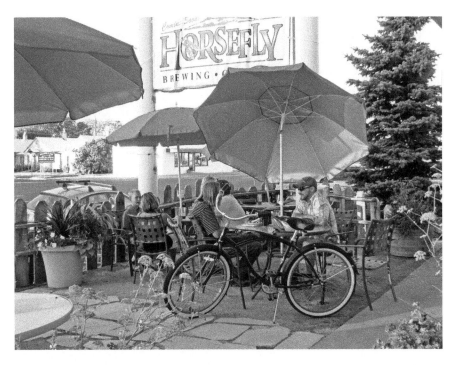

Patrons relax on the front patio of Horsefly Brewing, situated on one of the main roads running through downtown Montrose. *Courtesy of Horsefly Brewing.*

Though Askew calls himself a "Reinheitsgebot purist"—referring to the sixteenth-century German law limiting beer to four ingredients—Horsefly offers a wide variety of options on its eleven taps. They include Eurocentric creations such as a Highland Scottish or English-style old ale. And the brewery may bust out a raspberry ale or a seasonal sour.

The Montrose brewing community grew to include Two Rascals Brewing in 2012 and Colorado Boy Pizzeria & Brewery in 2013. And Horsefly has expanded as well, operating a location at Montrose Regional Airport (Airfly) and the Black Canyon Golf Course (Brew and Bogey Club). Plus, it has a mobile bar, known as "Tilly," that drives to festivals and offers up six taps of Horsefly goodness.

Despite the breadth of its locations, Horsefly doesn't bottle or can its beer. You have to show up, maybe take in some music and try its wings and Rocky Mountain oysters—both offered with ten dipping sauces. Enjoy the bar with patrons' initials carved into it at the "mother ship" or play on the checker board that is embedded in your table.

"You literally get the full range of ages here—little toddlers to old geezers," Askew noted.

Askew is planning to break off and start his own venture—Zulu Brewing—which would show off his African roots and may be located right across the street from Horsefly. It's all good. It'll just add to the growing fabric of this beer community.

TRIP #7
SOUTHWESTERN COLORADO

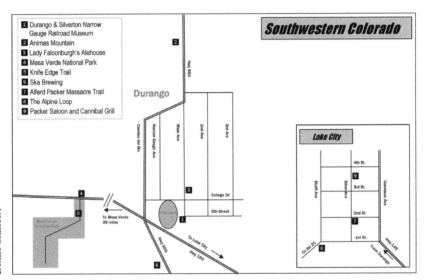

1 Durango & Silverton Narrow
 Gauge Railroad Museum
2 Animas Mountain
3 Lady Falconburgh's Alehouse
4 Mesa Verde National Park
5 Knife Edge Trail
6 Ska Brewing
7 Alferd Packer Massacre Trail
8 The Alpine Loop
9 Packer Saloon and Cannibal Grill

Southwestern Colorado

Durango

Lake City

Denise Sealover.

DAY 1
CENTRAL DURANGO

HISTORIC SITE: DURANGO & SILVERTON NARROW GAUGE
RAILROAD MUSEUM

479 Main Avenue, Durango / 7:00 a.m. to 7:00 p.m. daily in summer;
1:00 to 4:00 p.m. daily in winter / www.durangotrain.com

While the railroad was the nineteenth-century economic engine of many
Colorado towns, Durango has the distinction of actually being founded by
the Denver & Rio Grande Western Railroad, which reached the city in 1881.
And while this hub of southwestern Colorado is now more a tourist magnet
and outdoor enthusiasts' paradise, the rail yard that remains in the heart
of downtown tells the tale, both physically and symbolically, of Durango's
importance to the state.

General William Jackson Palmer, who had founded Colorado Springs
a decade earlier, wanted a hub closer to the booming mines of Silverton.
Durango became the smelter town for that region after the narrow-
gauge railroad began running to Silverton in 1882. Over the years, $300
million in gold and silver made their way south to Durango. By the
1960s, however, the mining era was ending and the railroad was ready to
abandon the tracks.

In 1981, a Florida businessman bought the line and began offering the
ninety-mile round-trip rail ride as a scenic journey between two historic
spots; cars still run daily. The next owners went one step further and opened

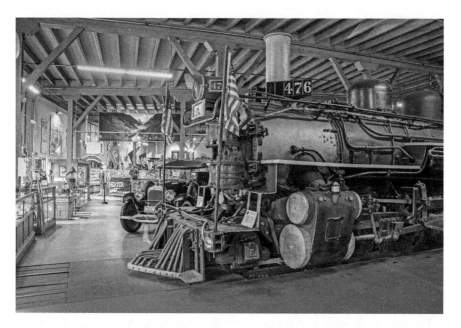

Engine 476, which ran between Durango and Alamosa as a passenger train, is on display in the Durango & Silverton Narrow Gauge Railroad Museum. *Yvonne Lashmett.*

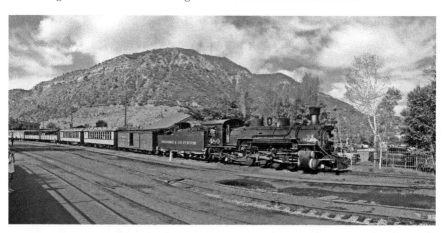

The Durango & Silverton Narrow Gauge Railroad runs daily between the towns from May through October. *Yvonne Lashmett.*

the museum in 1998 as a storehouse of artifacts commemorating both the rail line and the town, specifically its means of transportation.

The museum today is a mish-mash of sometimes unrelated items, bouncing visitors from collections of antique crystal electric lamps to 1920s

automobiles to a section honoring the military. But in its many treasures lie some essential to the prosperity of this part of the state.

Two railroad cars—one from 1886 and another from 1923—ran on the tracks and can be boarded. A baggage car employed in the movie *Butch Cassidy and the Sundance Kid*, which was shot in the area, represents the transition Durango made from an industrial economy to a visitor hub. And an immigrant sleeper car in which a man was stabbed and his fiancée committed suicide supposedly still is ridden by both; workers tell tales of school kids asking about a strange woman waving from the train, while employees have photographed a ghostly fellow on a makeshift musical stage in the museum.

Whether or not you ride the train, a stop here gives you a sense of Durango's reason for being—and its desire to remember the past.

NATURAL SITE: ANIMAS MOUNTAIN

One block north of Thirty-second Street and Fourth Avenue, Durango /
Open around the clock

While the railroad is essential to Durango, it is not all there is to the city. Fort Lewis College, a host of local businesses and recreational activities on the Animas River help to define its character as well. And the best place to take all of them in is from the top of Animas Mountain.

Few urban parks in Colorado offer you the vantage of the city as a whole. A 5.6-mile trail up to and around the top of the roughly 8,500-foot-high mountain rewards you with that, however. And even though it is only a few blocks off Main Avenue on the north side of town, Animas Mountain can be a lightly trafficked area that gives the impression that you are much farther from this bustling city than you actually are.

The trail begins uphill at a steady pace and picks up its incline as you go. By the time you reach your third switchback, you glimpse the full expanse of the downtown area, with the San Juan Mountains serving as a towering backdrop.

Such views come frequently because of the number of lookouts set up just beside the trail. Almost two miles into the hike, your vision turns from the dense downtown to the curves of the Animas River on the east side of the city, extending into a more open area. Though you can hear the buzz of the traffic on U.S. 550 below, there is a great peacefulness here.

The city of Durango extends southeast to the San Juan Mountains in this photo taken from Animas Mountain. *Author photo.*

The Animas River snakes east of Durango, as seen from Animas Mountain. *Courtesy of City of Durango.*

The trail curves inward and the incline slows, depositing you in a forest of trees and shrubs. On the far north side of the mountain, you emerge with a view of a gently rising plateau and a cliff of red clay. The Durango & Silverton Narrow Gauge Railroad ambles by on a track beside the now empty roadway.

While you now face the choice of whether to continue to the west side of the mountain, know that you've hit the apex of scenery already. The return path through the woods is a quiet, almost soothing experience. The same overlooks that allowed you to spy the fading of civilization on the way up can be fantastic portals to the setting sun on the way down. And you're likely to pass a bevy of evening visitors, some climbing only a short way with their dogs.

DRINKING SITE:
LADY FALCONBURGH'S ALEHOUSE AND KITCHEN

640 Main Avenue, Durango / 11:30 a.m. to 2:00 a.m. Monday–
Saturday; 11:30 a.m. to 11:00 p.m. Sunday

Durango is home to 17,500 residents, and just two airlines fly year-round into its airport. But it sports six breweries, including three with statewide distribution, earning it the unofficial title of best small beer town in the Centennial State.

At the heart of the craft culture is the place locals call Lady Falc's, an underground bar tucked into the downtown area that touts thirty-eight taps and skews local in its beer selection. Owner Miguel Ramos, the third operator of the establishment since it converted in 1995 from a grungy biker bar known more for its brawls than its brews, sees both locals and recurring visitors piling in, hoping to drink enough to earn their brick on the wall of fame.

Ramos actually had his first (un-carded) bar drink at Lady Falc's as a nineteen-year-old Fort Lewis student in 2005, and he was hooked. As his professional cycling career ended, he saw that it was for sale and decided to invest, wanting to focus on increasing its variety of beers.

Lady Falc's pours local brews from the likes of Ska Brewing and Durango Brewing, and its statewide and national craft selection leans heavily on known auteurs like Alaskan Brewing and Deschutes. But the bevy of taps hanging around the bar testifies to its ability to bring in rarer offerings such as Russian River Damnation.

Left: Taps of beers that have been poured there hang from the rafters at Lady Falconburgh's Alehouse and Kitchen. *Author photo.*

Below: The historical painting on the wall of Lady Falconburgh's Alehouse and Kitchen features likenesses of friends of the original owners. *Courtesy of Lady Falconburgh's Alehouse and Kitchen.*

While this is a craft beer bar, it's not for snobs. Locals stroll down its steps into the a.m. hours, ordering shots to go with their wings or bacon-wrapped meatloaf. A mural on the wall, painted by former owners, features a number of the early regulars celebrating in historic beer-hall scenes.

One of the best-known trademarks of Lady Falc's is its promise that anyone who can log one hundred drinks on a punch card can get their name

and any artwork they'd like to accompany it on a wall of painted bricks. Some regulars have a half dozen bricks, while some out-of-towners bring back their card and build it up every time they visit.

There's just one thing that Ramos can't do for regulars: tell them who Lady Falconburgh actually is.

"That is a great question," he shrugged. "I just like to think of her as this mysterious lady who loves to drink beer."

DAY 2
CORTEZ/DURANGO AREA

HISTORIC SITE: MESA VERDE NATIONAL PARK

Thirty-six miles west of Durango on U.S. 160 / Open around the clock / www.nps.gov/meve

Spread across eighty-one miles on mesas and within the alcoves of cliffs are dwellings that prove a civilization known as the Ancestral Puebloans had a stunning command of both agriculture and architecture as it made this sometimes harsh ground its home from about 550 to 1300. But what has drawn visitors to this spot ever since ranchers stumbled onto the Mesa Verde structures in 1888 are two questions that have no definitive answers: Why did they move from the mesa tops into the shelter of the cliffs? And why did they abandon the area less than one hundred years later?

This national park—the first in the country designated to preserve the work of man rather than nature—is home to more than 4,500 archaeological sites that chronicle the evolution of Native American civilization in the Southwest. Some are open to foot traffic, and others are accessible just by guided tour. But the immensity of the park—including multiple museums, hiking trails and a campground—almost demands that you rope off the time from dusk until dawn to scramble around and contemplate who has walked this ground before you.

When the nomadic people of the area first settled here, they did so in pit houses dug several feet into the ground and covered by a

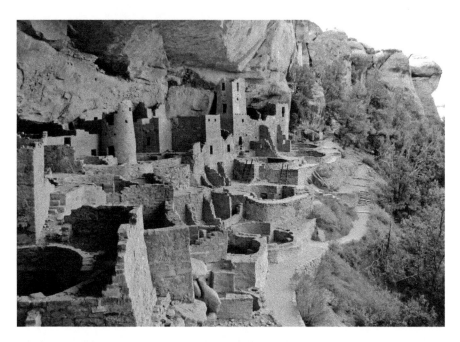

Above: Spruce Tree House, with its dwellings and kivas, is one of the most visited spots at Mesa Verde National Park. *Courtesy of Mesa Verde National Park.*

Below: Ladders descend into ceremonial kivas at Spruce Tree House in Mesa Verde National Park. *Author photo.*

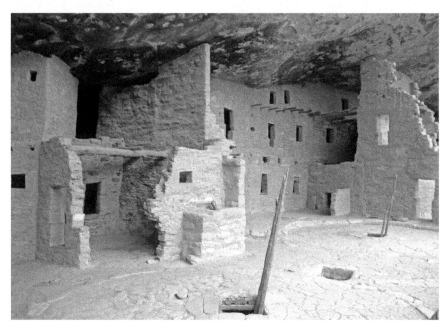

timber-supported earthen roof. As they farmed corn and squash and domesticated turkeys and dogs, they moved over the years to small stone dwellings and then to above-ground pueblos. Finally, around 1190, they migrated into complex, multi-family sandstone dwellings tucked within the cliffs and accessible by small hand-holds and steps carved into the walls. While it's long been assumed that they took to the more sheltered areas for protection from enemies, no evidence has been uncovered of enemy excursions into the region.

Spruce Tree House—the third-largest and best-preserved area of cliff dwellings—offers hints of what life was like, as the Puebloans left no written records. Families appeared to occupy several rooms, while a giant courtyard served as a communal area. Ladders continue to lead down to kivas that seemed to be ceremonial rooms. And archaeological excavations have uncovered an area of refuse in the back offering clues to what they ate and what pottery they used.

While these communities appear to have taken the better part of the 1200s to be constructed, they were vacant by 1300, as their residents headed south to meet up with other Native American tribes. Tree rings indicate the last twenty-five years of this century were a time of major drought. But researchers have wondered whether internal strife among the people also contributed to the mass exodus.

Today, Mesa Verde stands as arguably the best-preserved ancient dwelling area in the country. Chapin Mesa Archeological Museum gives extensive details about these ancients. Guided tours of Cliff Palace and Balcony House are revealing excursions for those who don't mind climbing a few ladders. And roads built throughout the park by the Civilian Conservation Corps offer views of just about every structure. It then will be up to you to decipher what it all means.

NATURAL SITE: KNIFE EDGE TRAIL

Morefield Campground area of Mesa Verde / Open around the clock / www.nps.gov/meve/planyourvisit/hiking.htm

A day of exploring cliff dwellings can be both physically and intellectually exhausting. In order to shift gears, Mesa Verde offers nine hiking trails, ranging from just over 2,600 feet to nearly eight miles in length. For those wanting something that's easy on the legs but requires some use of the mind,

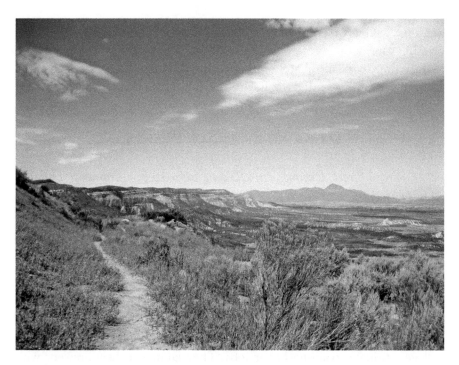

Knife Edge Trail offers spectacular views of the Montezuma Valley as well as Sleeping Ute Mountain in the distance. *Author photo.*

the Knife Edge Trail along the north rim of the park is a worthwhile two-mile round trip.

Constructed in 1914 as the original automotive road into the park, this route proved too narrow and too close to a steep cliff, and it was abandoned in 1957. As a hiking area, however, it combines eye-popping views of the surrounding Montezuma Valley with a lesson on the plants that the Ancestral Puebloans used to survive and thrive in this region.

A trail guide available at the visitor center explains thirty-two numbered stops along the flat trail that denote the flora that have grown here for thousands of years. You can learn how the cliff dwellers used these plants for spice (wild tarragon), dye (rabbitbrush), medicine (black sagebrush) or even building materials (stems of the serviceberry).

Knife Edge isn't just a botany classroom, however. It is eye candy too. The trail leads you beside the towering, jagged cliffs of Point Lookout, and its end point allows you to peer out to the mountain formation known as Sleeping Ute Mountain (which looks like a resting chief with a very large belly). And with most of the thousands of visitors focused elsewhere in the park, it is

peaceful, with its quiet broken only by an occasional bunny or garden snake crossing your path.

Take time to see all of Mesa Verde's ruins. But take time too to take in the mesa in the same way that the Puebloans did so long ago.

DRINKING SITE: SKA BREWING

225 Girard Street, Durango / 9:00 a.m. to 8:00 p.m. Monday–Friday;
11:00 a.m. to 7:00 p.m. Saturday; noon to 6:00 p.m. Sunday /
www.skabrewing.com

Gotham has the Joker. Asgard has Loki. And the town of Durango has its own archenemy: the Rotgutzen Intergalactic brewery. But Ska Brewing, much like Batman and Thor, is the hero of this story—and, in many ways, the town's drinking culture.

In 1995, Ska founders Dave Thibodeau and Bill Graham were recent college graduates wanting better jobs. They launched their brewery with a goal to make what they liked to drink, always while jamming out to ska music. And they told its story with comic-book characters they created when they were still in school. Twenty years into their adventure, the free-wheeling friends and co-owner Matt Vincent still decorate their labels and Ska paraphernalia with hero Lana the True Blonde and villain Pinstripe, the CEO of Rotgutzen. But now they do so as one of the largest private employers in Durango and a business whose products are sold in eight other states, Sweden and Great Britain.

Ska's is a success story driven by the personalities of both its operators and its beer. Located about three miles east of downtown, the brewery features some twenty of its own creations on tap, ranging from its original True Blonde Ale and Pinstripe Red Ale to its newest experiments with fruit and spices. Modus Hoperandi IPA may be its best-seller, but you can also get it aged on orange peels. And if you'd prefer your stout beers made with peppermint, grapes or mole, it's got that too.

Meanwhile, the guys are some of the leaders of the Bootleggers Society, which teams with Durango's other five breweries—including community mainstays like Steamworks Brewing and Carver Brewing—to make collaboration beers for charitable events. And as it continues to grow, Ska has expanded overseas, winning a competition to have Modus sold in Sweden.

Above, left: A sign hangs at the entrance to the property of Ska Brewing, which has grown from humble beginnings to become an internationally distributed beer maker. *Courtesy of Ska Brewing.*

Above, right: Ska Brewing owners Bill Graham, Dave Thibodeau and Matt Vincent strike a serious pose in their Durango brewery. *Courtesy of Ska Brewing.*

Right: Ska Brewing's Modus Hoperandi has become one of the most popular IPAs in Colorado. *Courtesy of Ska Brewing.*

Below: Ska Brewing's facility features an outdoor area popular with families. *Courtesy of Ska Brewing.*

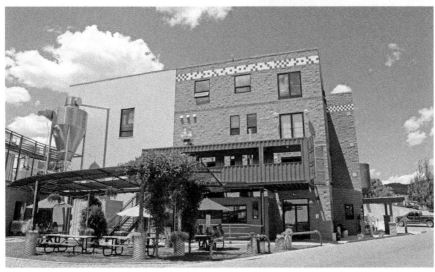

That's led to collaborations with Swedish beer makers and participation in the Stockholm Beer and Whisky Festival.

Thibodeau acknowledges that his first business plan was written on the back of a napkin. And he's cognizant how far the support from Durango has taken Ska since then.

"It's been a lot of fun," he said. "Sweden? We didn't foresee that when we were writing on the napkin."

DAY 3
LAKE CITY

HISTORIC SITE: ALFERD PACKER MASSACRE TRAIL

*Hinsdale County Museum: 130 North Silver Street, Lake City /
10:00 a.m. to 5:00 p.m. Monday–Saturday; 1:00 to 4:00 p.m. Sunday
from Memorial Day to Labor Day / www.lakecitymuseum.com*

On February 9, 1874, a six-man prospecting party led by a guide named
Alferd Packer left the Delta area in northwest Colorado. On April 16 of
that year, Packer arrived alone at the Los Pinos Indian Agency just north
of Saguache. Exactly what happened during the sixty-five days in between
remains unknown, though historical markers have no trouble denoting it as
"one of the most notorious events in Colorado history."

In two confessions given nine years apart, Packer told different stories but
acknowledged one thing: He'd eaten his cohorts' flesh to stay alive. Reviled
at the time, he grew to be seen as a wrongfully convicted man by the turn of
the twentieth century. Today he is known as America's favorite cannibal, and
a dining hall at the University of Colorado is named in his honor.

Packer left with those five men against the advice of others. When he
arrived in Saguache, he was flush with cash and in good physical shape.
In a confession elicited in May 1874, he claimed that the men got lost in
the mountains, and as they died one by one of starvation, he and fellow
traveler Shannon Bell ate them—until Bell attacked Packer and he killed

him to defend himself. But when searchers found the bodies, they discovered hatchet wounds on each. And as this was happening, Packer escaped from jail.

Caught nine years later in Wyoming, Packer gave a second confession—that he'd come back to camp one day to find Bell had gone mad and killed everyone. He shot Bell to defend himself and then survived off everyone's flesh. The jury didn't buy it. He was sentenced to hang in 1883, though the case was overturned on a technicality. Tried again in 1886, he received forty years for five counts of manslaughter.

As the century waned, leading figures at the *Denver Post* pushed for a retrial. In 1901, Governor Charles Thomas paroled him. Packer died in 1907. But his legend has outlived him.

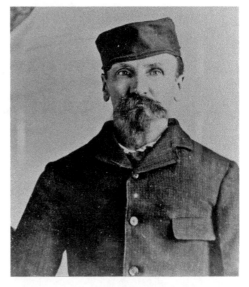

Top: This historical photo shows Alferd Packer as he looked while confined in the Colorado State Penitentiary. *Courtesy of Hinsdale County Museum.*

Middle: The shackles that held Alferd Packer in the Lake City jail are on display at the Hinsdale County Museum. *Author photo.*

Right: A marker guides visitors just outside of Lake City to the gravesite of the five victims of Alferd Packer's cannibalism. *Author photo.*

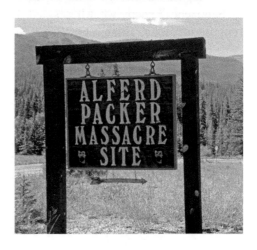

The Packer story remains a compelling one, played out at a memorial site, museum and courthouse in the only city within Hinsdale County, the most remote county in the lower forty-eight states.

The first stop on this trail is a lonely plain marked by a roadside sign above Lake City, which holds the grave of his victims with five white crosses in a fenced-off area. Staring at the mountains that envelop what is now known as Cannibal Plateau, one can almost sense the desperation the party must have felt as it ran out of food in the cold, harsh conditions.

Next is Hinsdale County Museum, open only during the summer, which retells the cannibal's story, illustrating it with a cast of the skull fragment of one victim. Surrounding it are the shackles that held Packer in the Lake City jail, an invitation to his hanging and a dollhouse he made while in the state pen.

The last stop is the Hinsdale County Courthouse—the oldest courthouse in Colorado, which displays Judge Melville B. Gerry's eloquent sentence. Gerry is frequently misquoted as ranting, Yosemite Sam–style, at Packer about how there were only seven Democrats in the county and he ate five. But that misrepresentation came from a barkeeper's retelling of the story at his saloon, according to Robert Fenwick's *Alferd Packer: The True Story of the Man-Eater*.

You may come away from the trail feeling that Packer was a serial killer or that he was innocent. But you will understand why Coloradans still debate him today.

NATURAL SITE: THE ALPINE LOOP

Begins at the intersection of First Street and County Road 20, Lake City /
www.lakecity.com

The geography around Lake City is one of brutal beauty—jagged fourteeners jutting into the sky amid repeated mountain passes. The best way to experience it is to rent a jeep or ATV from any one of several local businesses and set out on the Alpine Loop, a rugged four-wheel-drive road connecting the former mining town to Silverton.

Traveling counterclockwise on the road, you pass two remnants of the industry that once drove 1,100 people to live in this remote town. First is Hard Tack Mine, a former transport tunnel for silver ore that now gives tours. Several miles farther up the road is the ruins of the Ute-Ulay Mine, the

Henson Creek runs beside the Alpine Loop road as it cuts between a pair of wilderness areas near Lake City. *Author photo.*

Lake San Cristobal, the second-largest natural lake in Colorado, sits along the Alpine Loop. *Author photo.*

What remains of the Ute-Ulay Mine, the former economic engine of Lake City, is visible from the Alpine Loop. *Author photo.*

first and largest strike in this area that produced $12 million worth of silver from 1874 to 1903. It got its power from a hydroelectric dam on Henson Creek that collapsed in 1973, leaving only tattered remains here.

A four-mile four-wheel-drive road just past the mine takes you to the two-tiered Nellie Creek Falls, tucked behind a grove of trees. About nine miles down the road from its starting point, you can catch a glimpse of the more impressive Whitmore Falls, where stairs bring you down into a cavern where Henson Creek drops quickly from a crevice in the surrounding rocks.

Ghost towns like Capitol City and Sherman mark the loop, which turns back toward Lake City before reaching Silverton. And just before reaching Lake City, you pass by Lake San Cristobal, the second-largest natural lake in Colorado and a popular spot for fishing.

But the beauty of this path is the almost eerie remoteness of being surrounded by high peaks on the north and a steep drop-off to Henson Creek on the south. You're left with no doubts as to how even an experienced wilderness guide like Packer could have gotten lost here.

DRINKING SITE: PACKER SALOON AND CANNIBAL GRILL

310 North Silver Street, Lake City / 11:00 a.m. to 9:00 p.m. daily

Like many mining towns, Lake City's economy fell apart following the 1893 silver bust. Then, fire took down a large number of saloons and other structures in 1915. By the 1970s, its population had dipped to about ninety.

But the remote town in the San Juan Mountains has grown to about four hundred residents these days—many of whom live in houses marked with extensively detailed historic plaques on their front lawns—and it's experiencing a revival thanks to summer tourism. As such, there are multiple options for food and drink, but maybe none that capture the vibe of this laid-back getaway so much as the Packer Saloon and Cannibal Grill.

Opened in 2004, the eye-catchingly named hangout was meant to be a double entendre. The original owners were Green Bay Packers fans.

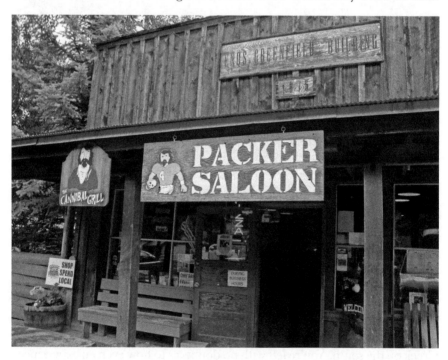

Alferd Packer wears the jersey of quarterback Brett Favre of the Green Bay Packers on the sign outside the Packer Saloon and Cannibal Grill. *Author photo.*

Cannibal wings—pork shanks with barbecue sauce for dipping—are among the menu items at the Packer Saloon and Cannibal Grill. *Author photo.*

But they also wanted to play off the town's most famous (imprisoned) resident, as can be seen in the door sign of the cannibal wearing a No. 4 Brett Favre jersey.

The menu is appropriately meat-heavy, from the cannibal wings (pork shanks with barbecue sauce) to buffalo chipotle brats. Memorabilia of both famous Packers and the famous man-eater adorn the walls.

What surprises most is the beer and spirits menu for a place in Colorado's most out-of-the-way county. Colorado craft brews from Oskar Blues, New Belgium and Odell Brewing are served on tap or bottle. The whiskey list runs twenty-five deep and is accompanied by a dozen tequilas and vodkas.

Grab a beer and a cannibal salad. You can be confident of the ingredients in both.

TRIP #8
SAN LUIS AND UPPER
ARKANSAS VALLEYS

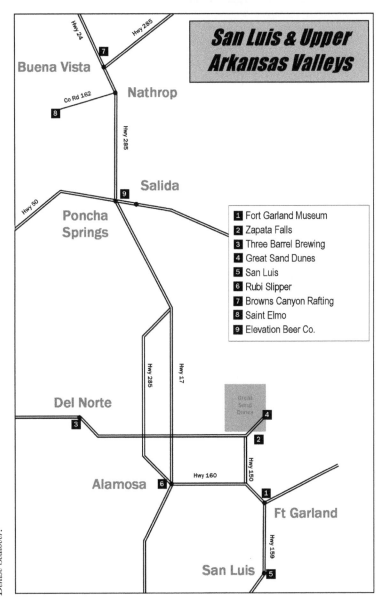

San Luis & Upper Arkansas Valleys

Hwy 24

Hwy 285

7

Buena Vista

Co Rd 162

Nathrop

8

Hwy 285

Salida

9

Hwy 50

Poncha
Springs

1 Fort Garland Museum
2 Zapata Falls
3 Three Barrel Brewing
4 Great Sand Dunes
5 San Luis
6 Rubi Slipper
7 Browns Canyon Rafting
8 Saint Elmo
9 Elevation Beer Co.

Hwy 285

Hwy 17

Del Norte

Great
Sand
Dunes

3

4

2

Hwy 150

Alamosa 6

Hwy 160

1

Ft Garland

Hwy 159

San Luis 5

DAY 1
SAN LUIS VALLEY, PART ONE

HISTORIC SITE: FORT GARLAND MUSEUM

29477 Highway 159, Fort Garland / 9:00 a.m. to 5:00 p.m. daily,
April through October; 10:00 a.m. to 4:00 p.m. Wednesday–Saturday,
November through December / www.historycolorado.org/museums

Situated in the sparsely populated San Luis Valley, Fort Garland may have seemed an odd location for U.S. Army resources when it opened in 1858. But over the twenty-five years it operated, the garrison, now preserved as a historical museum, played a central role in two important military movements of the nineteenth century—and as the final post for one of the most notable characters of the time.

Just three years after its opening, the fort became an enlistment station for the Second Colorado Volunteers, who played a key part in the westernmost confrontation of the Civil War. In March 1862, they joined volunteers marching from Denver and defeated a Confederate force at Glorieta Pass, New Mexico, that had intended to seize gold from Colorado's recently discovered mines and help to fund rebel efforts. The battle and the soldiers are detailed in an exhibit at the museum.

After the war, Fort Garland came under the command of Kit Carson, a mountain guide, Indian agent and soldier whose life was recounted in dime novels and newspaper accounts of the time. Carson—who fought

The entrance to Fort Garland Museum, which served as a U.S. Army post from 1858 to 1883. *Author photo.*

Native Americans but also treated them with respect and had an Indian wife—hosted General William T. Sherman in 1866 as he negotiated with Ute leaders. After leaving the post in the summer of 1867, Carson died just a year later. His story is told in detail in the former commandant's quarters.

Finally, Fort Garland housed the Buffalo Soldiers—black enlistees who fought Indians throughout the West—from 1876 to '79. While in the valley, they spent much of their time removing white settlers from lands given to Native Americans in treaties, though they also fought in a key battle of the Plains Indian Wars in northwest Colorado. The history of the Ninth Cavalry is told in the former tailor's shop.

The museum also details the spartan life at the garrison, where soldiers shared one coat on guard duty and slept two to a bed, head to feet. Historical reenactments are frequent. And five of the original twenty-two buildings at the post remain, allowing a modern look into a fort that served as the military crossroads as the Rocky Mountain area it protected was being settled.

Fort Garland is shown in this historical photo from 1874. *U.S. National Archives and Records Administration.*

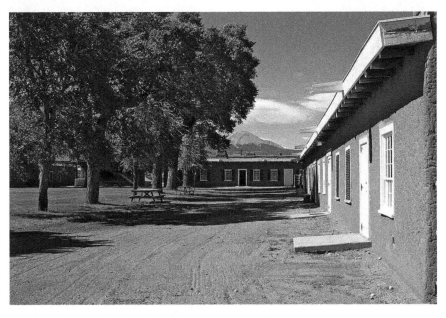

Five original buildings remain standing at Fort Garland Museum. *Courtesy of History Colorado.*

Natural Site: Zapata Falls

Three miles up BLM Road 5415 from Highway 150, Mosca /
Open around the clock

To get to Zapata Falls, you must drive eleven miles up Highway 150 toward Great Sand Dunes National Park, turn onto a Bureau of Land Management road for three miles and then hike half a mile along a sometimes-rigorous path. But few destinations are as worth the trouble of going so far out of the way.

The rocky trail, which begins at a twenty-three-site campground overlooking the dunes, climbs four hundred feet into a forested and smooth rock–laden nook of the Sangre de Cristo Wilderness. It leads down to South Zapata Creek as the creek meanders out of a grotto and into a basin area where children splash in the water.

Stroll up the creek, climbing treacherously over a few wet rocks as you hold on to cliff walls, and you land smack in the middle of a cave. To get

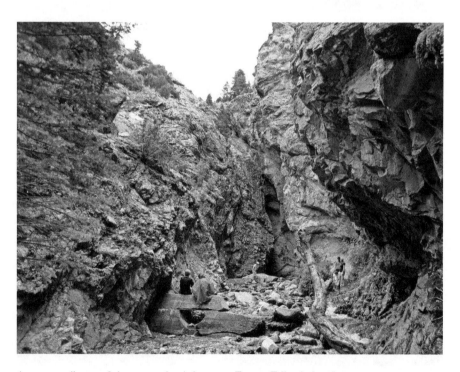

A stream rolls out of the grotto that is home to Zapata Falls. *Author photo.*

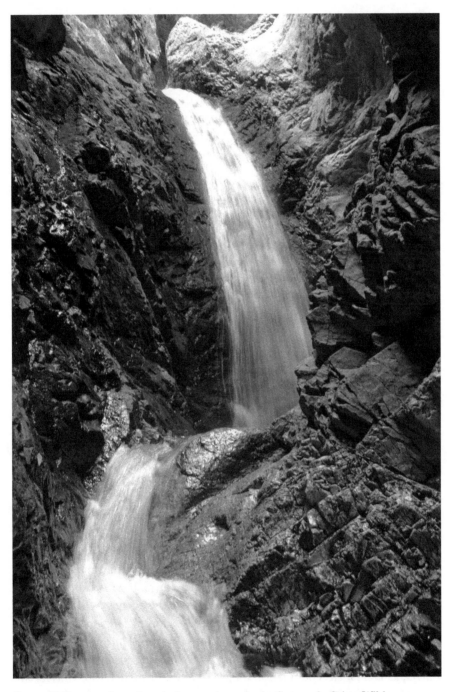

Zapata Falls pours through a glacier-cut chasm in the Sangre de Cristo Wilderness.
Chris Hanson.

there, you must cross through the stream and soak your feet; embracing this is part of the experience.

The true laugh-at-where-you-are-in-amazement moment comes when you teeter over a few more rocks inside the crevasse and find yourself no more than fifteen feet away from a thirty-foot waterfall streaming through the glacier-cut chasm. The roar is yell-at-the-person-next-to-you deafening, and you must cling to the sides of the grotto to navigate the best view. Some people stare in amazement, while others climb up the cave walls and into the falls, ascending to a rock ledge one-third of the way up the formation.

Many people come in to snap a photo and leave. A better experience, however, is staying here for a while and soaking it in, possibly even as you dance in the pool at the bottom of the falls. Watch the people around you as they enjoy this and look up every once in a while in realization of what you've found, like you've discovered a secret world far removed from the forest. The towering rock formations are beautifully rough, and the water is quite calming once it's deposited itself in the pool. There's really nothing else like it.

Drinking Site: Three Barrel Brewing

475 Grand Avenue, Del Norte / 10:00 a.m. to 9:00 p.m. Monday–
Saturday; 3:00 to 9:00 p.m. Sunday / www.threebarrelbrew.com

When people drop in to Three Barrel Brewing, owner John Bricker asks if they'd like a pizza with their beer. It's a far cry from the brewery's early days, when he'd inquire whether they wanted to renew their home insurance policy while they were drinking in his office.

In a town that has more buffalo herds (two) than stoplights (one), you do some unusual things to grow a brewery. For Bricker, that meant making beer in a space in back of his insurance office for eight years after opening in 2005. He eventually put in a bar next door to the agency before going for broke and establishing a sixty-two-seat pizza restaurant in November 2014.

Travelers heading west from Alamosa or east from Durango and Pagosa Springs along Highway 160 make up most of the customers for Three Barrel, as Del Norte's population totals out at fewer than 1,700. And its two best sellers—Trashy Blonde and Hop Trash IPA—are the kinds of relatable ales that motorists of all sorts can enjoy over lunch or dinner.

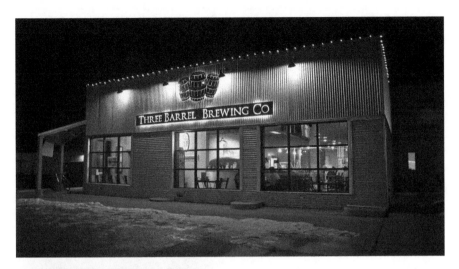

Top: Three Barrel Brewing is lit up at night to attract visitors passing through Del Norte along its main highway. *Courtesy of Three Barrel Brewing.*

Above: Oven-fired pizzas are the main menu item served at Three Barrel Brewing with beers like its Trashy Blonde. *Courtesy of Three Barrel Brewing.*

But the success of Three Barrel—which has outgrown its originally appropriate name and now brews on a fifteen-barrel system—is linked more to the sour offerings Bricker dreams up, ranging from classically Brettanomyces-fermented tart beers to experiments that use the likes of Asian pepper or beet sugar. These are sought after in liquor stores and beer bars across the state. And they have ensured that what once was a pseudo-secret brewery has become more well known than its hometown.

Bricker is a herald for the San Luis Valley, however—a humble man who embraces and seeks to promote his home area as the reputation of Three Barrel grows. Barley that is grown and malted nearby is a key ingredient, and the brewery's labels, heavy with images of early area settlers, are done by a local artist. And the question-evoking names of the beers often relate back to local stories, from

Dilley Incident (an adventure of a local buffalo-rearing family) to Bad Phil (a neighbor's surly rooster).

Del Norte may be a spell away from pretty much everywhere—it's thirty miles northwest of Alamosa—but living and brewing there offers an advantageous lifestyle that compelled Bricker's daughter and son-in-law to leave Denver jobs to help him run the business.

"We want to grow about to the point where it's starting to not be fun as much as it is work, and then we want to plateau," said Will Kreutzer, that son-in-law. "We're just having fun."

DAY 2
SAN LUIS VALLEY, PART TWO

NATURAL SITE: GREAT SAND DUNES
NATIONAL PARK AND PRESERVE

*11999 Highway 150, Mosca / Visitor center open 8:30 a.m. to 6:00 p.m.
daily in summer and 9:00 a.m. to 4:30 p.m. daily otherwise /
www.nps.gov/grsa*

The San Luis Valley that sprawls across south-central Colorado is the
highest and driest high-altitude valley in the United States, giving it a feel
far different from much of Colorado. Nothing jumps out to the visitor as
much, however, as the sight of 750-foot-tall sand dunes dropped seemingly
from a different continent at the foot of the Sangre de Cristo Mountains
northeast of Alamosa.

These dunes—the tallest in North America—are land that has eroded
from the San Juan Mountains some sixty-five miles to the west and been
carried by wind and water into the valley. The granules settle at the foot
of the Sangre de Cristos, refreshed annually by sand grains carried down
in glacial streams from those nearby mountains and blown back onto the
impressive mounds.

The best way to be immersed in this landscape is a hike to the top
of High Dune—the most popular, though not the tallest, dune in the
park. The trek represents arguably the toughest one mile of walking in

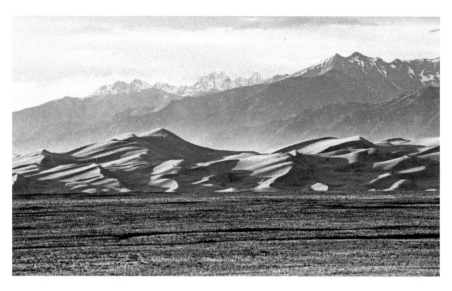

Great Sand Dunes National Park and Crestone Peak stare over the San Luis Valley. *National Park Service photo.*

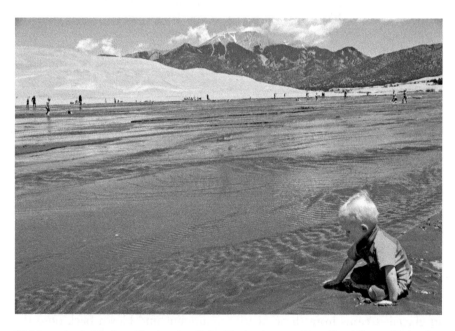

Children play in Medano Creek as it rolls beside the dunes at Great Sand Dunes National Park. *Courtesy of National Park Service.*

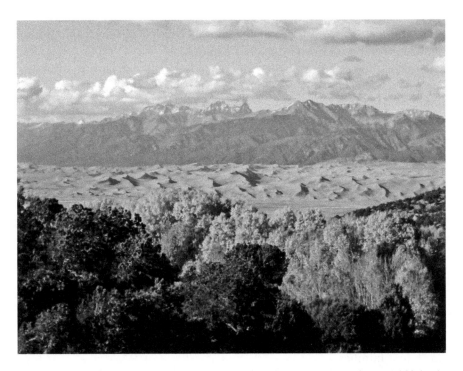

The Great Sand Dunes are seen from the Zapata Falls Recreation Area. *Courtesy of National Park Service.*

Colorado, as the ground gives way from beneath you with every step. You first cross over Medano Creek and then follow switchbacks along the dunes until a final slog straight uphill. There you get a stunning view of both the size of this sand accumulation and the diversity of life zones surrounding the dunes. An early-morning jaunt is recommended to avoid high midday temperatures.

If the path up is tough but rewarding, the return trip downhill is more an excuse for childlike adventure. Some visitors barrel down in kayaks or sandboards that they've rented outside the park and hauled to the top. Those without equipment have the option of walking down, leaping from point to point or rolling shoulder-over-shoulder down the open slopes, stopping only when the world is spinning at too fast a pace. The latter option is highly recommended.

The 150,000-acre park is more than just a giant sandbox, however. Its diversity of ecosystems ranges from the wetlands that ring the area to the scrub-covered sand sheet that is home to more than half of the actual sand deposit to the subalpine forests and alpine tundra that culminate in six peaks

above thirteen thousand feet in height. An eighty-eight-site campground allows for resting over several days of exploration.

And for those who want the experience but may not have the physical capacity to handle the hike to High Dune or beyond, the visitor center offers dune-accessible wheelchairs.

HISTORIC SITE: TOWN OF SAN LUIS

Forty-two miles southeast of Alamosa along Highway 159

Seven years before gold seekers began streaming into Denver, northern New Mexican residents, recently made Americans by the treaty that ended the Mexican War, crossed the modern border into Colorado and began to populate the San Luis Valley. Today the eight-hundred-person town of San Luis—established in April 1851—stands as the oldest settlement in the state, a place in which history is both demarcated and imbued into a culture where many of the residents are descended from those first families.

The Hispanic settlers that came north brought with them their communal cultural heritage, strong religious faith and traditional agricultural practices. Farmers in the sparsely populated valley continue to raise Navajo-Churro sheep and grow heritage crops like bolita beans. And they continue to draw their limited supply of water from acequias, shared ditches around which they have parceled their land.

Just twelve blocks long, San Luis features several historically significant sites. R&R Supermarket, opened in 1857, is the oldest continuously operating business in Colorado. The San Luis People's Ditch that is used for irrigation holds the oldest water right in the state, adjudicated in 1852. And the 1886-built Sangre de Cristo Parish, while thirty years newer than Our Lady of Guadalupe in neighboring Conejos County, features stained-glass windows and an elaborate altarpiece dating back to the early decades of settlement.

The faith and culture handed down from Colorado's first settlers are most evident in the Shrine of the Stations of the Cross, a three-quarter-mile uphill hike past life-sized bronze representations of fourteen moments in the final day of Jesus Christ's earthly life. Created by local sculptor Huberto Maestas, the depictions of suffering and death stand in stark contrast to the spacious green valley that spreads around the hill on which they are placed near the

Above: Jesus Christ meets his mother, Mary, in one of the statues of the Shrine of the Stations of the Cross overlooking the town of San Luis. *Author photo*.

Left: Pilgrims come from more than one hundred miles away to make the hike up the Shrine of the Stations of the Cross in San Luis each year. *Author photo*.

center of town. Pilgrims—some of whom walk 110 miles from Pueblo each year—are greeted at the top by a peaceful chapel.

Surrounding counties feature explorer Zebulon Pike's stockade from the winter of 1806–07 and the boyhood home of boxer Jack Dempsey. But Colorado's oldest town basks in a history that seems as visible today as it was in the antebellum days when people came here seeking a new life.

DRINKING SITE: THE RUBI SLIPPER

506 State Avenue, Alamosa / 11:00 a.m. to 10:00 p.m. daily

Alamosa grew into the biggest town in the San Luis Valley when it became a narrow-gauge railroad hub in the late nineteenth century. Though home to just 9,500 year-round residents, it now features Adams State University, a scenic railroad and a restaurant with twenty beers on tap and thirty-two types of burgers on its menu.

The building that houses the Rubi Slipper, located in the heart of downtown, had hosted a succession of restaurants and pool halls. But in 2012, Pamela Trujillo—an Alamosa native who spent fifteen years working in the hotel industry in Denver before coming home to open a previous fine-dining restaurant—had the opportunity to rejuvenate this property. And though she didn't originally plan for a craft beer–focused gathering place with so many beef-centric selections, she ended up building the menu around the desires of locals.

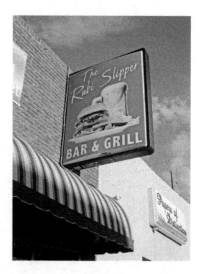

Today the Rubi Slipper offers the most diverse selection of burgers in the valley. Those include the standard fare topped with guacamole or grilled onions. But the menu also features a peanut-butter-and-bacon burger, a sandwich topped with macaroni and cheese and the Iron Mike, which substitutes a pair of grilled-cheese sandwiches for the bun.

Trujillo noticed after opening that customers had tapped into the craft beer

A sign hangs in front of the Rubi Slipper in downtown Alamosa. *Author photo.*

craze that had moved across the state, leading to the establishment of more localized small breweries—including San Luis Valley Brewing, less than a block away. So the tap list grew to include Sierra Nevada, New Belgium, Oskar Blues and Lagunitas. Alaskan Brewing makes a sweet and accessible Rubi Slipper Amber Ale for the restaurant. Patrons can order five-ounce samples of any beer for a dollar

Alamosa and the San Luis Valley seem in many ways a world removed from Denver. But the Rubi Slipper offers a little of that same unique vibe that infects beer bars and restaurants in the big city.

"The good thing here is that there is no hustle and bustle to get places, and you are minutes away from any destination," Trujillo said of Alamosa. "Everyone knows you. That's good—and then, of course, sometimes not so good."

DAY 3
UPPER ARKANSAS VALLEY

NATURAL SITE: RAFTING BROWNS CANYON

Buena Vista Area

The water for which Colorado is best known is found in granulated frozen form on the state's ski slopes. But some 200,000 people per year also flock to a 150-mile stretch of the Arkansas River that runs between its source near Leadville and the town of Cañon City, making it one of the most popular whitewater rafting destinations in the United States.

The best place to experience Colorado's unofficial summer sport is Browns Canyon, which covers a roughly thirteen-mile stretch of the river and which, buoyed by its diversion away from nearby highways, is considered the most remote boating experience along the Arkansas.

Browns Canyon National Monument is Colorado's newest federally protected area, having had more than twenty-one thousand acres set aside in February 2015 for continued use by rock climbers, rafters and anglers who come to draw trout from the Gold Medal area. Decades before its designation, however, scores of rafting companies set up shop to ferry thrill-seekers and families down a stretch that won't scare the daylights out of most but won't leave them yawning either.

A typical trip through Browns Canyon will take rafters over Class III rapids, guiding them through wider rock formations that feature swiftly running currents. Much of the trip offers opportunities to gaze

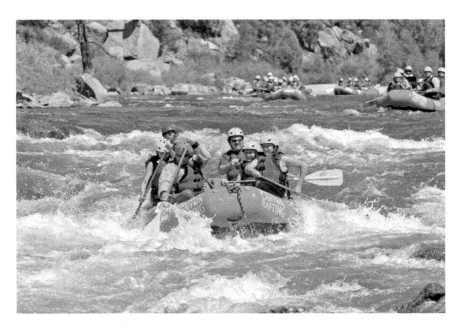

Rafters paddle the Arkansas River as part of a guided trip from Browns Canyon Rafting. *Courtesy of Browns Canyon Rafting.*

at the towering Sawatch Range of mountains, as well as formations like Pink Panther Rock or the Sleeping Lion whose shapes seem surprisingly familiar.

But while Browns Canyon is largely devoid of whirlpools, rapids like Pinball or the Boneyard require the four to eight people in the raft to follow the lead of a guide shouting, "Forward three!" or "Back two!" or some other command intended to get the crew to row hard together in one direction. The result can be a temporarily chaotic bouncing off of rocks or shooting down the river—it loses some 4,600 vertical feet over its most traveled stretch—followed by a collective high-five of paddles to celebrate.

A typical ride takes about two hours and often may finish with excited participants choosing to leap out of the boat to swim the final stretch in chilly fifty-five-degree water. This is a summertime outdoor celebration, and it's one that can give you a new perspective on the natural wonders of the state.

HISTORIC SITE: SAINT ELMO

Sixteen miles west on County Road 162 from U.S. 285

Colorado is littered with more than three hundred ghost towns, remnants of the mining boom that grew cities overnight and abandoned them almost as quickly when resources dried up or mineral prices fell. But none are as well preserved as Saint Elmo, a once-thriving mountain hamlet whose story is emblematic of much of the early days of the state.

Home originally to trappers and prospectors, this town between the modern-day cities of Buena Vista and Salida officially formed in 1880 and reached a peak of two thousand residents just a year later, serving as a supply hub for roughly 150 mining claims in the surrounding area. There were multiple hotels, restaurants and sawmills, making it Chaffee County's richest mining district.

But the silver crash of 1893 put a dent in the economy of Saint Elmo and numerous other towns. Then in 1910, one of the main railroad routes into town stopped running because of problems navigating through snow. By the time the final train route ended in 1922, Saint Elmo's obituary was written. Owners of the Home Comfort Hotel kept

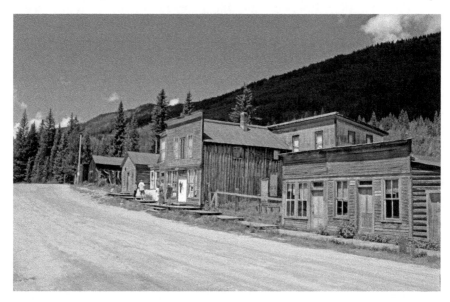

Visitors stroll along the boardwalk on the main street in the ghost town of Saint Elmo. *Jeffrey Beall.*

Above: Saint Elmo is considered by many to be the best preserved of Colorado's ghost towns. *Melinda Duncan*.

Right: The St. Elmo Mercantile building stands along the main road in the ghost town of Saint Elmo. *Author photo*.

The former Miners Exchange in Saint Elmo has become a general store selling souvenirs and snacks. *Author photo.*

it open for decades for a shrinking group of visitors, but in the late 1950s, the town was abandoned altogether.

For all the weather and aging damage the buildings accrued in the ensuing years, they did not disappear. In fact, forty-three wood-frame commercial,

residential and public buildings, many that are more than 130 years old, still stand in the ghost town that's listed on the National Register of Historic Places. Some are active again; a general store and a bed-and-breakfast operate throughout the summer. And Buena Vista Heritage has rebuilt the town hall and jail that burned down in a 2002 fire.

Some old facilities—many of which are privately owned—remain in good condition, windows covered in lace. Others, such as the St. Elmo Mercantile building, are cluttered with junk inside but retain their character. A one-room schoolhouse located a few blocks off of the main drag is in the process of being renovated too. Taken together, it gives a full sense of what a successful mining town looked like in its heyday.

Drinking Site: Elevation Beer Company

115 Pahlone Parkway, Poncha Springs / Noon to 8:00 p.m. daily / www.elevationbeerco.com

If the Upper Arkansas Valley is Colorado's tucked-away recreational paradise, the 750-person town of Poncha Springs is like an outpost within an outpost. Yet when four friends decided to launch a brewery in 2012 with goals of making both accessible beers and barrel-aged experiments, this was the place they chose to lay down roots.

The reason for putting a production brewery so far from an interstate highway or an airport, simply, was for the rafting- and hiking-heavy small-town lifestyle. Two of the founders, Sheila Bustamante and Carlin Walsh, had gone to high school together up the road in Buena Vista. Sheila's husband, Xandy, was working in beer distribution, and Carlin's good friend Christian Koch was making beer at Tommyknocker Brewery in Idaho Springs. They decided Poncha Springs, located just five miles west of downtown Salida, would allow Elevation to be a celebration of life and the outdoors.

They launched with gusto, releasing as their first beer Apis IV—a 10.9 percent alcohol-by-volume Belgian quadrupel brewed with honey produced by fourth-generation valley beekeepers. An IPA, a porter and a chardonnay barrel–aged saison soon followed.

The foursome didn't think originally that many people would come to visit their taproom. But they found that not only did people stop over as they trekked from Denver to the southwestern part of the state, but curious locals also came around. And they liked what they found.

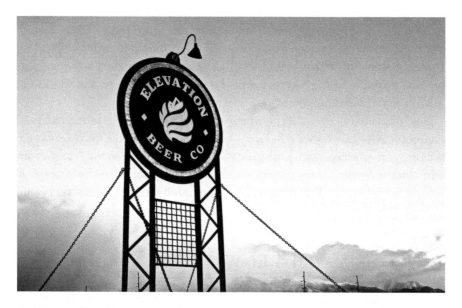

An Elevation Beer Company sign rises outside the brewery in Poncha Springs. *Courtesy of Elevation Beer Company.*

"Now it's amazing. We have pig farmers that are drinking Belgian tripel," Koch said.

The most attention-grabbing attribute of Elevation, now sold throughout Colorado and three other states, is its range of offerings, explained through the same system that ski resorts use to note the difficulty of their slopes. They go from the lone green-diamond offering—an 8 Second Kolsch that the brewery developed when it took over sponsorship of the Chaffee County Fair & Rodeo—to double black diamonds like Fanboy, a barrel-aged double IPA that's one of the few of its ilk in the country.

Walsh and Koch—who remain from the original quartet as current owners of the brewery—are just as proud of the fact that they employ seventeen people in a small town. And they hope that they can attract not just passers-through but also brewers and workers who want to stay.

"Ultimately, the area is a super cool place to live," Walsh said.

TRIP #9
SOUTHEASTERN COLORADO

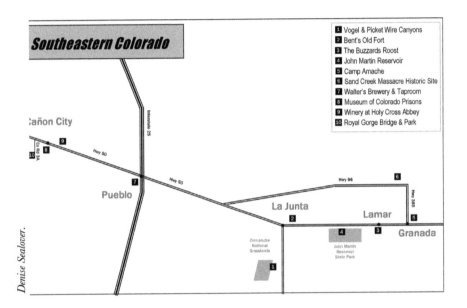

Southeastern Colorado

1. Vogel & Picket Wire Canyons
2. Bent's Old Fort
3. The Buzzards Roost
4. John Martin Reservoir
5. Camp Amache
6. Sand Creek Massacre Historic Site
7. Walter's Brewery & Taproom
8. Museum of Colorado Prisons
9. Winery at Holy Cross Abbey
10. Royal Gorge Bridge & Park

Denise Sealover.

DAY 1
LA JUNTA TO LAMAR

Natural Site: Vogel Canyon and Picket Wire Canyonlands

Take Highway 109 thirteen miles south of La Junta, then follow signs /
Open around the clock

The short-grass prairie fields and juniper-strewn plains of Comanche National Grasslands are the equivalent of a geologic timeline, leading hikers from the age of the dinosaurs to the era of Native American tribes to the early white settlement of the area. And there are two ways to trace that history, depending on how you'd like to explore and how much time you have.

First is a hike through Vogel Canyon, a tributary-carved area that has supported life since hunters and gatherers traveled through it around 5500 BC. Plains Indians took shelter here from 1500 to 1880, and the Westbrook family homesteaded here through the Great Depression, leaving the remains of their estate for today's visitors.

The 1.75-mile Canyon Trail leads you over rocks and onto the floor of the canyon, where spur trails guide you to overhangs sheltering rock art from early native dwellers. The abstract symbols of the art are light, and they are obscured in many places by modern vandalism. But while standing beside them, you can see why this was an attractive place to hunt and tend corn.

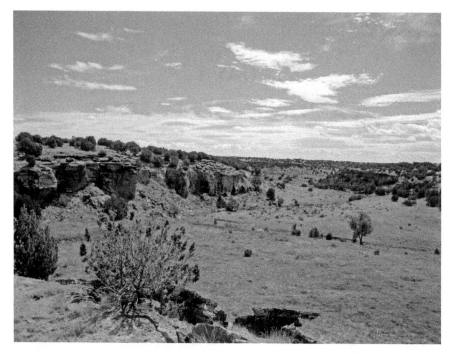

Top: Vogel Canyon is viewed from the top of a small cliff along the Overlook Trail. *Author photo.*

Above: Fossils and rock art can be found along the walls in Vogel Canyon. *Author photo.*

Three other trails traverse the area, including a paved overlook trail that presents a bird's-eye view of the land below and a Prairie Trail that partly follows an old stage road that was part of the Santa Fe Trail.

Sixteen miles west of Vogel along the dirt road that led you there is Picket Wire, a bedrock playground that houses the largest known collection of dinosaur tracks in North America. Settled alongside the Purgatoire River—named because Spanish explorers died in this harsh climate in the 1500s without receiving last rites—the roughly 1,400 prints sprawl over one hundred different trails, displaying the marks of both large carnivores and smaller omnivores.

An overhang shelters a rock wall within Vogel Canyon. *Author photo.*

While hiking the pathways is a strenuous option, the better way to see them is through guided four-wheel-drive automobile tours offered on Saturdays in May, June, September and October. Though they are eight-hour round trips, these take you close to the tracks and let you in on the oldest secrets in the area.

Historic Site: Bent's Old Fort

35110 Highway 194 East, La Junta / 8:00 a.m. to 5:30 p.m. daily, June through August; 9:00 a.m. to 4:00 p.m. daily, September through May / www.nps.gov/beol

From the early 1850s, Colorado became a military stronghold, with forts built to protect settlers, serve as launch points for attacks on Indians and, later, prepare Americans for wars overseas. It should not be forgotten, however, that the first fort maintained in the area was a place of peace and trading and a respite for attack-weary travelers on the Santa Fe Trail.

In 1833, traders William and Charles Bent and Ceran St. Vrain erected a two-story adobe bastion just north of the Arkansas River, which was the boundary between U.S. and Mexican territories. But the civilian fort knew no national divide, becoming a cultural crossroads where white travelers, Mexicans and Cheyenne and Arapaho Indians came together to barter on equal terms. Today the reconstructed fort, located eight miles east of La Junta, brings to life the ruggedness and simplicity of that time before film could capture a location.

The primary trade at the fort was in buffalo hides, which Indians would bring to the area. Mexicans came too, hauling silver and gold and leaving with practical items such as corn meal and blankets. William Bent was the primary overseer.

But even for those who did not stay for weeks at the fort—which held as many as two hundred people at a time—it was a safe haven along the Missouri-to-Mexico trail that took six weeks or more to travel. It offered water and food. And with one hundred or more men who had gone weeks without bathing there, it was said you could smell the fort for miles around.

With the onslaught of the Mexican War in 1846, though, the U.S. Army began using the civilian fort as a base of deployment into that country, and Indians stopped coming around as much. Charles Bent and William

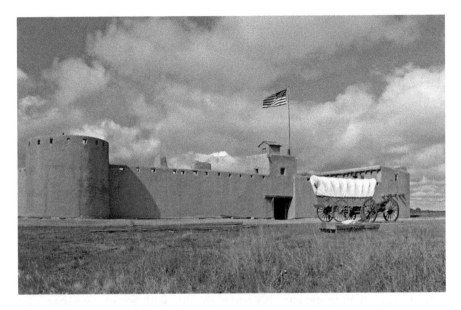

Bent's Old Fort has been rebuilt to look like it would have appeared to a traveler encountering it in the 1840s. *Courtesy of National Park Service.*

Peacocks roam the interior of Bent's Old Fort. *Author photo.*

Bent's wife died in 1847, and the 1849 California Gold Rush crowd brought cholera with them as they passed through the area. Disheartened, William Bent torched the fort and later opened another trading shelter downriver. It did not reach the same heights, though.

More than a century later, preservationists rebuilt the fort based on drawings from visitors in its heyday. Today, costumed re-creators tell the story of this place that played a major role in making the expansion of the West possible.

DRINKING SITE: THE BUZZARDS ROOST

101 North Main Street, Lamar / 10:00 a.m. to 2:00 a.m. daily

To hear Jay Gruber tell it, Lamar was a more happening place when he was in high school in the late '70s and early '80s, with five to seven bars that would feature live music. That was before the bus factory closed in 2005, leaving 300 people in this town of 7,800 out of work. The seat of Prowers County is sleepier now.

Guitars and beer signs tell patrons about the two main focuses of The Buzzards Roost. *Courtesy of The Buzzards Roost.*

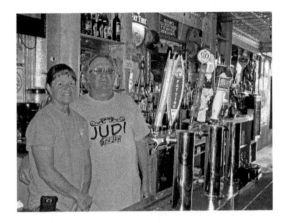

Karen Moreno and Jay Gruber, owners of The Buzzards Roost, stand by their row of beer taps. *Author photo.*

Gruber, however, wanted a place for his band to perform. So he bought the Pat-Sue Bar & Lounge—a music joint with low ceilings and orange shag carpet—and renovated it into The Buzzards Roost. Today it has live music weekly. It also has one of the best craft beer selections in southeastern Colorado.

"I bought it to have a place to play music, to keep the music going," said the T-shirt printer, motel operator and construction business owner who still jams with a rock band named JUDI.

Lamar isn't a natural stopover on the touring circuit, sitting 120 miles from the nearest Colorado town of at least ten thousand people (Pueblo). But Gruber built a stage in the back of The Buzzards Roost, hauls in bands from throughout the area and makes an effort to catch musicians traveling from Texas to Denver, hoping they might want to add a Thursday night gig.

Come at the right time and you'll discover even more happening around The Buzzards Roost. Gruber puts on Country Jam in the summer and Road Jam in the fall, closing down the adjacent street and setting up a stage for classic rock, country and blues bands to play through the day. His bar also builds floats for the array of local parades, from the Christmastime Parade of Lights to May's Lamar Days.

Music lovers won't go thirsty here. Those who show up will find the likes of New Belgium, Odell Brewing and Great Divide on tap—with an even larger craft beer selection planned after an expansion in winter 2015–16. Passers-through sometimes insist on taking photos of the taps, shocked at what they find.

If this leaves you hungry, there are wings and pizza coming out of the kitchen. And not those boring big-city recipes, either. Gruber's creations include a pie topped with green chile, bacon, french fries and alfredo sauce.

Yeah, it's small-town Colorado. But it's got a lot of flavor.

DAY 2
LAS ANIMAS TO PUEBLO

Natural Site: John Martin Reservoir State Park

30703 Road 24, Hasty / Visitor center open 8:00 a.m. to 4:00 p.m. daily / www.cpw.state.co.us/placestogo/Parks/JohnMartinReservoir

Bent County is a land of sagebrush and echoes, packing just 5,600 folks into its 1,500 square miles and feeling every bit as sparse as when traders carved the Santa Fe Trail through it. But what may seem vacant to the human eye is a paradise to the 373 species of birds that pass through or take up part-time residence within its borders, making this outpost of southeastern Colorado one of the best bird-watching locations in the interior United States.

At the heart of this aviary activity is John Martin Reservoir, a place of leafy campsites and rock formations protruding into the largest reservoir in this part of the state. Situated nineteen miles east of county seat Las Animas, it has earned listings among the twenty-five top birding spots in the nation—an honor that is exemplified less by the crowds of ornithologists that converge here than by the stunning variety of winged creatures that return year after year.

Some of the park's stars include piping plovers and interior least terns, both endangered and both coming in family groups—about five pairs of plovers and about fifteen pairs of terns—from mid-spring to mid-August annually. Plovers stand out with their bright orange legs and orange bills, while the terns—which nearly were hunted to extinction for their feathers in

the late nineteenth century—nestle their parted tails on the reservoir's protected south shore.

Bald eagles visit the north shore each winter, plucking fish from the water. Their appearance is somewhat out of peak season, as most birders flock to the park in spring and summer.

Lake Hasty Campground, just east of the reservoir, is the best spot for observation, as picnic benches and campsites spread out under a mass of foliage awash in a symphony of deep-throated warbles. Point Overlook, jutting into the reservoir farther west in

Top: A variety of birds, including bald eagles, congregate along the shoreline at John Martin Reservoir State Park. *Courtesy of Colorado Parks and Wildlife.*

Above: A pair of mallards strike a pose at John Martin Reservoir State Park. *Courtesy of Colorado Parks and Wildlife.*

the park, offers both the squawking of gulls and a human's-eye view of the setting sun glistening off the water.

And if becoming the next John James Audubon isn't on your itinerary, the reservoir is teeming with walleye, bass and crappie. Plus, the four-and-a-

half-mile Red Shin Trail encircles the park and ends at a marker on the old Santa Fe Trail.

John Martin Reservoir is miles from other human settlements. But it's clear the birds know something that we don't.

HISTORIC SITES: COLORADO'S DARK DAYS OF DISCRIMINATION

Site One: Camp Amache: 105 East Goff Avenue, Granada / 8:00 a.m. to 5:00 p.m. Tuesday–Saturday in summer; by appointment at other times / www.amache.org

Some fifty-five miles east of Las Animas, not far from the Kansas border, Granada is a tiny farming community surrounded by endless plains. Maybe that is why, in 1942, the federal government picked this out-of-the-way town to be one of ten across the western United States to house a relocation center and internment camp for Japanese Americans pushed off the West Coast during World War II.

After the bombing of Pearl Harbor, fear and resentment of Japanese descendants reached its apex. When President Franklin Roosevelt ordered the relocation of 110,000 of them, Colorado governor Ralph Carr became the only western governor to volunteer to house them, accepting some seven thousand into this quickly constructed, one-square-mile camp. Despite Carr's efforts to be an advocate for them, conditions were less than hospitable. Families crammed into a twenty- by twenty-four-foot space inside of drafty barracks and ate in community mess halls under the watchful eyes of armed guards stationed in eight watch towers.

Yet out of these conditions came amazing feats. The high school formed a football team and beat nearby Holly High in 1944. There was a camp newspaper, the *Granada Pioneer*, as well as a commercial silk-screen shop that printed posters for the navy. Amache featured the highest rate of volunteerism for U.S. armed service of any of the camps, and thirty-one members died defending the country that had segregated them, including one Medal of Honor winner.

When Camp Amache closed in October 1945, a number of residents stayed in the area. But after the barracks were torn down and the land left for grazing, its story was largely forgotten until John Hopper, a social

A guard tower—one of eight that ringed Camp Amache—stands near a reproduction barracks on the site of the former Japanese American internment camp. *Author photo.*

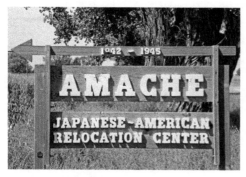

Above: A road sign erected by the Amache Preservation Society points the way to Camp Amache. *Author photo.*

Right: An original water tower still stands on the edge of the one-square-mile Camp Amache. *Courtesy of Amache Preservation Society.*

studies teacher at Granada High School, assigned a class in 1990 to dig up information on it as a research project. That turned into the Amache Preservation Society, which now operates a relic-filled museum on downtown's Goff Avenue and is working with the National Park Service to rebuild the site.

All that's left of the camp space two miles from downtown is one of the original guard towers, as well as a graveyard with the remains of the 121 people who died in captivity there. Still, stone foundations pop out of the grass intermittently, and wooden signs explain the buildings at which you no longer are looking, giving ghost-like images of what life here was like.

Site Two: Sand Creek Massacre National Historic Site: Kiowa County Road West and County Road 54 / 9:00 a.m. to 4:00 p.m. daily, April through November; 9:00 a.m. to 4:00 p.m. Monday–Friday, December through March / www.nps.gov/sand

Tensions were escalating in 1864. White soldiers killed Lean Bear, a Cheyenne peace chief, in an unprovoked attack in May. In June, Native Americans slaughtered the Hungate family, promulgating fear throughout Denver. But the final blow in this bloody year would send shockwaves across the country and the centuries.

Colonel John Chivington, a hero of the Battle of Glorieta Pass, wanted to reap glory from a temporarily raised cavalry regiment to respond to the attacks. Without a skirmish, though, his Third Colorado Cavalry Regiment became known as the "Bloodless Third." Shortly before enlistments were up, Chivington marched some 675 men through the night to a peaceful encampment of Cheyennes and Arapahos on Sand Creek. As dawn broke on November 29, Black Kettle raised a peace flag and an American flag over his lodge. Chivington ignored it and ordered an attack, sending soldiers thundering into a village made up mostly of women, children and the elderly.

Over the next eight hours, depredations were unspeakable. Children were bludgeoned to death. A pregnant squaw had her baby ripped from her womb. Soldiers scalped, took fingers from and mutilated genitals of the nearly two hundred dead. Twenty-four of Chivington's troops were killed, but at least some likely died of friendly fire in the chaos.

While the Third Regiment initially received a hero's welcome, two men who refused to let their soldiers participate, Captain Silas Soule and Lieutenant Joseph Cramer, wrote letters to a former commander documenting what they witnessed. Two congressional committees and an army commission

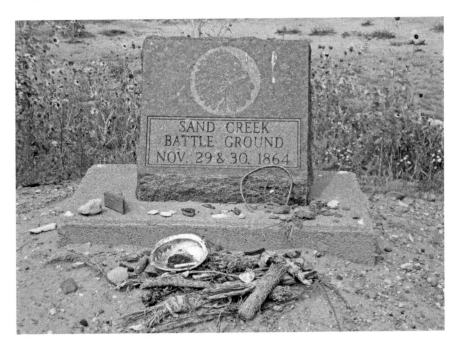

A memorial sits on a ledge overlooking the site of the Sand Creek Massacre. *Author photo.*

The field in which an army regiment massacred some two hundred Native Americans near Sand Creek in 1864 is sacred ground and is off limits to visitors. *Jeff Campbell/NPS.*

looked into it and determined the incident to be "acts of barbarity of the most revolting character rather than a battle." The massacre was, in fact, the most investigated incident of the Civil War.

The massacre sparked countless Indian raids on white villages and some twenty-five years of further battles between the U.S. government and Native Americans. Soule was killed in Denver after his testimony, and his attackers were never prosecuted. Chivington disappeared largely into obscurity; his gravesite at Denver's Fairmount Cemetery makes no mention of the incident. Cheyennes and Arapahos left the area around Sand Creek.

Today the site is the only Park Service location commemorating a massacre. Sacred to Native Americans, the field of killing is off limits to visitors, who only can stare out from an overlook at the vast plains, just as Chivington did that morning before giving orders. Located less than a mile from a visitor center explaining the massacre, it is a strangely serene place considering its black mark on U.S. history.

DRINKING SITE: WALTER'S BREWERY & TAPROOM

126 South Oneida Street, Pueblo / 3:00 to 9:00 p.m. Tuesday—Wednesday; 3:00 to 10:30 pm. Thursday—Saturday / www.waltersbeer.com

Located 130 miles southwest of the Sand Creek site, Pueblo grew into the steel-making center of Colorado in the late nineteenth and early twentieth centuries. Its wide streets and humble downtown still speak of that boom time.

So too does Walter's Brewery, a beer maker that opened here in 1889 and lasted through Prohibition until 1975. After working for ten years to convince the Walter family that they would honor its traditions, siblings Andy Sanchez and Diana Bailey got the green light to relaunch the brand in 2014. And walking into its downtown brewery and taproom is akin to taking a trip back in time.

Located in an 1883 train depot that once housed W.J. Lemp's Beer, the taproom is tucked into a back room, making one feel that they have to know a secret knock to enter. It's a storehouse of memorabilia from the original brewery, which grew popular by bringing buckets of beer to workers at the steel mill. Delivery jackets, neon signs and historic photos dot the windowless area.

The first beer Walter's brought back was its pre-Prohibition pilsner, a fuller-bodied version of the style. From there it added a host of other offerings, from a bock to a VolksWeizen to a Pueblo Chile Lager. Nine of ten growler refills are the chile beer, Bailey said.

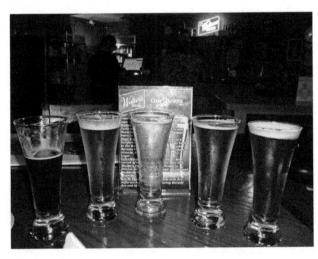

A sampler set of Walter's Beer sits within the Pueblo brewery. *Author photo.*

Pueblo was a town that never really went dry during Prohibition, and its downtown is pockmarked with tunnels leading between various taverns. As a result, it was rumored to have more bars per capita than any town in the United States up until the start of the twenty-first century.

Reviving a Pueblo classic from the days when the city had a handful of breweries seemed only appropriate, Bailey said. Stop in at the right time and you may get an impromptu tour.

"With a brand and a brand new name, you have to romance people," she said. "But they already like Walter's. So we'd really have to screw that up to ruin it."

DAY 3
CAÑON CITY

HISTORIC SITE: MUSEUM OF COLORADO PRISONS

201 First Street, Cañon City / 10:00 a.m. to 6:00 p.m. daily, mid-May through September; 10:00 a.m. to 5:00 p.m. Wednesday–Sunday, October through mid-May / www.prisonmuseum.org

Colorado was, in many ways, a lawless area as it settled, with the lure of gold being a primary motivator that brought men here and made them commit crimes against each other. The first territorial prison opened in 1871 in Cañon City; within ten years, it held 221 inmates and would grow steadily.

It only makes sense, then, that one way to tell the story of the state is through a museum dedicated to the history of the state prison system. And after the "Old Green Building," the women's prison that operated from 1935 to 1968, finally shut down, some of the local citizens in Cañon City—the seat of a county that is home to fifteen prisons—wanted to preserve it as a museum.

That museum is separated by only a wall and a guard tower from the Colorado Territorial Correctional Facility, the original 1871 joint that today houses seven hundred medium-security inmates. Across thirty cells upstairs and a series of rooms downstairs, the museum tells of the harrowing incidents, shady characters and larger-than-life wardens who have kept the system running for a century and a half.

The Museum of Colorado Prisons is accessed through a barbed-wire gate and is separated only by a stone fence from an active medium-security prison. *Jeffrey Beall.*

The gas chamber in which eight people were put to death is on display in the yard of the Museum of Colorado Prisons. *Author photo.*

One of the thirty cell exhibits in the Museum of Colorado Prisons shows the destruction that came from the deadliest prison riot in state history. *Author photo.*

Exhibits highlight famous prisoners—like cannibal Alferd Packer or John Gilbert Graham, the first airline bomber in U.S. history—as well as lesser-known but unique tenants such as Anton Woode, an eleven-year-old who murdered a man in Denver in 1893 because he coveted his gold watch. Female prisoners and controversial prisoner-control tactics also get their due.

Some of the most fascinating history surrounds the retelling of two riots on the grounds next door, one that left thirteen people dead in 1929 and another in 1947 that led to a movie being made just one year later that starred some of the breakout prisoners. If you're wondering how such things happened, a tabletop in the museum features guns, shanks and other weapons captured on prisoners.

Perhaps the most stare-inducing exhibit, located just inside the front gate, is the gas chamber used for the final eight executions of its kind in Colorado, a state that's put 103 people to death since 1890. Museum officials say they want the public to know that crime doesn't pay; nothing spells it out like staring into the belly of a machine meant only to make criminals pay with their lives.

DRINKING SITE: THE WINERY AT HOLY CROSS ABBEY

3011 East Highway 50, Cañon City / 10:00 a.m. to 6:00 p.m. Monday–Saturday and noon to 5:00 p.m. Sunday, April–December; 10:00 a.m. to 5:00 p.m. Monday–Saturday and noon to 5:00 p.m. Sunday, January–March / abbeywinery.com

Even prison towns have their softer sides. And in Cañon City, there is no more bucolic a location than the winery that opened in 2002 at a historic Benedictine monastery—though even its origins come from a dark event.

Father Paul Montoya traveled across the state to Palisade in 2000 to perform an exorcism at a winery that was being constructed there. He became so intrigued with the industry that he recommended starting a winery at his Holy Cross Abbey back in Cañon City. Three monastery leaders traveled to Sonoma to learn the business from consultant Sally Davidson and ended up convincing her just to move to Cañon City and open the winery with them. And when the monks left the abbey after its 2006 closure, recently relocated New York businessman Larry Oddo stepped in to lead the viniculture with Davidson.

Though the winery offers fifteen styles that include classic whites and reds, its signature creations defy easy categorization. Its annual Wild Cañon Harvest is made by blending thirty varieties of grapes grown in yards throughout Fremont County, and the sweet table wine, which has garnered awards, is released in a community celebration before the Christmas season

The Winery at Holy Cross Abbey, one of the largest wineries in Colorado, displays its range of offerings within its gift shop. *Courtesy of the Winery at Holy Cross Abbey.*

Winemakers plug the barrels holding their creations at the Winery at Holy Cross Abbey. *Courtesy of the Winery at Holy Cross Abbey.*

each year. Its Apple Blossom, meanwhile, uses only pressed apples rather than grapes and takes on a cider-like quality.

"We're not afraid to put a serious wine in front of you. And we're not afraid to put a sweet, fun wine in front of you," Oddo said.

The winery has a one-and-a-half-acre vineyard but gets much of its fruit from Colorado's Western Slope—and some from additional grape-growing land tended by prisoners from the Colorado Department of Corrections. The tasting room includes a porch overlooking the solitude of the vineyard, where visitors can sample meats and cheeses as well.

Now privately owned, the abbey is a backdrop for weddings and farmers' markets. It is a place that surprises many visitors who pass through the area expecting only barbed wire and instead find expertly crafted wines in a beautiful setting.

Natural Site: Royal Gorge Bridge & Park

4218 County Road 3A, Cañon City / 7:00 a.m. to dusk daily / www.royalgorgebridge.com

The difference between a gorge and a canyon is all about the floor. Specifically, a gorge is narrower at the bottom, while a canyon remains roughly the same width the whole way down. But as you stare 1,200 feet into Royal Gorge, located twelve miles west of Cañon City on Highway 50, you're likely to think less about semantics than about the awesome scale of the red granite rocks that descend before you.

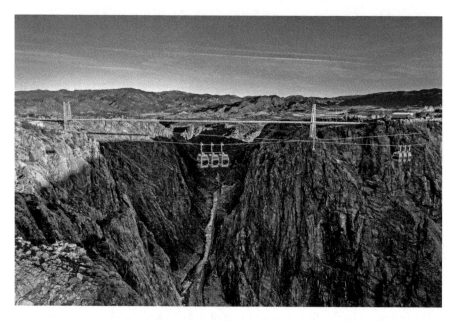

Gondolas carry some visitors over the Royal Gorge, while others choose to walk the 1,260-foot-long suspension bridge. *Eve Nagode.*

This natural wonder cut by the Arkansas River has inspired awe for centuries. Explorer Zebulon Pike's party camped here in 1806 and declared it the "Grand Canyon of the Arkansas." The Denver & Rio Grande Railway, which fought a bullet-riddled war with the Santa Fe Railroad to be the first to lay tracks against the gorge's walls, ran passenger cars in the late nineteenth and early twentieth centuries that made this the most advertised and photographed scenic spot on any U.S. railroad.

Today, there are many ways to take in the gorge. Both a railroad and a bevy of rafting companies ferry customers through the bottom. Meanwhile, visitors can stare down into the gorge from overlooks or from a quarter-mile-long suspension bridge that remains one of the tallest such structures in the world. Famous bungee-rope jumps and free rappels are noted on the bridge—though not the numerous suicides that have begun on the span. And while the bridge is largely stable even during wind gusts, peering over its sides is thrilling and almost dizzying.

People can gain even more bird's-eye views from the gondolas that take them on the 2,200-foot journey across the chasm, allowing unfettered views of the gorge. (A tip is to take the gondolas across from the visitor center and walk back over the bridge, which heads downhill in that direction.) The Zip

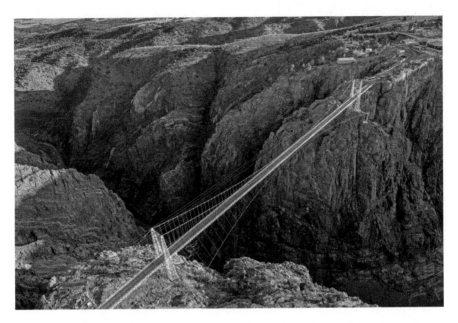

The quarter-mile-long suspension bridge over the Royal Gorge is one of the tallest such structures in the world. *Eve Nagode.*

Rider zip line also soars across the chasm at a semi-leisurely pace, and the Royal Rush Skycoaster will dangle you perilously above the descent.

Throughout the park are signs of the 3,200-acre fire that ripped through the area in 2013, hopped the gorge and destroyed forty-eight of fifty-two structures that were in the park, as well as the 1931 incline railway that used to descend into the gorge at a forty-five-degree angle. But the park reopened in August 2014, proving that even nature's most destructive onslaughts can't keep people from seeing beauty this grand.

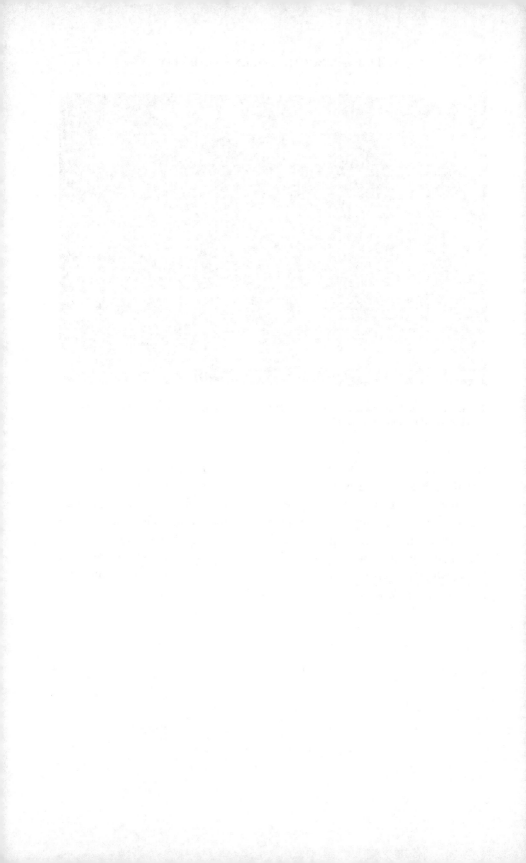

TRIP #10
COLORADO SPRINGS AND
CRIPPLE CREEK

Colorado Springs

1. Air Force Academy
2. Pikes Peak Cog Railway
3. Bristol Brewing
4. Garden of the Gods
5. Pro Rodeo Hall of Fame
6. Golden Bee
7. Gold Camp Road
8. Old Homestead House Museum
9. Boiler Room Tavern

Colorado Springs

Manitou Springs

Garden of the Gods Rd

Univ. Colorado Colo. Springs

Pikes Peak

Garden of the Gods

Colorado College

Cripple Creek

2nd St.
3rd St.
4th St.
5th St.
Hwy 67

Eaton Avenue
Carr Avenue
Bennett Avenue
Myers Avenue

Interstate 25

Nevada Ave

Hwy 24

The Broadmoor Hotel

Lake Avenue

Cheyenne Mountain Blvd

Gold Camp Road to Cripple Creek

Denise Sealover.

DAY 1
AROUND COLORADO SPRINGS

Historic Site: Air Force Academy

Exit 156 off Interstate 25, Colorado Springs / 9:00 a.m. to 5:00 p.m. daily for visitor center / www.usafa.af.mil

Colorado Springs was founded as a resort town and grew into the home base of area mining-company executives. But over time it evolved into the most military-centric town in Colorado—a distinction most exemplified by the presence of the U.S. Air Force Academy.

Established in 1954, seven years after the air force became a specific branch of the military, the primary training grounds for airborne officers landed in Colorado Springs only after Charles Lindbergh flew over the area and determined that air currents coming over the mountains would not impair flight training. The first class began its schooling the next year at a temporary location at Denver's now-closed Lowry Air Force Base, but it moved south in time for 207 students to spend their senior years on the eighteen-thousand-acre campus before graduating in 1959.

In the time since then, the AFA has graduated future astronauts, Medal of Honor winners and congresspersons. And the school remains one of America's top academic institutions, with 11 percent of incoming freshmen being valedictorians of their class.

The Barry Goldwater Visitor Center features exhibits on campus life and shows a movie documenting one year in academy happenings. A

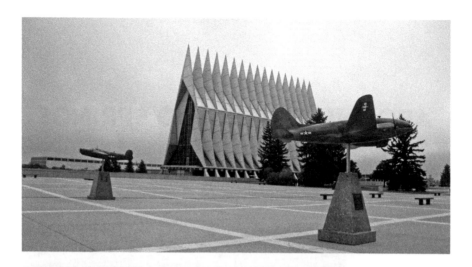

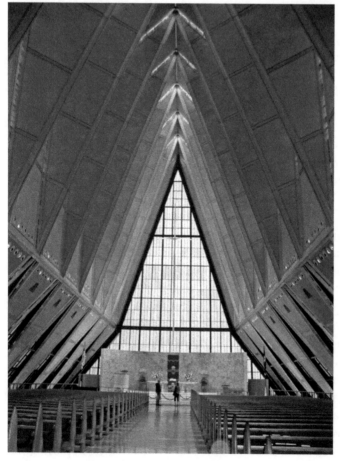

Above: Models of famous planes decorate the Air Force Academy's honor court in front of the Cadet Chapel. *Author photo*.

Left: The striking interior roof of the Air Force Academy Cadet Chapel is modeled after jets rising into the sky. *Author photo*.

driving tour of the accessible portion of the campus offers overlooks throughout and brings you up close and personal with retired aircraft.

For many, though, the highlight of the campus is the Cadet Chapel, a stunning aluminum, glass and steel building opened in 1963 whose design resembles a squadron of fighter jets thrusting 150 feet into the sky. Its interior features a nondenominational main chapel as well as Jewish, Buddhist and Catholic-specific worship areas, with the Catholic chapel being located under the rest of the building in the style of early churches that were built underground to avoid persecution of members.

The Colorado Springs area is also home to Fort Carson, Peterson Air Force Base and Schriever Air Force Base, and the bunker that once housed the headquarters of the North American Aerospace Defense Command (NORAD) is buried within nearby Cheyenne Mountain. But the AFA and its 4,500 students still tower over the city.

NATURAL SITE: PIKES PEAK COG RAILWAY

515 Ruxton Avenue, Manitou Springs / 8:00 a.m. to 5:00 p.m. daily in high season / www.cograilway.com

There are three ways to get up Pikes Peak, the mountain upon which Katharine Lee Bates was perched when she wrote "America the Beautiful." You can drive the nineteen-mile highway to the peak, if you don't mind its 154 hairpin turns. You can make the thirteen-mile hike up Barr Trail, which is rewarding but will take up your whole day. Or you can hop the railway for a ninety-minute ride to the top of the world.

Opened in 1891 by the same Zalmon Simmons who invented the box-spring mattress, the cog railway traverses grades over 25 percent as it crosses four life zones during a nine-mile, 7,500-vertical-foot ascent. And just as if you were hiking, the journey is half the joy.

You begin by passing through the 1.1-million-acre Pike National Forest, past the likes of Rose Emma Falls and Minnehaha Falls and beyond the remains of the former Half Way House Hotel that used to house burro-back guests who couldn't make the ascent in one day. Then it's through the aspen- and wildlife-heavy mountain zone, where Bates sat on Inspiration Point while composing her poem, originally titled "Pikes Peak." Third comes the subalpine region, including train stop Windy Point, where gusts have

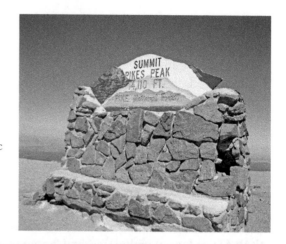

Right: A sign announces to visitors that they have reached the top of Pikes Peak, Colorado's most iconic mountain. *Author photo*.

Below: Train No. 24 of the Pikes Peak Cog Railway reaches the summit of the mountain. *Photo by Milan Suvajac*.

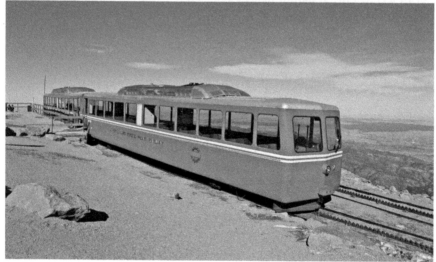

reached 150 miles per hour. Finally, you break through the alpine tundra and arrive at your destination.

If you're lucky, you might have caught a glimpse of the range of wildlife on the way up, from mule deer to marmots to wild turkeys. Maybe you could pick out the gold-rich Cresson Mine or some other landmark that's miles away by car but suddenly in your line of sight.

Though passengers have forty-five minutes to wander the top of the 14,115-foot mountain that explorer Zebulon Pike just dubbed "The Grand Peak" when he spotted it from fifty miles away in Pueblo, it goes far too quickly. (The peak was renamed after Pike died in the War of 1812.) There are plaques on Pike and Bates, and a souvenir-filled visitor center.

A cog wheel train of the Manitou and Pikes Peak Railway is seen at the summit of Pikes Peak. *Detroit Publishing Company Photograph Collection. Library of Congress Prints and Photographs Division Washington, D.C. 20540 US.*

But the thing to do is to find a short rock staring out into the vastness of four surrounding states that are visible and just admire. There are a limited number of times in your life that you'll be here, and this breadth of creation unfolding below you is something you can glimpse from only a few places. In every direction there is beauty, whether sky, mountains or plains.

Drinking Site: Bristol Brewing

1604 South Cascade Avenue, Colorado Springs / 11:00 a.m. to 10:00 p.m. Monday–Thursday; 11:00 a.m. to 11:00 p.m. Friday–Saturday; noon to 9:00 p.m. Sunday / www.bristolbrewing.com

Bristol Brewing owner Mike Bristol (third from right) and other employees enjoy the deck of their brewery at the former Ivywild School. *Courtesy of Bristol Brewing.*

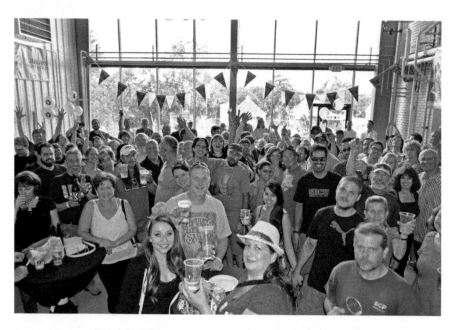

Crowds celebrate the opening of Bristol Brewing's venture in the Ivywild School in May 2013. *Courtesy of Bristol Brewing.*

Fifteen years into its award-winning existence in 2009, Bristol Brewing was in need of room to grow. The Ivywild neighborhood in south-central Colorado Springs that it had supported for more than a decade, meanwhile, was in decline, losing its ninety-three-year-old elementary school to closure. And suddenly an idea was born.

Today the Ivywild School is a thriving community center with a coffee shop, restaurant, cocktail bar, gathering area for concerts and community meetings and, of course, a two-story brewery in the space that several classrooms used to occupy. And Bristol Brewing, which prides itself in distributing solely within Colorado, is once again leading an effort to build community with a few beers and a lot of charitable contributions.

"We're not just here to make beer and money," founder Mike Bristol said. "We live here. So, what can we do to make it better?"

That attitude has pervaded the brewery since its opening. The profits from several seasonals, including its fawned-over Venetucci Pumpkin Ale, go to local charities. And Mike Bristol even has tried his hand at bringing a music festival to the area.

Bristol's beers rarely push boundaries too far, but many are spot-on examples of their styles. The Laughing Lab Scottish Ale remains the Colorado beer that's won the most medals at the Great American Beer Festival. The Red Rocket Pale Ale maintains its same medium-hopped body from its original 1994 introduction. And specialty beers like Red Baron Octoberfest and Winter Warlock Oatmeal Stout are smooth and flavorful without being overbearing.

The traits that endear Bristol to the community also made its transition into the 1916 school building with a pair of partners a success. It kept the school's child-focused paintings on the walls and in the former student bathrooms. Tiled handprints still descend the stairs. Mike Bristol said he's had teachers come back to their old grounds and congratulate him on the reuse. And he's had others contact him about how to replicate such an idea in other states.

Patrons can look through floor-to-ceiling glass walls at the brewery, which continues to expand its selection, recently launching a Belgian series. Mike Bristol hopes people see more than just the beer.

"I like to create an environment that can make great beer but is also in a pleasant area," he said. "I love when people from the neighborhood talk about it…I'm glad we haven't let them down."

DAY 2
COLORADO SPRINGS' WESTSIDE

HISTORIC SITE: PRO RODEO HALL OF FAME & MUSEUM
OF THE AMERICAN COWBOY

101 Pro Rodeo Drive, Colorado Springs / 9:00 a.m. to 5:00 p.m. daily,
May through August; 9:00 a.m. to 5:00 p.m. Wednesday–Sunday,
September through April / www.prorodeohalloffame.com

Colorado's official state winter sports are skiing and snowboarding, and professional football takes on a near-religious status here. But only one sport can brag that it was invented in the Centennial State, and that is rodeo.

Texas soldiers returned from the Civil War to find cattle roaming the plains and realized there was money in moving them north and east to the rail lines. Those cattle drives passed through multiple states, and cowboys in their down time would compete to see who was most skilled in their trades. On July 4, 1869, ranch hands gathered for an organized bronco-riding contest in the tiny town of Deer Trail fifty-five miles east of Denver, and the modern rodeo was born.

Rodeo today consists of a number of events, from bull riding to calf roping and steer wrestling to old-fashioned bareback bronc riding. America's roughly four hundred professional cowboys gather each year in Las Vegas to determine who is best. But it's in Colorado Springs, which is home to the Professional Rodeo Cowboys Association, that the best of the best are honored.

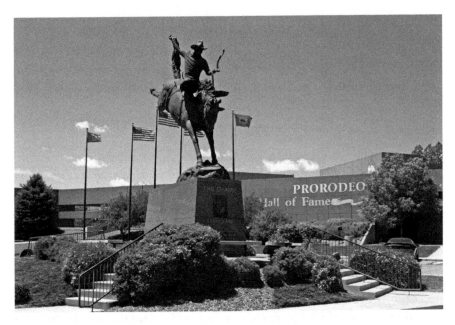

A statue of Casey Tibbs aboard his horse, Necktie, greets visitors to the Pro Rodeo Hall of Fame & Museum of the American Cowboy. *Courtesy of Pro Rodeo Hall of Fame & Museum of the American Cowboy.*

A larger-than-life statue of bronc-balancing Casey Tibbs—a flashy star who transcended the sport and introduced mainstream America to rodeo through roles in a number of movies—greets visitors to the museum. Inside, exhibits take you through the history and evolution of equipment from saddles to the ropes that were popularized by nineteenth-century Mexican Vaqueros. They explain how certain events rose to prominence and how others, such as buffalo wrestling, faded quickly from the scene.

The hall of fame occupies an immense room where stories of the greats, such as seven-time all-around champion Ty Murray, are told. But it also commemorates some of the less glamorous members of the industry, from rodeo clowns to stock contractors. Even some of the livestock, such as bulls like Tornado and Bodacious, get their due.

In some ways, the popularity of rodeo was an evolution from the crowds that gathered to see Buffalo Bill's Wild West show, but with competition and without the gimmicks. By the time you leave the museum, you'll understand how that happened and want to go see a rodeo yourself.

Natural Site: Garden of the Gods

1805 North Thirtieth Street, Colorado Springs / 5:00 a.m. to 11:00 p.m.,
May through October; 5:00 a.m. to 9:00 p.m., November through April /
www.gardenofgods.com

When a surveyor suggested in 1859 that the massive sandstone formations in what is now western Colorado Springs would make a great beer garden, his companion Rufus Cable countered that it was "a place fit for the gods to assemble." But while Zeus never strolled here, more than 1.7 million people do flock to this 1,370-acre city park annually, gazing at rocks that rise from the earth like a symphony, each striking a different note with those wandering among them.

Garden of the Gods is a place to hike, climb or just whip out a camera and capture the light that creeps around and through some nineteen unique formations, many of which are clustered around a central one-mile path that is wheelchair-accessible.

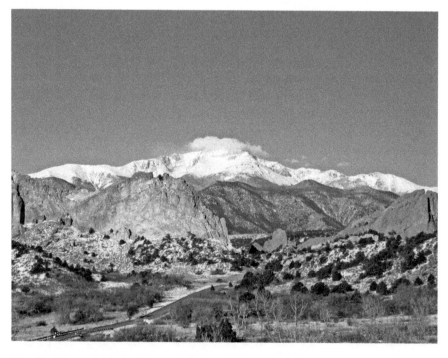

Pikes Peak is seen in the background of the sandstone formations of Garden of the Gods. *Mark Gallagher.*

Kissing Camels, which lies atop North Gateway Rock, is the most photographed feature of the park, a simple but poetic joining of two formations that bring to mind a whimsical dromedary romance. It looks out over the park like a sentinel, and brown bats make their home in its crevices.

Other formations offer similar monikers that make you stare at them until their visages become clear—Siamese Twins, Sleeping Giant, Pulpit Rock. A formation atop the Three Graces spires once received the title "Seal Making Love to a Nun"; not only did it crumble in time, however, but the publicist who labeled it soon found himself without a job.

In addition to the pathway through the central garden area, trails lead you across the high-desert landscape, winding through and over smaller rocks to glimpse Pikes Peak through the formations at different angles. A road also traverses the park, taking you to the Garden of the Gods Trading Post teeming with Native American art and to Balanced Rock, where an entrepreneurial businessman once snapped twenty-five-cent photos for long lines of visitors who wanted to pose beside the boulder that appeared ready to tumble onto them.

Charles Elliott Perkins's children donated the area to the city in 1909 with the provision that it remain free and open to the public. Though at times it may have been too open—the Civilian Conservation Corps planted juniper trees in the 1930s after sightseers had trampled the land barren in previous decades—it remains as towering and majestic as it seemed to Cable in 1859.

DRINKING SITE: GOLDEN BEE

1 Lake Avenue, Colorado Springs / 11:30 a.m. to midnight Sunday–
Thursday; 11:30 a.m. to 1:30 a.m. Friday–Saturday /
www.broadmoor.com/golden-bee

In southwest Colorado Springs sits the Broadmoor, a posh resort founded by city philanthropist Spencer Penrose. Visited by celebrities and dignitaries, it is awash in jacket-required, five-diamond restaurants. But the spot that draws the most visitors on the property is a casual pub with a ragtime piano that's been a gathering place for the city since 1961.

The Golden Bee began life as the Golden Lion, a seventeenth-century London pub that was dismantled and shipped to a New York warehouse in the 1880s, lingering there until Broadmoor officials stumbled across it in

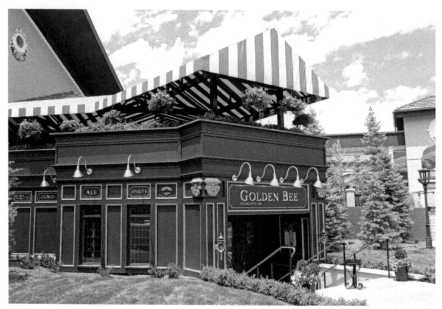

the 1950s. The tin ceiling and woodwork in the Bee are original to the 1600s, and burn marks over the lampshades show its history of gas lighting.

The pub retains its English feel, from the nineteenth-century fashion catalog drawings hanging on its walls to its European-heavy beer selection. Those Guinness and Boddington's draft selections are offered in yard and half-yard glasses that are hand-blown in New Mexico. And if thirty-six inches of beer sounds too much to master, the specialty drink is a Pimms Cup, made with an English gin-infused spirit.

With an atmosphere described as "Broadmoor rowdy," a pianist cranks out old-fashioned tunes from 7:30 to 9:00 p.m. each night and then leads sing-alongs from 9:30 p.m. to midnight. The air is filled with song but also with iconic stickers of bees that bartenders and hosts flick onto the shirts of unsuspecting patrons.

Top: The entrance to the Golden Bee is located not far from the main hotel at the Broadmoor resort. *Courtesy of the Broadmoor.*

Above: A mug displays the variety of occasion-specific bee stickers that workers flick onto patrons at the Golden Bee. *Author photo.*

Both hotel guests and city residents crowd the bar, but one must have special connections to join the Order of the Pewter Tankard, the Golden Bee's mug club. Three club members must sponsor you, in fact. England's Prince Harry is among those who got his invitation—and keeps his engraved mug on display for his return.

Penrose was a wild soul who didn't take kindly to Prohibition infringing on his fun following the resort's 1918 opening. Craig Reed, director of food and beverage for the Broadmoor, thinks he would have dug the Bee.

"The idea of a pub on-site where he could go with his friends is something he would have loved," Reed said.

DAY 3

COLORADO SPRINGS
TO CRIPPLE CREEK

NATURAL SITE: GOLD CAMP ROAD

Begin at Old Stage Road near the Cheyenne Mountain Zoo, Colorado Springs

Riding on the Colorado Springs and Cripple Creek District Railroad in 1901, Teddy Roosevelt glanced at the scenery around him and declared it to be "the trip that bankrupts the English language." The railroad is long gone today, but the road that connects southwestern Colorado Springs to Victor and Cripple Creek remains, and the twenty-six-mile ride along it still offers the best leaf peeping in the state.

To reach the rutted dirt road, take Penrose Road toward the Cheyenne Mountain Zoo, but turn right beforehand onto Old Stage Road. Turn right again after a mile and follow a sign toward Bear Trap Ranch. This puts you onto a winding route into the Pike National Forest.

While views of Cheyenne Cañon are immediate, so is the sense of claustrophobia as rocks hug the road and the trees hang low in the style of a magnolia canopy. The route narrows in the coming miles, and you pass through a series of crevasses wide enough for just one car. But after each squeeze, you emerge into valleys of aspens, and the overlooks for viewing these trees are frequent.

When the railroad went out of business in 1920, Colorado Springs businessman W.D. Carley removed the tracks and built a toll road. When

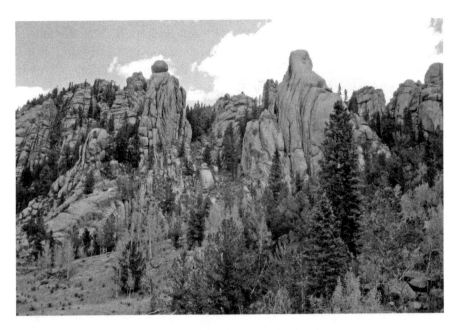

Cliffs rise along Gold Camp Road in Cathedral Park. *Mark Byzewski.*

An old mine shaft is gated off along Gold Camp Road. *Mark Byzewski.*

his special-use permit with the national forest expired in 1939, the federal government opened it free to the public and renamed it Gold Camp Road, recalling the days that cars hauled ore from the mines of Cripple Creek to the big city to the east.

Just one of the original nine tunnels along the route remains open to the public—the 245-foot-long Tunnel No. 9, which you'll reach nineteen and a half miles into the drive. Although rebuilt in the twenty-first century, it has an old-time feel, with wooden columns outlining its 16-foot-wide frame.

Big-horned sheep and other animals occasionally wander close to the road, which is accessible to almost every vehicle. But they don't compare in gape-worthiness to the large open fields that allow you to peer over the valley and see the aspens dotting it in beautiful fullness.

From the start of the path to the final break where you turn toward Victor or Cripple Creek, the road dazzles you even as it gets almost frighteningly narrow in places. It's as exhilarating today as it was in Roosevelt's time—though much less crowded now.

Historic Site: Old Homestead House Museum

353 East Myers Avenue, Cripple Creek / 11:00 a.m. to 5:00 p.m. daily,
June through October / www.oldhomesteadhouse.com

The town of Cripple Creek was a little late to Colorado's gold-rush party, with the element being discovered west of Pikes Peak only in 1890. But what it lacked in timeliness it made up for in wealth, as 24 million ounces of gold have been extracted from the ground since then, making it the fifth-richest strike in the world.

The town ballooned within five years to fifty thousand people, boasting a dozen newspapers, several dozen assay offices and more than one hundred saloons. Like all boomtowns, it had hundreds of prostitutes working the streets—but was wealthy enough to feature five madams' houses that catered only to mine owners as well. Just one remains today, and it has the distinction of being the only bordello museum in Colorado.

Pearl DeVere built the Old Homestead in 1896 after a pair of fires had wiped out practically every building in the business district. She employed four girls at a time, and gentlemen who wished to visit had to make letters of application through which DeVere checked references and finances. The girls were licensed by the city's health department, despite the illegal

An upstairs room at the Old Homestead House Museum shows what life was like for high-end prostitutes in turn-of-the-century Cripple Creek. *Author photo.*

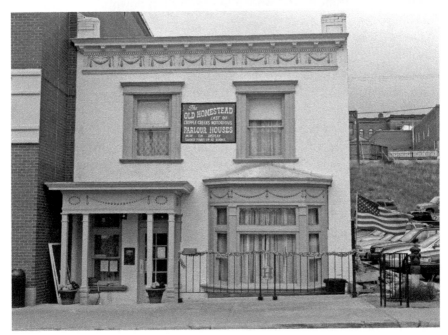

The Old Homestead House Museum is the only former bordello that now serves as a historical site in Colorado. *Courtesy of the Old Homestead House Museum.*

The chandelier and wallpaper of the Old Homestead House Museum's entertainment room are among the features original to the 1896 bordello. *Courtesy of the Old Homestead House Museum.*

nature of the business, and were allowed to shop downtown on Monday mornings.

DeVere was a local celebrity. When she died of a morphine overdose in 1897, her unsuspecting family refused to claim her remains after learning of her profession. But a one-thousand-person funeral processed through the town, and she is the only prostitute buried with a headstone in the town's Mt. Pisgah Cemetery.

The house, which closed in 1916 and was made into a museum in 1958, is stocked with original items that show the semi-charmed lives the girls led while making as much as $100 a night at a time when the average miner made $3 per day. Silver tea sets and Iranian quilts were gifts from customers. A woman who worked here in her younger days donated a lace bedspread that's now on display in an upstairs room.

Going beyond the city's seedy side, the house also tells the story of Cripple Creek. There are pictures of Bob Womack, one of the original discoverers of gold who sold his claim for $500 and died destitute. There are old city directories listing the madams as proprietors. And there is the sense of what the city—now a town of legalized gambling with a 1,200-person population—was like when men, and a few women, rushed here to strike it rich.

Drinking Site: Boiler Room Tavern

303 North Third Street, Cripple Creek / Hours vary / www.hotelstnicholas.com

While a house of ill repute remains intact from Cripple Creek's glory days, few original saloons do. But one can taste the history of the town—and a few Colorado craft beers—by dropping into the bar now found in what was the laundry area of the town's Catholic hospital.

Situated on the bottom floor of the historic Hotel St. Nicholas, the Boiler Room Tavern overflows with remnants of the area's past. A list of signals for being lowered into or hoisted out of a mine adorn the wall. The building's original coal-fired boiler sits prominently behind the bar. Poster advertisements harken back to the days when patients could pay twelve to fifteen dollars per week for a private room at the hospital—and tack on three to six dollars more for the use of an operating room.

The Sisters of Mercy built this as their second hospital facility in town, opening it two years after the fire of 1896. They ran it until Cripple

Hotel St. Nicholas, home to the Boiler Room Tavern, is the former Catholic hospital two blocks up from Cripple Creek's main drag. *Author photo.*

The Boiler Room Tavern is located in the basement of the Hotel St. Nicholas, offering space for about a dozen patrons. *Author photo.*

Creek became a virtual ghost town in 1924, after which the building passed through several operators and then through iterations like a home for challenged juveniles. The current owners purchased it in 1994 and turned it into a historic inn.

Don Waite, the "nocturnal innkeeper" who tends bar, noted that Boiler Room patrons have long ties to the building. Regulars brag of being born here or even shoveling coal into the boiler. And some of the hotel's "guests" have been here a century or more.

At least four entities haunt the property, Waite said. A nun dressed in full habit and an old miner pop up occasionally. "Petey," a child ghost, may move your keys or glasses across the room. And guests still report the sound of crying near Room 11, a former surgical area.

A cozy tavern with just four tables and an additional four seats at the bar, the Boiler Room serves Colorado brews from the likes of Bristol Brewing, New Belgium and Odell Brewing, and it offers a small selection of wine and liquor. Though located just two blocks from downtown, it's all uphill, prompting Waite to certify people with a "hill climb ceremony" if they walk up from the casinos on Bennett Avenue.

The Boiler Room is small and unique and historic. In other words, it's Cripple Creek.

INDEX

A

Air Force Academy 231
Alpine Loop 173
Animas Mountain 159
Aspen Brewing 125
Avery Brewing 62

B

Bates, Katharine Lee 233
Bent's Old Fort 208
Black Canyon of the Gunnison
 National Park 149
Boiler Room Tavern 249
Bonfire Brewing 109
Booth Falls 104
Box Cañon Falls 145
Bristol Brewing 235, 237, 250
Brown Palace 27
Browns Canyon 196, 197
Buckhorn Exchange 24
Buffalo Bill 26, 58, 95, 239

Buffalo Soldiers 182
Buzzards Roost 210, 211

C

Camp Amache 214
Camp Collins 75
Camp Hale 113, 115
Carr, Ralph 48, 214
Carson, Kit 181
Carver Brewing 168
Casey Brewing & Blending 131
Central City Opera House 93, 94, 95
Chief Ouray 152
Chipeta 151, 152
Chivington, John 217
City Park 22, 24
Civilian Conservation Corps 34,
 166, 241
Civil War 24, 58, 78, 97, 181,
 218, 238
Colorado Boy Pizzeria & Brewery 154
Colorado National Monument 137

Colorado Ski & Snowboard
 Museum 106
Colorado State Capitol 47
Colorado State University 69, 72,
 76, 80
Confluence Park 31, 32
Continental Divide 81, 100
Crazy Mountain Brewing 109

D

Daniels & Fisher Tower 30
Dearfield 67, 68
DeBeque Canyon Winery 142
Dempsey, Jack 194
Denver Post 172
Devil's Head Lookout 52
Dillon Reservoir 100
Dinosaur Ridge 34, 36
Dostal Alley 95, 97
Dry Dock Brewing 49, 50
Durango Brewing 161
Durango & Silverton Narrow
 Gauge Railroad 157, 161

E

Element 47 123, 125
Elevation Beer Company 201

F

Falling Rock Tap House 32
Fort Collins Brewery 71
Fort Garland Museum 181
Funkwerks 71

G

Garden of the Gods 240, 241
Georgetown Loop Railroad 98
ghosts 54, 250
Glenwood Canyon Brewing 130
Glenwood Hot Springs 132
Gold Camp Road 244, 246
Golden Bee 241, 243
Golden Gate Canyon State Park 60
Grant, Ulysses 94
Great American Beer Festival 32,
 51, 71, 97, 108, 131, 237
Great Depression 100, 205
Great Divide 39, 41, 211
Great Sand Dunes National Park
 184, 189

H

haunted places 85
Hickenlooper, John 97
Hinsdale County Courthouse 173
Hinsdale County Museum 171, 173
History Colorado 21, 22, 152
Holliday, Doc 117, 126
Horsefly Brewing 153
Horsetooth Rock 69, 71
Hotel Colorado 126, 128, 132

I

Indian Wars 58, 182
Inter-Laken Resort 115, 116, 117

J

John Martin Reservoir State Park 212

K

Kennedy, John 26
King, Martin Luther 24
King, Stephen 85
Knife Edge Trail 166, 167
Ku Klux Klan 48, 67

L

Lady Falconburgh's Alehouse and
 Kitchen 161
Lake San Cristobal 175
Larimer, William 30, 31
Laws Whiskey House 56
Lebanon Silver Mine 98
Lincoln Hills 21
Lindbergh, Charles 231
Linden Hotel 77
Littleton Museum 54, 55
Longs Peak 81, 83
Ludlow Massacre 39

M

Maroon Bells 121, 123, 137
Matchless Mine 119, 121
Mayflower Mill 143
Mayor of Old Town, The 71
McDaniel, Hattie 77
Meeker, Nathan 139, 152
Mesa Verde 22, 164, 166, 168
Mexican War 192, 208
Million Dollar Highway 145
Molly Brown House Museum 36
Mount Elbert 116
Mount Falcon Park 45
Mount Margaret 74, 75
Museum of Colorado Prisons 221

Museum of the Black American
 West 68
Museum of the West 139

N

National Mining Hall of Fame and
 Museum 119
New Belgium Brewing 71, 177,
 195, 211, 250

O

Odell Brewing 71, 78, 177, 211, 250
Old Homestead House Museum 246
Oskar Blues 85, 86, 87, 177, 195

P

Packer, Alferd 171, 173, 223
Packer Saloon and Cannibal Grill 176
Palisade Brewing 140
Palmer, William Jackson 157
Peach Street Distillers 140
Penrose, Spencer 241
Picket Wire Canyonlands 205
Pike National Forest 233, 244
Pikes Peak 52, 93, 233, 241, 246
Pike, Zebulon 95, 194, 226, 234
Prohibition 97, 117, 219, 220, 243
Pro Rodeo Hall of Fame 238
Pug Ryan's Brewing 102

R

railroads 56, 58, 98, 157, 161,
 226, 244
Red Rocks Amphitheatre 34
Roaring Fork Beer Company 131

Rocky Mountain National Park 71, 81, 83
Rocky Mountain News 49
Rocky Mountain oysters 26, 154
Roosevelt, Franklin 214
Roosevelt National Forest 74
Roosevelt, Teddy 26, 126, 244
Royal Gorge 225
Rubi Slipper 194, 195

S

Saint Elmo 198
Sand Creek Massacre 216
Sangre de Cristo Mountains 189
San Isabel National Forest 115
San Juan Mountains 159, 176, 189
San Luis 192
Santa Fe Trail 206, 208, 212, 214
Silver Dollar Saloon 117
Sitting Bull 58
Ska Brewing 142, 161, 168
Snowbank Brewing 72
Sousa, John Philip 84
Stanley Hotel 84
Shrine of the Stations of the Cross 192
Steamworks Brewing 168
St. Mary's Glacier 91, 93
Stranahan's Colorado Whiskey 56
Strange Craft Beer 48, 49

T

Tabor, Horace 119
Taft, William Howard 130
Teller House 94, 95
Telluride Brewing 147, 148

Tenth Mountain Division 106, 108, 113, 115
Thompson, Hunter 21
Three Barrel Brewing 186
Twin Lakes 115
Two Rascals Brewing 154

U

Union Station 30
Ute Indian Museum 151

V

Vail Cascade Resort 108
Varaison Vineyards and Winery 140
Vogel Canyon 205

W

Walter's Brewery 219
White River National Forest 104, 121
Wilde, Oscar 117
Winery at Holy Cross Abbey 223
Works Progress Administration 22
World War I 38, 47, 68, 117, 143
World War II 48, 56, 106, 113, 115, 132, 139, 214

Y

Yat-sen, Sun 27

Z

Zapata Falls 184

ABOUT THE AUTHOR

 d Sealover is a reporter with the *Denver Business Journal* covering a range of beats, including state government, tourism and the beverage industry. Over his twenty-one-year journalism career—which has included stints at the *Rocky Mountain News* and the *Gazette* in Colorado Springs—he has received seventy-seven state, regional and national awards in categories ranging from investigative reporting to political reporting to public service.

Sealover has been writing about beer since 2003, including his 2011 book M*ountain Brew: A Guide to Colorado's Breweries* and his ongoing Beer Run Blog. While this is his first stab at historical writing, he is a history buff and a volunteer tour guide for History Colorado.

Sealover holds a bachelor's degree in journalism with a minor in history from Northwestern University. He lives in Denver with his wife, Denise, and their children, Lincoln and Jane.